# SECOND CHANCE

# Second Chance

## My Life in Things

*Ruth Rosengarten*

OpenBook Publishers

https://www.openbookpublishers.com/

ISBN Paperback: 9781800643741
ISBN Hardback: 9781800643758
ISBN Digital (PDF): 9781800643765
ISBN Digital ebook (EPUB): 9781800643772
ISBN Digital ebook (AZW3): 9781800643789
ISBN Digital ebook (XML): 9781800643796
ISBN DIGITAL ebook (HTML): 9781800646704
DOI: 10.11647/OBP.0285

Cover photo by Ruth Rosengarten
Cover design by Anna Gatti.

*for Dan and Leora*

Memory is a second chance.

Ocean Vuong, *On Earth We're Briefly Gorgeous*

'But we have other lives, I think, I hope,' she murmured. 'We live in others, Mr... We live in things.'

Virginia Woolf, *Between the Acts*

After she died I don't think he felt any reason
to go back through all those postcards, not to mention
the glossy booklets about the Singing Tower
and the Alligator Farm, the painted ashtrays
and lucite paperweights, everything we carried home
and found a place for, then put away
in boxes, then shoved far back in our closets.

He'd always let my mother keep track of the past,
and when she was gone—why should that change?
Why did I want him to need what he'd never needed?

Lawrence Raab, 'After We Saw What There Was to See,'
*The History of Forgetting*

# Contents

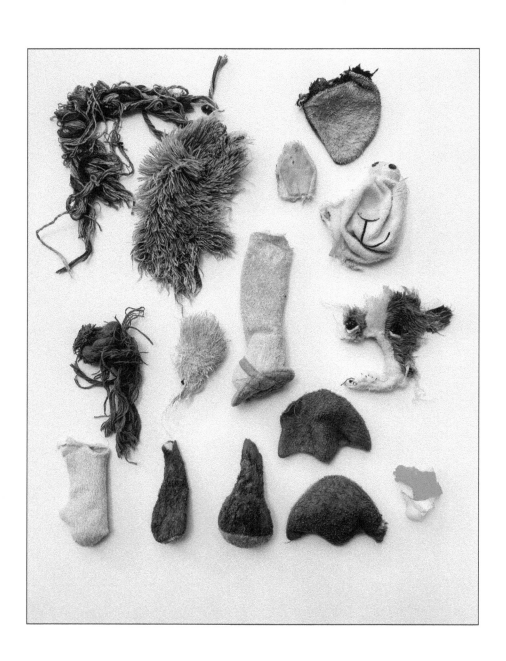

# Situating

I was a child, perhaps eleven or twelve years old, when it occurred to me that there existed a link between things—I mean physical things, material objects—and grief. That realisation seeped through me like a blooming of ink when I understood that the cat had gone but the water bowl remained. Imbued with a no-longer-usefulness, that water bowl was imprinted with absence. Previously a mute and unexceptional object, it had been transformed into an emblem of sorrow, a fetish occupying the site of loss.

This was maybe two or three years after I realised for the first time that one day, not only would my parents be dead, but also: my younger brother, my newly born sister and I myself. We would all, one day, be dead. There would be no 'I' to think thoughts or fret or know things. How to think about nothing, an absence in the place of this vital knot of feelings that was *me*?

Thinking of my future deadness (and of course, this is me, now, thinking of my past-future deadness), I knew (I know) that what mattered to me about that cat's water bowl—about all my future dogs' bowls and chewed toys (the ones that look like roadkill), the special pencil stub and musty handkerchief with its stencil of my mother's lipstick lips; boxes of letters and photographs; my father's hairbrush and Seven Star diary; that battered edition of *The Mersey Sound,* with its too-long, childish dedication in the hand of a friend who was my idol and my rival; the talismanic trinkets (a brooch in the shape of a pig, a tin St Christopher) given by lovers and now signifying nothing so much as the loss of love, as though one could ever have really possessed it—what mattered about those things would evaporate with the extinguishing of my consciousness. Someone will one day throw all that away.

Without me, it will become mere stuff, junk.

That is a great deal of thought to impose retrospectively on the mind of a young girl ardently striving to understand the disappearance of a

 https://doi.org/10.11647/OBP.0285.01

cat, a beloved pet; a girl suspicious—knowingly uncertain—that her mother had a hand in that disappearance. Decades later, I can scarcely tolerate thinking about the day that Ginger was taken away and the dawning that came with it, the blending of recrimination, impotent fury (fury is always impotent), sorrow, guilt.

The things that mean the most to me—I am using the words *things* and *objects* interchangeably here, though arguably they are not the same—are seldom objects of great (or any) monetary value. The phrase *sentimental value* often appears with a qualifier: *only*. It is possible for the qualities of material and sentimental value to overlap and coincide: think of Edmund de Waal's *netsuke* whose extraordinary trajectory he traces in *The Hare with Amber Eyes* (2020). But mostly, objects to which the word *sentimental* adheres occupy a different order of value. We might scoff at them, but they are the very things that we would attempt to salvage from flood or fire or war.

There is an attitude everywhere present in the English use of the term *sentimental* that denigrates it as a thing of little import, a trifle. Unlike the broader French use of that term, the English one suggests an exaggerated emotion for which, in Oscar Wilde's formulation, one has not paid. Poet and essayist Mary Ruefle borrows the definition of *sentimental* from novelist John Gardner, who describes it as causeless emotion; that is, says Ruefle, following a skittish riff on cute kittens, 'indulgence of more emotion than seems warranted by the stimulus.' Sentimental value is pitted not only against material value, but also against artistic value: the word *kitsch* brings the field of aesthetics into focus. Aesthetic merit is generally attributed to artefacts around which, ostensibly, not a scrap of sentimentality is wrapped. Yet when we talk of objects of sentimental value, we admit that it is a value that must be respected; that without such sentimentality, we move towards the threshold separating us from bare life.

This is a book about objects that are of sentimental value to me; my evocative objects.

You could say it is a book of modest—even blinkered—scope, since it shines no direct light on the wider (political, environmental, bureaucratic) contexts in which I find myself. I write, in other words, from a cocoon; cognisant of the intruding world but not addressing it directly. To do so would be to use a voice that was not my own, since (for

reasons I cannot entirely fathom), when I talk in the voice of politics, I feel I am ventriloquising. Yet I am writing from a body that is embedded in culture, with its crosscurrents of voices and changing concerns. I am writing from my embodied position as a middle-class, white woman of advancing years (I am thinking a lot about that metaphor of advance), a person without descendants living in the guilty comfort of a too-large home in the English countryside, inexorably drawn into a vortex of virtual spaces and statistical algorithms, rapaciously devouring books or (more accurately) sections of books, lamentably enmeshed in the habits of consumption that contribute to capitalism's insatiable momentum, yet also possibly at the point of giving up certain polished habits of work and long-if-loosely-held-and-partly-disavowed ambitions, thinking about excess, my excess, and what to do with and about it.

If this project is in no way political in its declared drives (although a political beast lurks in some of the words that I use, such as *excess* and *indulge*), I nevertheless believe that humans are linked to other humans, and also to non-human beings by shared vulnerabilities: to power, to violence, to language, to pathogens. This makes all our destinies a matter of politics and policy. But it is really the human vulnerability to neediness and love, the accommodations both to desire and to injury that I touch on, taking as specimen, target and source my own self, my life in this body.

There would have been a different story to be told had I chosen objects of archival value, friable, disintegrating documents salvaged from my family's migrations and my own; or if I had chosen objects of cultural significance (had I such objects), as Marina Warner does in her *Inventory of a Life Mislaid: An Unreliable Memoir* (2021). Warner's objects (including two diamond rings, a cache of German marks, a Box Brownie, expensive brogues, but also nasturtium sandwiches, which now exist only in memory) are magnets to which shared cultural signifiers have been drawn well before the writer's own memory work begins. Her brilliance resides in a mesmerising capacity to braid intimate memories and family myths together with—and into—broader cultural narratives. Warner's memoir is always simultaneously personal and historical/political. It speaks of class, and it speaks of Englishness and it speaks of gender and of Empire, all the while homing in on a few objects (icons, metonyms) to tease out the details of a short period of the author's early

life, and the few years preceding her birth. 'Mrs Warner,' she writes of Ilia, her Italian mother, 'was beginning to cook *all'inglese* and learning the words to match.' A nasturtium sandwich is as much a thing in itself as a thing named and reified in the naming: a twinning of words freighted with significance, foods eaten during wartime rationing but described with the delectation of a cordon bleu chef: 'the flower's seed pods were draw-purses packed with tangy seed,' Warner writes as she launches into a paradoxically sensuous description of making do.

Marina Warner's memoir sits comfortably alongside other volumes of memory work—a method and practice of unearthing untold stories, connecting their parts and making them public—constructed around material objects. In *Motherwell: A Girlhood* (2020), Deborah Orr uses her mother's bureau and its contents as the centrepiece from which her personal recollections issue: a clipping of baby hair, a reference letter for Dad's work, Harry's silver cigarette case, school reports, an album of tea cards. Though focusing on her own girlhood, Orr builds a bigger picture of an unhappy marriage, mid-twentieth century factory employment, class aspiration (a front and back garden), keeping up appearances, and an architectural and social experiment in Motherwell, Lanarkshire.

In *What They Saved: Pieces of a Jewish Past* (2011), American literary scholar and memoirist Nancy K. Miller examines a small store of things she found after her father's death, personal objects—an unexplained land deed, a lock of hair, a postcard from Argentina—that she sees as mnemonic remnants steeped in silence. Alighting on clues in photographs and letters, Miller uncovers inevitable skeletons, conjuring evidence and navigating through six generations of her paternal history, building up a picture of pogroms and migration, resourcefulness and adaptation.

Maria Stepanova's monumental *In Memory of Memory* (2017) begins with the death of her father's sister Galya; Stepanova finds herself in 'the cave' of Galya's tiny apartment, a place heaving under 'layered strata of possessions, objects and trinkets,' objects which become 'suddenly devalued.' In streams of writing that wind history and reflection in and out of descriptions of this stash of old family belongings, Stepanova establishes an ambivalent, multidirectional relationship with memory, moving sometimes towards it, sometimes away. The piles of clothes, crockery, postcards, toys, photographs and towers of yellowing

newspapers and clippings, form the architecture of Stepanova's monument to memory, which is also, it turns out, an apologia for forgetting; sometimes more a critique of the cult of memory than its celebration.

Unlike these moving, intricate works of research and reconstruction, mine is not a book in which a writer minutely tracks past events using as points of departure a paper trail of documents and objects found in the family home. My evocative objects are not necessarily linked to my family, and none is an heirloom. Yet singly and together, they stand for the loss that invariably attends the passing of time. Each of them addresses me with a quiet statement of that loss.

To associate the objects I have chosen with loss and therefore with grief is to invoke the idea of memory work as a process of recovery and to ask what aspects of the past those objects are able to retrieve. But it is also to query how they do that work and to what extent that retrieval is itself an invention. The traffic back and forth between subjects and objects is incessant: a dialectic of projection and internalisation. Susan Pearce, a doyenne of museum studies who has focused on material culture and the process of collecting, notes that the projection *into*, and internalisation *of* objects reverts to infantile experiences, suggesting that an early association is forged between our bodies and the ways we imaginatively construe the material world. And yes, we once found our boundaries through working out which objects felt good, which hurt, and we have had to continue practicing this exercise, reiterating our earliest negotiations with things-that-are-not-me. For when you were a baby, says poet and essayist Anne Boyer, parsing D.W. Winnicott, 'objects said everything about whether or not you were alone.'

But Susan Pearce arrives at an affirmation that is perhaps surprising in the context of museum studies, a discipline which focuses, after all, on material things. It is an affirmation that points to the persistence of Winnicott's infant in the adult: not of the separate thingness of objects, but of what she calls their potential inwardness. She thinks of this inwardness as one of the most powerful—even if ambiguous and elusive—characteristics of objects: 'Objects hang before the eyes of the imagination, continuously re-presenting ourselves to ourselves, and telling the stories of our lives in ways which would be impossible otherwise.' Objects, in this formulation, are not only *out there* functioning

as mirrors, they are also inner agents forging links in private narrative chains. My evocative objects are those things that—modest, intertwined, interconnected—'conspired to tell me the whole story,' as Pablo Neruda puts it in his poem 'Ode to Common Things' (1961; 1954) with its breathless opening gambit: *Amo las cosas loca/ locamente.* 'I have a crazy, crazy love of things' does not quite capture the break in the adverb *locamente* and the pre-iteration of its first syllable.

Of all the objects that people collect and keep, it is doubtlessly photographs that hold the most special (almost sacred) place as treasured miniature memorials; they are, to flip metaphors, our sentimental capital. Writing from a situation of acknowledged privilege, I feel chastened scrolling on screen through documentary photographer Muhammed Muheisen's *Memories of Syria* (2015–2017), a series of images of refugees, each holding a photograph picturing—so as to hold at bay the conditions of bare life—their loved ones; images of their lives before the war.

Philosopher Giorgio Agamben has defined bare life as a life in which a person is excluded from religious and political community and is no longer able to 'perform any juridically valid act.' That person's existence is 'stripped of every right by virtue of the fact that anyone can kill him without committing homicide; he can save himself only in perpetual flight to a foreign land.' In Muheisen's images, faces and bodies are outside the frame; he narrows in on the hands holding the photograph, in some cases no larger than a postage stamp. Each of these photographs acts as a thin interface between a life of human connectedness and bare life, one in which subjects are banished, stripped of legal status and expelled from coherent community.

Snapshots especially, in their casual and often artless compositions, seem most poignantly like arrested and distilled segments of a past time and a lost space. They are always retrospective; for Muheisen's photographic subjects, they are imprints of a life before its reduction by a sovereign power. The subjects of snapshots look out of the photographic frame at us, their viewers, through history, just as we look at them in retrospect. Meanwhile, as history unfolds, meanings change and possibly get lost, giving way to conjecture and interpretation and leaving us further away, more acutely aware of being somewhere else, mired in our own material and historical present. And, however much

we know that a photograph is an artifice—a frame randomly imposed on space and an act of severance in time—the compelling relationship between the photographic image and the real presses photographs into service as essential instruments in memory work.

In his book *About Looking* (1980), John Berger asks how photographs work as mnemonic prompts. He examines not only the phenomenon of the photograph, but also the things remembered through it. He notes that a memory 'is not like a terminus at the end of a line.' Rather, memory requires varied and multiple but confluent approaches. Similarly, he suggests, multiple approaches converge upon a photograph, comprising a radial system whose constituent parts are 'simultaneously personal, political, economic, dramatic, everyday and historic.'

Borrowing the metaphor of a radial system from John Berger, feminist cultural historian Annette Kuhn writes of the modest resources required for memory work. In *Family Secrets: Acts of Memory and Imagination* (1995), she writes that if you have a family album or some loose photographs, a few letters or a small cutting of hair, you have the material for such work. For Kuhn, a radial system integrates personal photographs into social and political memory. Such a system describes her own practice of weaving together '"public" historical events, with structures of feeling, family dramas, relations of class, national identity and gender, and "personal" memory.' Note that she puts both *personal* and *public* between quotation marks, as though the distinction were a mere formality. Outer and inner lives coalesce: we are not conscious of the precise workings of ideology and external influence (parental, but not only) on what we apparently freely choose, or how such constructs intrude upon and constitute that which we 'remember'. My recollections are certainly affected by those of others (parents, siblings, husbands, friends, lovers, colleagues) around me who were co-participants in occasions or events. And importantly, memory itself is not stable: 'the stories, the memories, shift,' writes Kuhn. The passing of time affects how we remember. Traces of our former lives are 'pressed into service in a never-ending process of making, remaking, making sense of, our selves—now,' she writes.

Memory work, which entails an excavation and bricolage of documentary evidence and material traces, also involves running with speculation: not only acts of memory but also acts of imagination. The

starting point that Kuhn describes is necessarily in the present time of writing; an ongoing present moment as the temporal fabric in which the making, remaking and making sense of the self unfold. I feel closely allied to this kind of practice, one in which the elusive present tense of writing is welcomed as the point of departure. That present moment is both real and chimeric, ever shifting, accommodating (without necessarily specifying) smaller and larger changes of circumstance.

To designate certain objects as evocative is not to say they encapsulate memories so much as that they coax out of me states of being. Those states erupt in me as feeling-thoughts that are linked to recollections but that are not well-formed or contoured enough to be identifiable as distinct memories. Perhaps *reverie* would be the term best suited to describe the kinds of states into which I am seduced by my evocative objects: they reach out to me, almost as though they had agency, enveloping me in a dreaminess through which the forms of the objects themselves are vaporous, unevenly distributed. The work they exact of me is not that of detailed, phenomenological description. It is more akin to dreamwork in waking.

## Objects and Things

In recent decades, scientists and historians of science have brought to light complex mutual entanglements between different forms of life. In doing so, they have unsettled previously categorical, binary thinking: studies of forests and of fungal life, for example, have turned given classifications into questions. Importantly, under the rubric of the new materialisms, especially driven by feminist and queer studies, such a shift in thinking from categorical to non-binary emphasises the extent to which the (human) body has never been singular and self-same (think of the billions of microbes living in our gut and orifices, of the lives constituting our microbiomes); we exist in fluctuating states of vital entanglement with other kinds of bodies. In addition to this, we exist in systemic entanglements with non-organic matter too.

Terms such as *viscous porosity* (Nancy Tuana, 2008) and *vibrant matter* (Jane Bennett, 2010) underline the ways in which beings are interpenetrative and interactive with other beings and with the inanimate world too. Both Tuana and Bennett posit matter as unstable, permeable,

unruly, difficult to categorise and in flux. For Tuana, ontological divisions (say between the biological and the social), though deeply entrenched in bodies and practices, are shifting rather than fixed. The notion of vibrant matter has been especially influential: Bennett suggests that subjects and objects intervene in each other's being; that objects are enmeshed in a political ecology and have what she calls 'Thing-Power'. She writes of 'the curious ability of inanimate things to animate, to act, to produce effects dramatic and subtle.'

Does it remain philosophically relevant, in this context, to enquire about the nature of a chair, especially if you do not have a chair, or the essence of 'chairness' if you do? And what is the status of a chair in an empty room? To ask that question is to enter a web of words around the thing-in-itself, the existence of things outside of our perception of them, and to summon the lofty names of Heidegger and Merleau-Ponty, of Plato. And it is to invoke, with Anne Boyer in *A Handbook of Disappointed Fate* (2018), questions about words and truths, the 'infinite amounts of untruths about chairs and also all the new truths you could tell about chairs, the ones that no one had yet discovered.'

But to ask how an emotion—love and its anticipations, or the pain of love's ending, say—affects the objects in a room is to invite oneself into the domain of literature. In Virginia Woolf's *The Waves* (1931), a scene is described from the perspective of Neville, who has come early to experience the anticipation of Percival's arrival. The door opens.

> 'Is it Percival? No; it is not Percival.' There is a morbid pleasure in saying: 'No, it is not Percival.' I have seen the door open and shut twenty times already; each time the suspense sharpens. This is the place to which he is coming. This is the table at which he will sit. Here, incredible as it seems, will be his actual body. This table, these chairs, this metal vase with its three red flowers are about to undergo an extraordinary transformation.

The transformations of, and exchanges between, inert objects and evocative ones, between objects that we ignore or simply don't pay attention to and others that offer us their thingness as unique, is one that may be occasioned by the proximity of the material objects to Neville's—or my—objects of desire, the *actual body* of the-one-who-is-desired transfiguring the chair or the metal vase with its three red flowers into a symbol of the most excruciating eroticism.

Bill Brown, a celebrated theorist of things, initially distinguishes between objects and things in the following way: objects circulate through our lives, he tells us in an article titled 'Thing Theory' (2001), and we look *through* them 'to see what they disclose about history, society, nature' rather than really experiencing them with our senses. In their functionality, they are transparent; we have established habits with and around them. But we begin to grasp the thingness of objects, Brown argues, when they resist us, when they stop working for us (that printer that always lets me down, the watch that needs a new battery: in defying my will—obstructing me— they state their objectual nature). I did not see Ginger's water bowl until Ginger was gone, and then that vital absence enlisted my preoccupation with its thingness, which signified loss. The ponytail is severed; the photograph folded, the trinket is broken off from ongoingness by the end of the love that occasioned its giving. 'The story of objects asserting themselves as things,' Brown writes, 'is the story of a changed relation to the human subject and thus the story of how the thing really names less an object than a particular subject-object relation.'

I find this formulation resonant: I like the idea that *things* are objects that are within the range of people's attention, noticed objects, relational more than functional. Yet I query the validity of the distinction. I certainly can appreciate the heft of a ceramic jug—its thingness—before dropping it to the floor, thereby making it lose its functional integrity; can enjoy the engineered beauty of a pen without necessarily breaking its nib. Some years after 'Thing Theory,' in the introduction to his book *Other Things* (2015), Brown's distinction has become more nuanced. He regards the earlier separation between objects and things as totalising in its simplification. He is now concerned, he writes, with 'how objects grasp you: how they elicit your attention, interrupt your concentration, assault your sensorium.' How they stop being things you look through, in other words, and present themselves in their quiddity. (There is tautology in writing those very words: you can hardly write about objects or things without using the words *object* and *thing* to define them).

Everyday objects that persist in people's daily lives have about themselves a factual ordinariness onto which memory readily alights, sometimes more easily than memory alights onto certain events. Max Morden, the narrator of John Banville's melancholy *The Sea* (2005),

speaks of his memory groping for details, and it is 'solid objects' that are, for him, 'components of the past.' In people's lives, objects compose themselves into familiar formations, and then just as readily decompose, disaggregate in the mind's eye. If they are clothes or tools, implements or instruments, they might lose their autonomy and act as prosthetic devices, extensions of my body. Not only do I not notice these ordinary objects on whose existence I rely to provide a background of continuity, they also, in their taken-for-grantedness, blend 'so profoundly with the stuff of thought,' as Virginia Woolf observes in her story 'Solid Objects' (1918) 'that each thing loses its actual form and recomposes itself a little differently in an ideal shape which haunts the brain.'

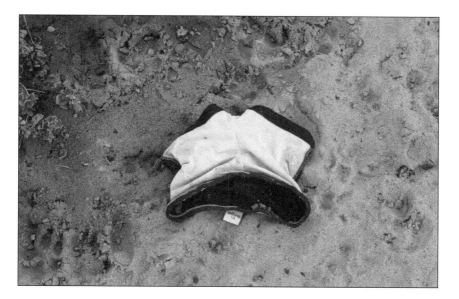

To see an object as a thing, it occurs to me one night on the edge of sleep— that time when you know that if you don't put pen to paper, you'll forget the idea—does not entail a necessary alteration in its material conditions or a stripping away of its functionality, but rather, a change of focus. When you allow an object to interrupt your concentration, to assault you; when you permit yourself to experience its thingness, your focal length shortens as though you had changed a lens on your camera. This operation, this shift from one kind of looking to another, brings about a defamiliarisation, much in the way that a photographic close-up would defamiliarise an object, making the known thing strange.

If a *thing*, then, is an object made strange—estranged from its everydayness, removed from the context in which it merges, unnoticed, with other things—you might think that I should be talking about evocative *things* rather than evocative objects. But the term *evocative objects* already has traction, a history. And while I am interested in the thingness of objects, I am equally interested in the slippage of that word *object*, first describing something in the material world, and then describing a grammatical and also psychoanalytic relation: I am the subject of my speech, I may at times be the object of desire or of love, and I certainly address some of the objects of my own love or desire in writing about my evocative objects. The term *evocative objects* embraces not only things in the world, but also how those objects are internalised and processed, how they become objects of thought and feeling, how they are entangled with—and work upon—me.

## Evocative Objects

In an essay titled 'The Things That Matter' (2007) introducing an edited volume on evocative objects, Sherry Turkle, a social scientist whose work focuses on the relationship between technology and the construction of self, uses the term *evocative object* to describe objects that we use to think with. I find a similar suggestion in 'A Friend's Umbrella' (2009) by American poet Lawrence Raab. In this poem, Raab describes the way, towards the end of his life, Ralph Waldo Emerson would forget the names of familiar things.

> Later the word *umbrella*
> vanished and became
> *the thing that strangers take away.*
>
> Paper, pen, table, book:
> was it possible for a man to think
> without them? To know
> that he was thinking? *We remember*
> *that we forget*, he'd written once,
> before he started to forget.

And then, further: 'Without the past, the present/lay around him like the sea.' Familiar objects anchor Raab's Emerson in his unique biography. With their names taking leave of him, he is left unmoored, bereft of

himself. The present, a tense in which all the yoga teachers tell you to be, is actually nothing when it is unhooked from the past, when it is unbuttoned from body and language.

Objects are of course material things, but they also offer themselves as matter for thought. (I am considering now the expression *food for thought*, its attention to objects whose very function it is to be incorporated and metabolised.) They are vehicles of subjective energies, essential signposts on the path between interiority and the world out there. This is particularly so with those things that, through their presence at significant moments in our lives (the still-life objects that attend the scenes we shall never forget) or contrariwise, through their persistence in the inbetween moments, the unremarkable ongoingness of life (the fountain pen I've always used, the thin gold chain I cannot remember ever having been without) enlist us to project onto them states of being.

Citing the celebrated formulation of William Carlos Williams 'no ideas but in things,' Turkle describes how she would rummage among objects safeguarded in a cupboard in the kitchen of her grandparents' apartment in Brooklyn when she was a child, searching for clues to the backstory of her own existence. This memory closet, as Turkle calls it, held her family's keepsakes, including her mother's and aunt's trinkets, souvenirs and photographs. Each object in the closet, she writes, 'every keychain, postcard, unpaired earring, high school textbook with its marginalia, some of it my mother's, some of it my aunt's—signalled a new understanding of who they were and what they might be interested in.' More to the point, every photograph of her mother on a date at a dance 'became a clue to my possible identity.' She attributes her lifelong interest in objects and their mnemonic and associative power to the fact that she did not know who her biological father was. As a child, she anxiously ransacked the photographs and knickknacks in the closet for traces that might have served as pointers to his identity.

While Maria Stepanova is led by the accumulation of old family possessions and mementos to explore her Russian-Jewish genealogy in broader historical contexts including the history of anti-Semitism, Turkle uses her family possessions to think about thought. Though interested in the historical and personal contexts that brought those particular objects together, she becomes more concerned with how she might hold onto them internally. Seeing herself as she once was, a

young woman on a trip to Paris in the late 1960s, Turkle describes her immersion in the intellectual world of the French structuralists. While she is away, her grandparents move out of their Brooklyn home and many of the contents of the memory closet are dispersed, given away to charity. 'Far away from home,' Turkle writes, 'I was distressed at the loss of the objects but somewhat comforted to realise that I now had a set of ideas for thinking about them.'

That set of ideas comes from her reading of the work of French structural anthropologist Claude Lévi-Strauss. She compares her elaboration of an associative and creative thought process around those now-lost objects to what, in the opening chapter of *The Savage Mind* (1966; 1962), Lévi-Strauss calls the science of the concrete. This describes a form of thinking that deals with the 'sensible world in sensible terms' (*sensible* in its two French meanings, sentient and sensitive), rather than in the more abstract, speculative terms of the natural sciences privileged by rationalist thinking. Linked to an attempt to understand the process of myth-making in 'primitive thought' (*pensée sauvage*—these terms were later to become problematic), the science of the concrete 'was no less scientific,' he argues, 'than the results achieved by the natural sciences' and its results equally genuine. 'They were secured ten thousand years earlier and still remain at the basis of our own civilization.'

Lévi-Strauss finds that the readiest way to describe such a way of thinking is by analogy to the process of bricolage. Bricolage is an improvisatory form of making in which the maker deploys what is already to hand rather than honed, task-specific tools and materials. It is an ethos of making-do materially, but it is also a mindset. It is an accommodation to contingency, serendipity, and circumstance. Riffing on Lévi-Strauss' notion of animals as 'good to think with', Turkle speaks of materials as 'goods to think with' as well.

Turkle proposes an additive, extemporising approach to piecing hypotheses and facts together in an operation that entails not only objects but also the temporal and spatial distances between them (displacement, memory); not simply things, but the ways in which we channel them, how they help constitute the building blocks of thought. Seen through this prism, evocative objects are those things that lead us from the material to the immaterial, enable us to devise new configurations, combing the familiar for the unfamiliar. In this way,

such objects tap into a vein that psychoanalyst Christopher Bollas calls the unthought known. Wordlessly, they give form to 'abstract thoughts, sensed memories, recollections, and felt affinities.'

Bollas, who has written about evocative objects for over three decades, sees them as generative and defines their psychic role as that of unleashing free association. 'We may extend the domain of the free associative to the world of actual objects,' he writes in *The Evocative Object World* (2009) 'where the way we use them—and how they process us—is another form of the associative.' Also adopting and adapting Winnicott's term subjective objects, Bollas sees our engagement with the objects that carry our subjective states as playing a vital role in our investment in the world.

The unconscious meaning that I project onto my objects and that makes them uniquely my own, expresses what Bollas calls a 'syntax of self experience.' Put otherwise, this is an idiom through which I experience my *self*. Evocative objects interrupt the temporal flow of the everyday, disrupt my ordinary perceptions, intruding on my sensorium and bringing the past into the present. In that interruption—that movement from perceived object to thought-object—I feel myself to be in a fecund state of estrangement, a feeling that is close to the one I experience when I am drawing or making collages, or, closer still, the strange sense of mindful embodiment I experience when I have just woken from a dream.

I address these thought-objects through a process of making that communicates with other works of art and literature, works in which similar or associated objects play a significant, or structuring, role. In doing so, I experience free association as extending beyond my personal objects to the cultural artefacts that have entered my being by a kind of osmosis, an affinity less elected than absorbed and felt.

Put another way: my evocative objects offer me my own trajectories and associations in nuggets of remembered personal experience, while simultaneously enjoining me to linger on works of art and literature that I have carried with me on those rutted paths as internal objects.

The radial metaphor that John Berger uses, and that Annette Kuhn borrows from him, furnishes me with a sense of how my excursions function structurally. A radial system describes what I have constructed around my evocative objects: a series of associations that do not all tie

up or connect with one another, but that converge upon that object, at least as it exists in that particular consciousness that is mine. I see this private and particular process as also extending an invitation to others to engage with their own evocative objects, however modest or apparently irrelevant they might appear to be. And similarly, I feel, in each act of association that nets together my own intimate concerns with works others have made, an opportunity, an unfolding and entanglement.

# My World

I began writing this book in a spirit of experimentation during a small personal lockdown. In the late summer of 2019, I broke my right patella falling on a concrete ramp while rushing to the ceremony that would grant me British citizenship, and I was more or less immobilised for a couple of months. I was lucky enough for Brexit to have been the most troubling thing on my horizon, which is to say, I was again happy in love and beginning to feel energised by work too, after a hiatus. I was still researching for a book on the exploration of evocative objects by a wide range of photographers, a book that I had pitched once, unsuccessfully. The pandemic turned everything inwards. I took refuge in my home, setting my mind into an unusually introverted standby mode. My work changed direction, became personal. In this process, there were procrastinations, hesitations and head scratchings, archival meanderings and revisions as this book took shape during the collective lockdown that began in March 2020 in response to the Covid-19 pandemic.

It would be no exaggeration to say that, from the beginning of the pandemic, I felt my imagination rewritten, shifting my sense of place in a greater scheme of things. It is only at the time of revising the final edits of this book that I feel a new quickening, a sense of being able to participate in a broader flow of life again, an exhilarating rush of collective energy. It did not help that my partner P made a sudden and shockingly unilateral decision to end our relationship at long distance six months into a lockdown he was spending with the youngest and neediest of his three daughters, 200 km away. If lockdown narrowed the perimeter of my life, depression exacerbated my tendency to cocoon myself (not always the first thing people notice in the company of a

gregarious person) and to live in my head, which offers me a comforting if permeable architecture.

There we were, here we are, in a house, in a head: my dog Monty and me. The house is embarrassingly large, and my main source of carbon-footprint-shame. It is also a generator of daily pleasure. We are surrounded by Monty's toys (a huge array of soft scraps and a ball within a ball) and my books. There are cushions on sofas and throws of different fabrics bought in countries I visited in that other time when I used to travel, and there are beautiful drawings on the walls, often gifts from—or exchanged with—artist friends, which situates me squarely in a particular demographic. I have airy workspaces (a study, a studio, several reading corners) in this light-filled house overlooking a paddock. Standing at one of the upstairs windows in the late afternoon, I can watch the sun dipping into the horizon, watch two horses—not mine—going about their horsey business.

In such privileged and luxurious confinement (a custodianship rather than ownership, through the happenstance of marriage, but that is another story), with silence ringing through me and solitude disciplining me, thinking about my evocative objects seemed at once unreal and grounding, pinning me into my own life and holding me back from the temptations offered by a new idea: I could spend my days curled up under a blanket; no-one would know and my superego was giving me the slip.

During this time, not surprisingly, I was in intimate conversation with texts written by others, a communion which saved me—in the episodes when I succumbed to the lure of the blanket—from excessive self-pity. And if I allowed myself to doze off during those long afternoons, reading filled my nights of insomnia and made them not only tolerable, but oddly comforting: piles of bedside books dipped into with an intensity that dissipated into distraction in the light of day, but that, to borrow a phrase from the peerless Elizabeth Hardwick, were now 'consumed in a sedentary sleeplessness.' Reading, which has always been central in my life, now seemed to replace it, or constitute it. Every thought or memory of what used to be called reality seemed to have an equivalent in the books I read. I chimed with Annie Ernaux saying, in *Exteriors* (2021; 1996) that she was always 'combing reality for signs of literature.'

Abandoning the rigours of writing within a single discipline—art history—I found that reading and writing functioned ever closer than before, in tandem with each other, adhering one to the other in a sinuous, slow dance. Like the undulating transitions between familiarity and strangeness, the movement back and forth between these two intertwined activities makes its way through this book. It is an oscillation that struggles constantly with the vicissitudes of attention, both reading and writing vying with the hundreds of other things that, in the interspace between them (on my screens, in my books and notebooks) try to claim my attention. John Ashbery's 'Late Echo' is a poem that I reread, now differently. Though written in 1979, it speaks directly to the 'chronic inattention' of the present time, and to 'our unprepared knowledge/Of ourselves, the talking engines of our day.'

> Alone with our madness and favorite flower
> We see that there really is nothing left to write about.
> Or rather, it is necessary to write about the same old things
> In the same way, repeating the same things over and over
> For love to continue and be gradually different.

Just the *same old things*, then... bewilderment, joy, loss, terror, death, *for love to continue and be gradually different.*

For love to continue and be gradually different (and what else is there?) here are some of my objects, or perhaps their material proxies, since my real objects are the layered experiences to which these material things point:

- a severed ponytail
- a family album
- a book
- another book
- a cache of letters, ribbon bound
- a box of letters and postcards
- a cigarette lighter
- a hairbrush
- a napkin in its darkening silver ring
- an audio cassette

- a white plastic carousel with women's underwear pegged on
- a photo album
- more photographs
- two snips of baby hair in an envelope
- a selection of chewed dogs' toys
- a pig made of balsa wood
- a drawing on a piece of cardboard
- the collected poems of e.e. cummings with two dedications on its frontispiece,
- a pair of man's pyjamas
- a recipe book so crammed with bits of paper it has to be held together by an elastic band
- a cloth bag containing half-used lipsticks
- a baby book
- a painting,
- an accordion-folded Kama Sutra
- a diamanté brooch
- a thin gold chain
- a pair of suede, wedge-heeled sandals
- a postcard, another postcard, many postcards
- a painting
- sunglasses
- a tiny drawing on a scrap of paper

These are things through which I experience not only a sense of loss, but also a sense of self, even as I renew and renew again the habitation and possession of my world, its cycles of engorging and depletion.

In the great infection of fear that has been the collective experience of the closing down of the world as it existed before the pandemic, thinking about my evocative objects was a way of figuring out what provides me with necessary psychic continuities. 'Things hold life in place,' says the unnamed narrator of Claire-Louise Bennett's compelling novel

*Checkout 19* (2021). 'Like pebbles on a blanket at the beach they stop it from drifting away or flying up in your face.' Those objects that enable me to experience myself as I inhabit my world are not only pebbles on a blanket, they are also remnants—survivors—and as such, they say something about my own survival as the narrator of my life.

Each of the objects I have chosen to write about here is intimately connected to someone or something now vanished: a person or a part of myself, an experience or a love. Some are metonymies of a person I once was; others are so redolent of another person, they serve almost as ensigns. With their close link to loss, these evocative objects enshrine states of mourning, but they have also served as reminders that the interruption we experienced at the time of pandemic anxiety finds its place in a larger ongoingness. They are landmarks in the continuum of my own subjectivity.

If the plates, thimbles, scissors, keys, cups, rings, pliers and saltshakers that Neruda addresses in his odes to common things speak of moments of sensory and affective caress, such objects also extend an invitation beyond that of attention, perception and sensuality: an invitation to narrative elaboration. Not plot, but story, and the transubstantiation of story into thing.

With each telling of my evocative objects, I feel an enlivening: remembering as an act of creative bricolage, with overlaps and gaps and changes of scale between its constituent parts. Ocean Vuong says it is memory that gives us a second chance at life; but it is art, really, and writing especially, that gives memory itself (so tenuous, so easily fetishised, so readily side-tracked) a second chance, or a third. It is writing that offers me the kind of consolation that life (at least a secular life like mine, with no thought of redemption) does not.

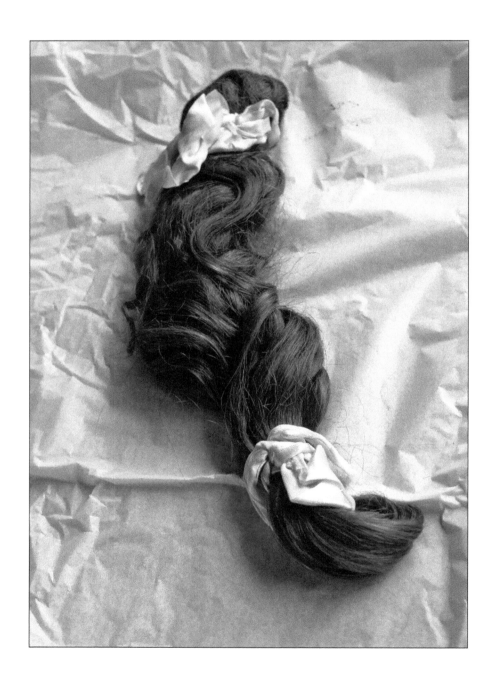

# Hair

I am thirteen, and this is Johannesburg. Everyone praises my long, auburn hair. Titian, some call it, though it will be several years before I learn that Titian is the name of a painter; that many voluptuous women in his paintings have rich red tresses. I love my hair, but it seems old-fashioned: the wavy ponytail, the wayward fringe. It's the 1960s, and voluptuous is the last thing I want to be.

I scour magazines when I can lay my hands on them: *Cosmopolitan, Elle.* With my pocket money, I have started buying *Jackie,* which comes from London. London occupies a big chunk of the real estate of my imagination. There are pull-out centrefolds of singers and bands I've never heard of. Longingly, I examine fashion models with pixie cuts. I hanker for their doe-eyed, skinny loveliness, the edginess of their hairstyles, the crisp geometry of their short dresses. Especially, for the boys they surely attract.

*You'd look beautiful with your hair like that*, my mother says. *You have such a pretty face. Such a pretty face.* She says this many times, or so it seems to me. The pretty face, in its reiterations, pushes against something else that I don't have, and I think I know what that is. My mother makes sure I do, but indirectly, surreptitiously. It's something to do with my body, which must be always reined in, educated, made hungry. My mother is quite the hunger artist, but such notions are still unavailable to me. I am only vaguely aware that the site of her battle with her own body is my body, and it is a struggle expressed in opposing imperatives: Eat! Don't eat!

I live clumsily in my body, but I also live in pictures, in music, in books. My reading seems to situate me outside of the world, and yet also, my reading is of this world: my books get yellow as my skin reddens and peels and freckles because I've forgotten to wear a hat; and its pages warp and waffle where I've forgotten to dry my hands after pulling up my pants. The attention to my body and its comforts accompanies my early readings even as now, I need to nestle and find an absolute accommodation before I can settle into reading. Back then: like most youngsters, I am a fantasist; I am

   https://doi.org/10.11647/OBP.0285.02

earnest and questing. I dream through the books and songs and pictures I consume; they all transport me elsewhere. But those conveyances take me to places not too far away. Nurturing a kind of realism that has persisted as a character trait, and sustaining a disinterest in any form of the epic or heroic, my imagination plays on safe ground (and yes, that is a free instrument I'm sending out to my critics, go for it if you must).

I avoid sport at school and am happy when I have my period so I can get a note from my mother requesting that I be let off swimming lessons: I know that Mr Green stands on younger children's hands as they cling to the edge of the pool, forcing them to thrash about in the water. It strikes me as a terrifying form of pedagogy. I don't care if I never swim, despite the lovely silky smoothness of the water. My body wants to decline its own existence: I don't recognise myself in any of the loose-limbed, outdoorsy girls I read about. I am not Jo March. I have aching nipples popping out of breasts that already fit too tightly, and for the last time, into a B cup. My thighs are omelettes oozing together at the top, where I wish they were separate; my knees join too.

I look, I think, awkward, childish.

So, I take up my mother's suggestion of a haircut. I need to believe her: I need to trust that she knows a thing or two about short hair. That her urgings are not selfish, not personal; that she is neither moved by the daily drudgery of the school plait, nor driven by a darker, inchoate emotion.

I look at her hair made lustreless from straightening and hair spray, ruined by a longing to alter the curly course of nature. It's a longing I shall inherit. The word *envy* is waiting to form itself, out in the future, but Mama, right now I need you to be on my side. When I read F. Scott Fitzgerald's story 'Bernice Bobs Her Hair' (1920), I recognise something that was not present in Jo's altruistic self-shearing in *Little Women* (1868– 1869), a scene I always recollect with admiration and horror. Jo presents her mother with a roll of twenty-five dollars as a contribution to making her father— who was injured while serving as a chaplain in the Union army during the Civil War—'comfortable and bringing him home.' In Fitzgerald's story, the dramatic bobbing is a symptomatic acting out, the misguided conclusion drawn from a competitive web of youthful entanglements.

Hair, I'll come to understand, can be currency in unspoken exchanges, unnamed rivalries.

But that comes later.

At thirteen, I go along with the idea of the haircut despite the last-minute hesitation I see on the face of the girl in the mirror, a green salon cape draped around her shoulders. Tears etch her cheeks. *'Are you sure?'* the hairdresser asks. *Sure she's sure,* my mother says. It is then that I have an impulse that I now recognise as fully formed, characteristically my own. An archival impulse, I would call it now, using a phrase coined by art critic Hal Foster. *Don't cut it in bits*, I say. *Cut off the whole thing at once.*

Lop off the ponytail so I can keep it, is what I mean.

Even before it has been severed from my body, in thought, the ponytail has become a keepsake. And what is a keepsake if not a thought materialised, a thing narrativised?

Now the hair is wrapped in acid free tissue paper like a treasured artefact or work of art. This hair may be as dead as a relic, darkened where I might have expected it to have faded, but it has a wild, weird electricity that reminds me of its connection to a living body. My body.

After the ponytail is chopped off, I feel light: inexplicably transformed, briefly free. But it is not too long before I feel bereft, unsexed.

*It'll grow,* my mother says.

For forty years after that haircut grows out, I remain fetishistically bound to my head of long, burnished curls, the first descriptor I ever use when portraying myself to strangers, identifying how they might recognise me: my pocket carnation, my intimate calling card. Scrunchy or grip always to hand, hair up, hair down, screen and shield and weapon all in one. Eventually, menopause will teach me that there is freedom to be found in abandoning bodily ideals—fuck those—along with all the other attachments I need to shed; ageing will instruct me in the joys of ditching a fixed tag (*the girl with the long red hair*) and gaining, in its place, something changeable, less specific. And an ongoing relationship with Ollie, the hairdresser who now asks, twinkling all over, *well what will it be today? Little old lady or sexy bedhead?*

Years pass without my looking at the severed ponytail, this bodily remnant, this almost repellent treasure, this thing that is me and not me.

No one who has known me for a long time and to whom I show the photograph on the cover this book, doubts that it is a self-portrait; they all recognise the hair. But I can now scarcely remember what it feels like for my shoulders to be cloaked, the thick cascades of it heavy, swirling

from strawberry blonde to deep russet in the underlayer. I remember the hair resisting, then yielding, to the pull and stroke of lovers, husbands; I remember clips in, clips out. I remember pinning it up in summer, twisting it around several times before catching it with a toothy grip. I remember battles with sleekness, and the relief of submission to curls, the permission to do so granted by changing trends and new ideas in self fashioning.

But looking now at the photograph of the ponytail, the word that comes to mind has nothing to do with the sensuous pleasure of hiding behind my own hair, using it as a seductive veil. Rather, I am struck by the word *severance*. The cut looks blunt, brutal, and with the darkened redding rope tumbling away from the ribbon, it seems obvious to me now that this is an image of birthing, of radical separation, of something cleaved in order that something—someone—else might grow. It occurs to me that this is the most intimate evocative object I own, one that speaks of a painful personal individuation.

I want to think about this fragile parcel in crinkly tissue paper: a twisted rope filled with static, beribboned at either end. Safeguarded for decades, through three emigrations and many more house moves.

Why?

What gets kept? What gets thrown away?

The protagonist of Guy de Maupassant's story 'A Tress of Hair' ('La Chevelure,' 1884) is a deranged man, incarcerated for his necrophiliac obsessions. Never having experienced love with another human being, he loves, instead, old furniture. It evokes in him thoughts of 'the unknown hands that had touched these objects, of the eyes that had admired them, of the hearts that had loved them; for one does love things!' He is drawn to the past, terrified of the present, and 'the future means death.' In a phrase that foreshadows Roland Barthes, Maupassant binds together death and the future: a certain configuration of the past comes to a standstill with someone's death, and from that moment on, the survivors need to marshal their future. 'As soon as someone dies,' writes Barthes in *Mourning Diary* (2009), published posthumously but composed in intimate notes for two years after the death of his mother), 'frenzied construction of the future (shifting furniture, etc.): futuromania.'

Through objects, Maupassant's unnamed character experiences the arresting of time as an erotic charge, and in this frisson, it is as though death might be forestalled. He becomes obsessed with a rare Venetian bureau, which he buys from an antiquarian. In his rapture, he describes 'the honeymoon of the collector,' passing his hand over the wood 'as if it were human flesh' and looking at it repeatedly 'with the tenderness of a lover.' When he searches the bureau for a secret drawer, he is rewarded: 'a panel slid back and I saw, spread out on a piece of black velvet, a magnificent tress of hair.' Spread out like a lover's body, the hair has been severed close to the head and is secured by a golden cord; the hair is fair, 'almost red.' Every night, the man caresses and kisses the tress, and the dead woman from whose head it was severed comes to him, not as a ghost, but as a presence.

My mother loved Guy de Maupassant for the cruel ironies and comeuppances in his stories, filled with people who spend their lives under misconceptions, seduced by false appearances. Harsh social justice. When I first read 'A Tress of Hair,' I saw the eroticised relic as my own lopped off ponytail. Why had it been kept? Why secreted in a drawer?

The distinction between relic, fetish and garbage is hair thin.

There is so much I have discarded without giving it a second thought; without giving those things a second chance at igniting my imagination, enfolding me in narrative possibility. A full compendium—an archive of life's traces—would lead me into an infinite regression of multiple lifetimes. But in the long run, writer Julietta Singh's succinct formulation utters the truth: 'no archive will restore you.'

I recognise in the impulse of the hoarder a misconception about the selective nature of the archive; *this,* not *that.* But on what grounds, other than happenstance, random impulse, intuition? 'Remembrance itself is a type of hoarding,' writes Dodie Bellamy, 'a clutching at love or trauma—those "others" that make us fully human—and all of us are these futile Humpty Dumpties trying to put our shards back together again.' Bellamy writes of hoarding as *écriture,* but, having turned over 'fifty-five file boxes of ephemera to the Beinecke Rare Book & Manuscript Library at Yale,' she contrasts her writing and that of her late husband Kevin Killian (a queer and amazing couple) to hoarding: 'though we spent thirty years of our literary life hoarding its dejecta, our writing has been

committed to spewing all sorts of shit few would dare reveal. Hoarders of information we have never been.'

Intimate writing as spewing, a kind of extimacy; mulling on memories as hoarding. Our interconnected, intertwined body-minds constantly hit against questions of the archive, the body-mind as archive. What am I an archive of and what is constantly being omitted from this archive? What happens with the archive when I die?

Hoarding speaks of the limits of the archive, for who can keep—and keep track of—everything? Andy Warhol tried to. In the latter part of his life, he saved source material that he had used in his work, business records and traces of his everyday life in cardboard boxes that were then sealed. There are over six hundred *Time Capsules*. These boxes are now owned by the Andy Warhol Museum in Pittsburgh. On 30 May 2014, the museum staff began opening them in the presence of Warhol's assistant Benjamin Liu. The contents included correspondence, junk mail, fan letters, memorabilia from friends, soiled clothing, pornography, LPs, envelopes, packets of sweets, unopened Campbell's soup tins, toenail clippings, the mouldy corpses of half-eaten sandwiches, postage stamps, gift wrappings, condoms, and more; but also strips of photobooth photographs that Warhol used to create his celebrated portraits, and original works by his collaborators and friends like Jean-Michel Basquiat.

Considering personal and cultural ephemera as process-driven works of art, Warhol drove the logic of the found object and of Marcel Duchamp's readymade into the heart of American consumerism. His performative deadpan enabled Warhol to straddle the gap between seriousness and irony. He also had the resources—wealth, staff and storage—to act out a hyperbole of hesitation, the vacillation of those who live with excess and superfluity: to keep, or to toss away? Decluttering is not for the impoverished.

The studio where I make drawings and collages is home to a modest number of boxes containing my paper trail, a half-hearted archive of possibility. An aesthetic predilection for certain kinds of paper (no garish colours, a preference for the matt or the translucent, for monochrome, for the printed word or maladroitly printed image; old diaries and technical manuals, sewing patterns, washi paper) has led to certain choices (a distinctly non-archival practice of selecting on aesthetic grounds) and that means that there is much that I discard. A new cull is now overdue.

But sometimes I regret the many to-do and shopping lists I did not keep, the Zoom lecture notes scratched on backs of envelopes, those gorgeous nothings, the serendipitous poetry of adjacency, the scribbles and calendar pages that might later have served as triggers or keys: clues to how, in the past, I envisioned a future. So many notes to self and notes to others have been snubbed by second and third thoughts.

I am thinking of how enraptured I become when faced with works by artists who use such ephemera, and in doing so, touch on the collector's conundrum, the archivist's dilemma: what to discard? What to exclude? I am thinking of certain artists other than Warhol: of Keith Arnatt and Candy Jernigan and Dieter Roth.

British photographer Keith Arnatt's work draws me for its skewed humour and the taxonomic attention paid to overlooked objects. Arnatt himself was fascinated with systems, collections, things cast off, trivial things kept. I whirr in sympathy with his photographs of discarded cardboard boxes and paint tins, each an almost un-ironic sculpture. His *Pictures from a Rubbish Tip* (1988–1989) focus on decomposing matter captured in golden early evening light, resembling richly sensuous still life tableaux with their memento mori subtext turned into the main event. For *The Tears of Things* (*Objects from a Rubbish Tip*) (1990–1991) Arnatt removed items from the Howler's Hill rubbish tip, brought them into his Tintern home and photographed them on an improvised wooden plinth in the manner of lofty statuary. Minute decaying and mouldering scraps of wood, fabric, glass, and rotting food stand out against a hazy, unfocused background. I want to find these hilarious, but their poignancy and abject beauty hits me. Arnatt's photographs of dog pee leaving abstract expressionist drip paintings on trees *is* hilarious and I wish I'd thought of that. And here is a series of photographs of notes Arnatt's wife Jo left him on the kitchen table in the early 1990s ('pies in microwave—press down thing that says "start" to start/In bed but awake/Where are my wellingtons, you stupid fart?/Let dogs out before you go to bed/You bastard! You ate the last of my crackers'). As it turns out, they served as poignant testimony after Jo died of a brain tumour in 1996: evidence of love and of the singularity of life *à deux*, made and remade in daily rituals of companionship and care.

Candy Jernigan, an American artist who died of cancer in 1991 at the age of thirty-nine and whose work was collated in a beautiful book called *Evidence* in 1999, collected traces of her living, the cast-off

ephemera of urban life. She would preserve these items in sealed plastic bags, but she also drew them. The presentation of her evidence brings together the meticulousness of the archaeologist or forensic pathologist with the energetic inventiveness of a dada bricolage artist, transforming trash into works of fragile beauty. Evidence was, for Jernigan

> any and all physical 'proof' that I had been there: ticket stubs, postcards, restaurant receipts, airplane and bus and railroad ephemera... food smears, hotel keys, found litter, local news, pop tops, rocks, weather notations, leaves, bags of dirt—anything that would add information about a moment or a place, so that a viewer could make a new picture from the remnants.

It is as though living itself were not enough (as, indeed, for me it isn't). She needed sustained acts of collecting: substantiation in the form of traces, indexical remainders.

Dieter Roth, a German-Swiss artist remarkable for the range and diversity of his practice was also an inveterate archivist of his own life, similarly obsessed with keeping track—and leaving proof—of his passage through time. His traces exist as physical items filed or boxed, but also as diary notations. To this end, every aspect of his existence, including his working process and the materials he used, constituted the content of his work and also its medium. For his *Tischmatten* (*Table Mats*) begun in the 1980s, Roth placed grey cardboard mats on tables in his homes and studio, collecting on them what he called the 'traces of my domestic activities,' which included drips and stains from studio and kitchen alike, doodles and encrustations of paint, and items that he affixed onto the mats: leftover food, notes, doodles and photographs.

In his durational project *Flat Waste*, which had two iterations (1975–1976 and 1992), Roth, like Warhol, gathered the banal, unique traces of everyday life under consumer capitalism. His only guiding principle was that every item collected be flatter than three sixteenths of an inch: this included food packaging, receipts, envelopes, slips of paper, handkerchiefs, offcuts of drawings and leftover food, amassed as the artist travelled between cities, visiting bars and restaurants, galleries and friends. Through the detritus of the life of a privileged, celebrated artist in the second half of the twentieth century, he created a kind of deadpan autobiography. This forms part of an ongoing reworking of the confessional genre through a representation of the material conditions

of his life. The stuff gathered was placed in transparent plastic sleeves and filed chronologically in ring binders. There are 623 ring binders in total, exhibited on wooden shelves and bookrests in an installation that models itself on the archive or the library.

Appearing as a motto on the front of Roth's book *2 Probleme unserer Zeit* (1971) published under one of his heteronyms, Otto Hase, Roth writes: 'Of what does time consist?—Of the fact that it passes.' This lies at the heart of the work of the artist as a collector of moments, as an archivist of his own transience. Such endeavour is hyperbolised in Roth's final work, still in the making when he died. *Solo Scenes* (1997–1998)—a work of one-upmanship on Warhol's real time movies—is a video diary made in real time, capturing the daily activities of what turned out to be his last year. In the final, posthumous installation, 131 video monitors are stacked in a grid, presenting the simultaneous, continuous footage, with each monitor dedicated to a different point in the artist's daily routine.

What struck me, looking at Roth's late work at an exhibition at Camden Arts Centre in London in 2013, was a sense of fascinating futility, since in all this endeavour, I could not find Roth himself. Jernigan is more present in her work: the drawings leave the unique marks of her hand, their combination with actual detritus has an improvised, individuated quality. But with Roth, whose work appeals to me immensely at gut level, I feel as though despite (or perhaps because of) all the obsessive record keeping, he has managed to slip away.

I find a formulation for this in Sven Spieker's book *The Big Archive: Art from Bureaucracy* (2008). In his discussion of how Andy Warhol seems to disappear from his own *Time Capsules*, Spieker says: 'What an archive records [...] rarely coincides with what our consciousness is able to register. Archives do not record experience so much as its absence; they mark the point where an experience is missing from its proper place, and what is returned to us in an archive may well be something we never possessed in the first place.' The question is more acute when the 'experience' referred to is a *mise en abîme*: the experience of attempting to pack life into an archive. The *arkheion*, it turns out, is not the storage space for memory, but rather a filing cabinet containing that which replaces memory: a technology, a system. It might even turn out to be nothing short of a lumbering monument to the obliteration of memory, a bureaucracy for upholding the art of forgetting.

But still, I feel safe thinking about how I archive my stuff: the systems I use to keep, retrieve, obliterate. Without such systems, I would be unmoored, floating in pure presence. I can't do that. I am an officiant at the altar of memory, and when I panic, in a futile attempt to align myself with my breathing at this very moment, there are always the mementos from the past to tether me, the idea of a future to establish a gravitational pull, and the imperatives of the digital infinite scroll to distract me from all of it.

I recognise in my youthful impulse to preserve the severed ponytail a fascination that I have continued to nurture with remnants and traces. Testimony of existence linking *then* to *now*. In my studio, I have drawn scuffed and battered shoes, gloves that bear the imprint of hands, bendy hats doffed. Outside, I photograph food leftovers on a picnic blanket, animal pelts and bones and viscera flattened on road and footpath, footprints in muddy soil, the impress of paws on beaches. I have many times photographed the scraped remainders of meals on plates; sheets that have been slept in, loved on. With my iPhone, I snap a mascara-impregnated tissue, a forsaken hairclip, a dust-snarled broom. The disembowelled, dismembered, flattened fluffy toys of several generations of dogs are precious to me, evoking the syncopated soundtrack of nails scuttling on wooden floors.

## Tracks, Traces, Evidence

These things that are almost no longer things—disintegrating, torn apart—are not only the past tense made concrete; they are also of course reminders of the future, which is death. Nothing lasts, and such scraps—as signs of erasure—are the bearers of a muted grief. Parents keep the evanescent mementos of infants precisely because infancy itself is so fleeting. Hair cuttings, nail parings, milk teeth: the parts that grow again and that transition between the body and the outside world—*of* the body but not *in* it. The strange tense of such squirreling of remnants is the future-past: it will come to be a snapshot of the now-time, a relic of this little person whose body will grow beyond recognition. (Lovers' hair in lockets, invested in a future separation or loss, served a similar memorial purpose; in a modern version, I kept the lint that P picked out

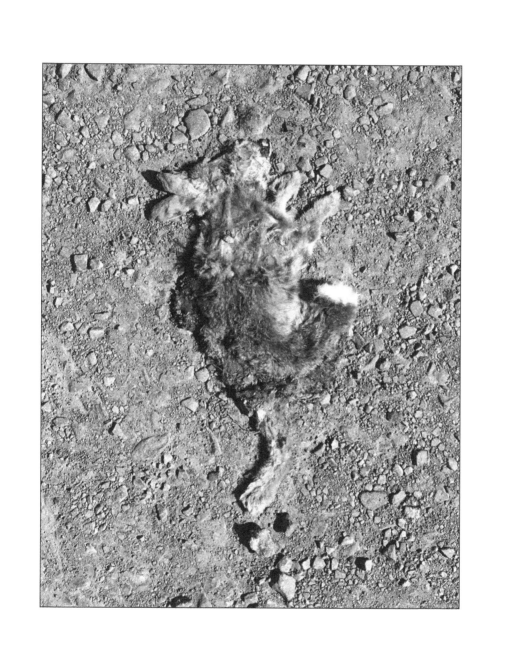

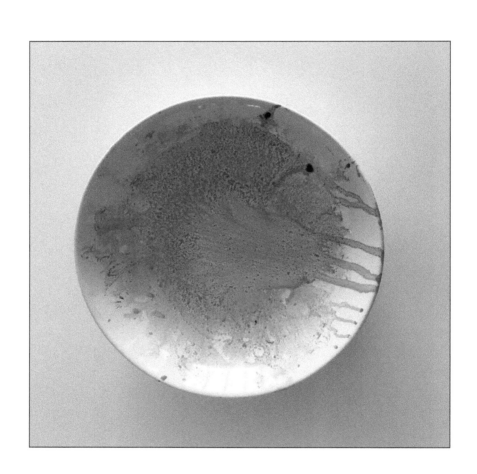

of his navel every night; kept it in a glassine envelope like the precious thing it was, half joke, half not-joke.)

With babies, the present appears especially fugitive, asking urgently and pointlessly to be snatched from oblivion, as though to keep a record were to impede two opposing forces: growth on the one hand, and obliteration on the other.

If I had been a mother, like artist Mary Kelly I would have made an archive of my child's nail parings, the fine curls of the first haircut, remainders of milk and poo and vomit, feeding bibs, precious scribbles. But Kelly's brilliance in her *Post-Partum Document* (1973–1979) lies in her ability to bring the elements of this intimate archive into the public sphere, making it as legitimate a subject for art as traditional portrayals of mothers and infants; from the point of view of the contemporary female observer, more convincing than the idealised Madonna and Child.

*Post-Partum Document* contributed to a complex conversation about motherhood and women's domestic labour at the emergence of second-wave feminism. It is a large-scale installation consisting of 139 individual pieces, mapping the relationship of a mother—Kelly herself—with her male child, Kelly Barrie, over the first six years of his life. Different aspects of the intimate experiences of mother and child are recorded in six sections (*Documentation I–VI*), fostering connections with varied discourses (scientific, medical, feminist, educational and so on) through which child rearing is considered. The work explores the trajectory from the original symbiotic relation of mother and child, through various stages of attachment and separation to the constitution of the child's identity and his growing autonomy. In the process, Kelly also documents maternal subjectivity in its struggle with contradictory impulses: on the one hand, the desire to merge with and protect the child; on the other, the impulse to enable the child to find his own way as an autonomous being.

The theoretical framework for *Post-Partum Document* was Lacanian psychoanalytic theory. In gesturing to the dearth of works of art exploring the mother and child relationship from the point of view of maternal subjectivity, it has been highly influential on numerous generations of feminist artists. Contained and constrained by the protocols of both minimalism and conceptual art (the use of documents, a predilection

for grid formations in hanging; an unemotional and coolly analytical approach to subject matter), *Post-Partum Document* juts through its theoretical structures and speaks to maternal compulsions.

I know I first encountered the work in reproduction in the early 1980s; I have never seen it physically in its entirety. I know that when I first became aware of this work, I felt liberated by the range of possibilities now offered by the moniker *artist,* though I had no idea how to translate this into my own practice as an artist, or my practice as a writer: the two remained separate for too long. I know, too, that when I first encountered this work, I was left with a feeling of longing, despite Kelly's refusal to engage with the more emotional side of maternity. This was long before I thought of myself as childless, or even child-free, long before the harrowing encounters with reproductive bio-technology. Children were in the future. For women of my generation, Mary Kelly was a role model, an older artist who not only combined practice and theory in her work, but who also made it look possible to be both a serious artist and a mother.

As things turned out (that sharp visibility afforded by hindsight), without children, it has been my own body—my own life—that became the source of such longing and loss, preservation and release.

I am consumed by the wish to document the material leftovers of my trajectories, to chronicle this singular and ordinary life through its traces. My need to preserve an archive of the ephemeral has adhered stubbornly to objects that have, in turn, become the transmitters of that very need. Objects to which I am immoderately attached.

I am, of course, not unique in this. In the opening lines of her memoir on the aftermath of the death of her husband, John Forrester, Lisa Appignanesi writes that though she has given away his clothes, discarded 'unopened packs of tobacco, wires that belonged to defunct machines and some of the other leavings of life,' she somehow cannot throw away 'a small translucent bottle of shampoo [...] the kind you take home from hotels in distant places,' something entirely banal and commonplace, which had outlived him. She knows that in some way, superstition drives her, for some reason, significance has attached itself to that particular object above others. 'We all know the dead inhabit select objects,' she says.

Similarly, considering photographer Tina Ruisinger's body of work *Traces* (2006–2016), a ten-year project photographing the things left behind after people have died, Nadine Olonetzky writes:

> There are some things that we associate with only one single person. Even when the object is a mass product. A leather belt, for instance; a pair of jeans; a pearl necklace. But for us, it is *the* leather belt; *the* pair of jeans; *the* pearl necklace. How very little is required to spark so much? We put our face in the scarf, and a whole world forms.

Ruisinger's photographs include a cardboard box containing five tuning forks, a pen, a pile of colourful shirts, a set of old kitchen knives, a pair of men's shoes, a manicure set, a child's jumper, diaries and ledgers, index cards, a bag of buttons, a pair of boots, a key, a photograph album, a small cutting of hair, folded jeans, a mended pipe, the corner of a chair. These items are photographed in isolation, close up. Sometimes, they are pictured, from above, in a way that links them to the images that I have included in this book, a tradition allied to documentary and forensic photography; in other images, the contrast between sharp and soft focus and a more off-centre framing speaks of an immersion in a tradition of still life. A tattoo brings memorialising traces right onto the body. One photograph shows the frontispiece of a book with a quote by Claude Lanzmann: 'life is banal; death is a catastrophe'.

Not only the dead, but those others who are now lost to me, others with whose stories mine are intertwined, who contain broken-off bits of my own past and my misplaced selves, are similarly contained in certain objects. Although they do not add up to a coherent portrait of me, the objects are touchstones. Like the iconographic details of Renaissance paintings that I was taught to decode—a shell, a fig-tree, a dog—they serve as narrative shortcuts.

The trail of free associations unleashed by my evocative objects tracks through not only vision, but all the senses. I cannot hear certain songs (*I'm So Tired of Being Alone* by Al Green springs immediately to mind; *Don't Give Up on Me* by Solomon Burke) without thinking of P, and *This Feeling* by Alabama Shakes takes my whole body into a big fat snog watching the last scene of *Fleabag,* and Janet Baker singing *Du Ring an meinem Finger* from Schumann's *Frauen-Liebe und Leben* will always transport me to a messy flat in West Hampstead in the early 1980s and to a then-new Australian friend throwing an olive up in the

air and not catching it with either mouth or hand on its return. Smell reaches even further, deeper into that region 'more intimate than those in which we see and hear,' as Marcel says in a hotel room in Balbec in *Within a Budding Grove* (1913). He locates 'that region in which we test the quality of odours' at the very heart of his 'inmost self,' where the smell of flowering grasses launches an 'offensive against my last feeble line of trenches.' There is no defence: when someone in my proximity applies TCP, my husband Ian—over a decade dead—is summoned: the timbre of his voice, the strigine combination of green eyes and spectacles, the sheer cliff of his nose; his scorn and his kindness too in that antiseptic hit.

Those of us who live amidst many possessions of whatever nature might feel the need to assess (continuously or occasionally) which objects to discard, which to preserve. 'Things are needy,' writes Ruth Ozeki in *The Book of Form and Emptiness* (2021). 'They want attention, and they will drive you mad if you let them.' Maria Stepanova describes her aunt Galya taking things from one room to another, then tidying and re-evaluating, decluttering and re-cluttering individual rooms. I have several friends for whom such an ouroboros of activity would be familiar; it describes me too. While Internet shopping has seduced many of us in the West with apparently seamless, obstacle-free access to *stuff*, further abstracting our already abstract notion of money (not linked to sheep or cows, not even to gold), we are also constantly assailed by an opposing solicitation: declutter. The word is sonorous with moral virtue.

## *In Extremis*

It is easy to forget, from the perspective of material comfort, that for millions of people, the need to strip away possessions is far more than a fashionable dialectic between excess and purification: it is an imperative of transience and precarity. In an essay 'Goodbye To All That' (2005), a riff on Joan Didion's eponymous essay (1967), Eula Biss reviews her four moves while living in New York. 'Each time I owned less,' she writes.

> I left New York without even a bed. I no longer had potted plants, or framed pieces of art, or a snapshot of my father. I remember the moment when I threw that snapshot out. I was sifting through my things before another hurried move with a borrowed car, and I looked at the photo, thinking *I don't really need this—he still looks almost the same.*

It is striking that Biss feels that even a photograph is too much to carry; this clearly speaks of an extreme of mental duress. It is more frequent, under such conditions of adversity, for people to preserve a bare minimum, however flimsy: material reminders of intimate ties and of how we come to be who we are. This *mattering* of our lives—the expressions of what counts through certain material things—throws a light on those elements of our autobiography that we value and wish to safeguard.

Several photographers in the last decade have sought to explore the relationship between subjects and their material objects. For his project *Home and Away* (2014–2015), Malaysian-based photographer Adi Safri spent time with asylum seekers crossing the border into Malaysia. Safri created photographic portraits of some of these refugees, each framed individually, facing the camera directly. Their quiet poise suggests, in each case, that being a refugee is a condition, not an identity. There is nothing *arty* here in these photographs: these images are unapologetically witness statements. Each person is captured holding a possession she or he could not bear to leave behind. These include a school bag, a stuffed toy (gift from a lost father), the dress of a small daughter who had to be left behind, a pair of flip flops used at the time of escape, a traditional Somali shawl, a slingshot given to a boy by a childhood friend, an engagement photograph.

In a similar vein, German/British photographer Kiki Streitberger's project *Travelling Light* (2015) considers, out of all the displaced people worldwide (around 65 million in 2015) the 30,000 people who undertook a perilous journey across the Mediterranean to Europe in 2015, often having paid extortionate sums to smugglers, and surviving—if they survive—gruelling hardship, while facing uncertainty and possible deportation at the other end. Streitberger's photographs of items of clothing flattened against a white ground have about them the cool, unemotional quality of documentary images, though her work is exhibited in art contexts (the two professional circuits—art and documentary—have often been kept apart). The images are paired with transcribed verbal testimony. A sample:

- Ahmad, 40, printer and shop owner: *I bought the kufiya in Syria and I bought it for the journey. It is very important in Palestine, but outside Palestine it's not. I had it with me to protect me from the sun*

*and the sand* [...] *The lighter is from my supermarket. I have had it for four years. It's now broken but I still want to keep it as a memory.*

- Nezar, 11, student: *The pink document is my school report. I brought it because I was the best in my class. My favourite subject was Maths. I had so many friends in school. I miss them.*

- Asmaa, 36, home economics teacher: *The prayer dress is a gift from my mother. I got it while me and the children stayed with her in Latakiya. I had another one in Damascus, but when our house got destroyed everything we had was lost* [...] *On the journey I didn't pray. I kept the dress in a bag.*

Streitberger's deadpan images display what people who leave almost everything behind to embark on a precarious new life choose to take on their journey and what these items mean to them.

I was struck by this body of work when I saw it in the 'Contemporary Issues' category of the Sony World Photography Awards exhibition in London in 2016. Now I look at them again. I google Streitberger to see what other work she has made. It includes a project titled *Chimera* (2013) tracking the effects on her of a stem cell transplant she underwent that saved her life. Writing of her donor, she says: 'for the rest of my life, his blood will flow through my veins. Genetically, it is always his. He will always be a part of me.'

I am interested in the different ways Streitberger's work focuses on borders and traces, including the boundaries between her and another human being, and the traces of another human being in her blood: otherness incorporated. I return to the images of the possessions of refugees to chastise myself, for bad faith, for excess.

## Reading and Writing Objects

Objects—like new facts about the past—make inroads into the fluid, ambiguous spaces of memory. Essayist Brian Dillon says that there is something terrible 'about the way a dumb artifact can lead us back to the past, if only because its very existence is at odds with the passing of the bodies to which it might once have attached itself, or with which it once shared the space of daily life.' Objects might remind us of our old selves or of other people, but that very association can land up

fossilising the living, changeable beings we once were, and those others whom we miss.

Such objects, though often totally ordinary at the outset, are plucked away from the realm of plainness—the category of the merely objectual—by the power of contiguity, the friction of usage, the pull of association, the force of evocation. Unlike Proust's madeleine, a sense impression that prompts a chain of uninvited associations by stealth, these are objects that we purposefully hold onto: mementos, keepsakes, souvenirs, amulets. I am, as I write this, remembering the gnarled potato that Leopold Bloom carries in his pocket in *Ulysses* (1920), first appearing in the 'Calypso' chapter, where, on leaving his house, he searches his trouser pocket for his latchkey. 'Not there. In the trousers I left off. Must get it. Potato I have.' Associated with Ireland's history, the shrunken tuber rubs against other pocket objects and gradually serves, for Bloom—who is strolling with hands in pockets—as a reminder of Molly's infidelity but also as a talisman against violence and other dangers, a possible prophylactic against rheumatism and as his 'poor Mamma's panacea.'

Like the treasured artefacts that fill the vitrines of historical and archaeological museums yet without any material value attached to them, my evocative objects are touched by the everyday magic of time as a medium. In them, self and body become enmeshed. They are reminders of how, incarnate, I glide or limp, sprint or amble into the future. They not only inhabit my life in ways that illuminate who I once was; subtly, they shape the very substance of that self as it moves forward into the future.

I think about the notion of a self and how shifting it feels, a conglomerate of agencies that are not autochthonous and identifications moving in different directions and in multiple temporal dimensions. I remember reading about Katherine Mansfield's conception of her 'many selves' and spend a good hour following it down a rabbit hole. I hear, and then track again, an episode of *Free Thinking* on Radio 3 recorded in 2020, in which neuroscientist Daniel Glaser describes the concept of self from the point of view of the brain. 'The self,' he says, 'is the consistency about the relationship between me and the world, it's that which is preserved.' From the brain's point of view, objects define a self through their solicitation to performance. Objects, in other words, are

things that make you want to act, with or upon or through them; not only verbs, but prepositions too. Through such an invitation to engage with a thing and also to use that thing upon other things in the world, you know you have a body. An espresso cup elicits a different response from, say, a sponge. A pen. A lipstick. I wonder to what extent that is still true when the self might be defined as that entity that responds with flickering attention to clickbait generated by bots and contributing to the huge complex machinery of global capitalism. Still, I find this reversal of everyday logic not only simplistic, but also seductive. Objects are addressed as physical entities with particular characteristics that invite—or in the case of the arrested status of evocative objects, have already invited—action.

Yet that material encounter does not describe the ways in which they also bear the contracted, compacted sediments of so many physical and affective encounters with us. Our appropriation and appointment of objects according to the expression they enlist is, in other words, also historical; it has its origins in our material and affective past.

Objects are further complicated by the fact that they change over time, both in themselves and in how they summon us to consider them. And when objects remain in a deep slumber for months or years, our re-encounter with them may be a kind of revivification. We rediscover them, we act on them once again, feeling anew the lure of the mnemonic, which is also the lure of the future. Perhaps these secondary acts are ones of restoration, touching us as we touch them, with hands as remedial and alleviative as bandages.

We attach ourselves to objects because of their perceived stability: *this* ponytail, *this* handkerchief, *this* sled with the word *Rosebud* inscribed upon it. The very thingness of our evocative objects, their staunch assertion of presence, confers the fantasy of stability on the subject, on *me*.

But with our fervent attachment to meaningful objects, we sometimes forget that the relationship between humans and the object world in which they are immersed is never that firmly fixed. We know the natural world is in flux, but a visit to any museum will remind us that the artefactual world is not stable either. Time not only corrodes and reshapes objects, it also affects our association with them. Even our relationship to deeply cherished mementos can suffer the whips and scorns of time. Objects,

in other words—even ones that are not charged with the burden of carrying our personal histories—have contours that are more porous than we might imagine; their quiddity is not necessarily assured. And so, the self finds and defines, and then re-finds and re-defines itself in the process of assigning shifting mental and emotional places to and for such things. Loved, unloved, loved again perhaps.

Simultaneously, much as evocative objects serve as pocket memorials, as I grow older, I find myself overwhelmed by the desire to disencumber myself of the dead weight of things, their meanings, their link to grief, to loss. This makes me think of Orson Welles' classic *Citizen Kane* (1942), where, amidst prodigious collections of useless objects, the memento enjoys a certain tyranny. And sometimes, its nested allusions point simply to other mementos, a meta-text of memories unmoored from any founding subjectivity. This seems like a cautionary tale. I find myself longing to achieve a whittling down, an existential minimalism. To examine my store of inner objects and count on them more confidently. And even perhaps to rely less tentatively on the flow and ebb of recollection, allowing what gets lost to remain lost. Making the job easier for those who will one day have to clean up after me. Or rather: I long for such release, and equally I don't. Because to long for it is to acknowledge ending. My ending.

Writing shares with photography the semblance of defying death, or at least of deferring it. It is a clean, space-saving way of laying claim to things, having them still, or having them again; an opportunity to reassemble fractured pieces of the near and distant past into the narrative shapes on which memory insists. I am hoping that eventually, it will obviate the need to cling onto stuff by writing about it, but I am not certain this will happen.

For me, now, writing away from my old discipline of art history has become a way of thinking about objects without the restraints of set methodologies; has become a vehicle for the meshing together of autobiography and theory, of experience and thought. And I love the way writing remains constantly in dialogue with other writing: I am always also a reader; perhaps first and foremost, a reader.

I have drawn on an archive of works by writers and artists that have been meaningful to me, that—for different reasons—have addressed me over the years in my capacity as writer, artist, occasional curator,

daughter, lover, friend, dog-mama. It has taken me many years to come to realise that my art practice and my writing practice do not exist in separate, airtight containers. What writer and curator Lauren Fournier describes as 'the entanglement of research and creation' in which 'artists and writers wrestle with the place of theory and autobiography' both in their lived experience and in their practice, speaks directly to me, of me.

Thinking through and with the objects that serve as signposts to my history seems to be but one step away from telling my stories through this miscellany of the non-functional, this bounty of useless, haunting objects. As I write 'telling my stories' I think: *no. No, it's not that.* I roll my eyes when I hear the words *storyteller,* or, worse, *raconteur.* Bore. This exercise, I feel, must surely throw light on connections that I have not previously made, that I forge in the telling, but that also speak to others of their entangled associations. More significantly, I am hoping for light to be thrown on aspects of my own thinking that have remained in hiding; that have slipped through the scaffolding of the stories that I have frequently, perhaps unthinkingly, told others, told myself.

The objects that unleash my trains of association and unfurling narratives are as idiosyncratic as anyone's private relics. My ponytail would certainly give some people the creeps: to me it evokes *me* in some quintessential form.

I find that in order to write about these objects—in order to experience them in a mediated, communicable way—I need to photograph them first, as if to fix and contain them, to pin them down and frame them already in representation. I am particular in how I do this. I want the ground on which the object is positioned to be pale; I want the light to be soft and fairly even. No artificial lighting, no horizon-line. But, despite the care I take in framing and lighting, I don't want these images to be too artful. Nevertheless, their quality as images is not immaterial to me either: they are not snapshots. And I cannot begin the process of mnemonic unwinding and rewinding, of un-forgetting and association, without first positioning the image on a blank page on my virtual document, the one here, on this screen. Scaling and centring it; containing it in a fine outline to separate it from the luminous page-that-is-not-a-page.

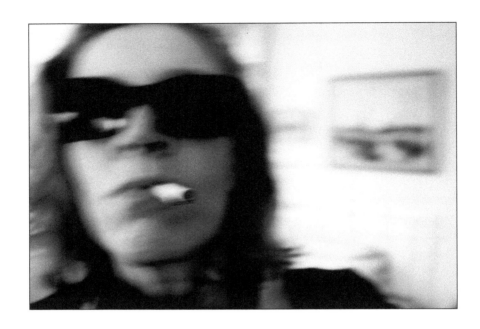

# Orphaned

There's a series of photographs taken on my mobile phone shortly after my mother died. They are the first photographs of me as an orphan. They exist only as constellations of pixels, but I can urge them into shimmering existence at will. They are immaterial, of course, but as evocative objects—objects that push me into cascades of thought and feeling—they are real.

This is Johannesburg, March 2012. My brother, my sister and I are clearing out the room where our mother lived out her last years. *Living out* her life is a peculiar phrase, but there was a sense in which she was biding her time till it was all over. She did not enjoy old age.

The iPhone passes from hand to hand; we click away. A sense of spontaneous gaiety and fanciful hilarity infuses these moments, which are, you might say, moments of denial. While some images are unexpectedly static and sombre, others convey our edgy hysteria. In one sequence, I've slipped into one of my mother's boxy, wide-shouldered blazers. Once again, I am inhabiting her body. We always found it funny that in her tailoring, our mother remained faithful to the spirit of the 1980s. I've knotted one of her silk scarves around my neck. I've donned sunglasses—my own—but my scarlet lips are hers, as is the unlit cigarette I ostentatiously puff. In this theatrical construction, I am wrapped in an appropriated and travestied glamour: I'm passing as my mother. Both my siblings recognise her in me and cheer me on. Later, they too will throw on the mother-blazer, each taking a turn at being Fay, who was once Fusia.

There is something excruciatingly, comfortingly, self-punishingly intimate about donning the clothes of the recently dead. After my husband Ian died, I slipped into his crumpled linen jacket, which enfolded me in its large embrace; there was a receipt from Homebase neatly folded into a tiny wad in the left pocket: he was left-handed and

 https://doi.org/10.11647/OBP.0285.03

several jackets had things secreted on that side. I find this intimacy years later in a poem written by Maxine Kumin for her friend, the poet Anne Sexton. The two were also literary collaborators, daily sharing details of each other's lives. In October 1974, after what appeared to be an ordinary lunch with Kumin, Anne Sexton committed suicide by carbon monoxide poisoning in her car. She was forty-five years old. A month after her death, Kumin slips into her friend's blue jacket and breaks your heart writing about it in a poem titled 'How It Is.'

> Shall I say how it is in your clothes?
> A month after your death I wear your blue jacket.
> The dog at the center of my life recognizes
> you've come to visit, he's ecstatic.
> In the left pocket, a hole.
> In the right, a parking ticket
> delivered up last August on Bay State Road.
> In my heart, a scatter like milkweed,
> a flinging from the pods of the soul.
> My skin presses your old outline.
> It is hot and dry inside.
>
> I think of the last day of your life,
> old friend, how I would unwind it, paste
> it together in a different collage,
> back from the death car idling in the garage [...]

The casual dejecta in pockets and the scent that a dog recognises turn into miniscule memorials, silent elegies, tokens of the vastness of loss, the collage and the movie separate metaphors working together to unwind time, piece the bits together differently.

I inhabit my mother's jacket, which makes me aware of how our competing bodies differed, her skeleton finer, narrower in its extremities, but a girdle of flesh latterly wrapped itself around her middle, her copious breasts, those places of attachment and nutrition onto which my mouth once fastened, turned heavy and droopy with age.

It is not long since our mother has been laid to rest in the red earth of Westpark Cemetery in Johannesburg. In accordance with ancient scripture, Jewish burials must take place within twenty-four hours of death. Our mother died in hospital before either my sister or I could reach her from the distant countries where we live: Israel, England. I was far away, too, when, over the years, she had a hysterectomy and

spinal surgery, polyps removed from her throat, cataracts excised from her eyes and a broken arm mended: various acts of subtraction and repair that enabled her life to continue. I was absent when bouts of depression kept her bed-bound (*magnetised to my bed* was how she put it); elsewhere when she took countless knocks and tumbles, emerging bamboozled, bruised and grazed. The sibling who stays, versus those who go, bears the brunt of the parent's scrapes with mortality. These tumbles are, it strikes me now, parodic enactments of the falling that is the ultimate destiny of the body; I think it was in Julia Kristeva's writing that I first learned the etymological link between *cadaver* and the Latin word *cadere*, to fall.

For her death, my brother—living in the same country, in the same city—also arrived too late. Although our mother was eighty-three, none of us had expected her to go just then: perhaps death always feels as though it has arrived too soon.

She had undergone surgery after slipping in her room and breaking a femur. She had seemed to rally for a day or so, but then she quietly waned and disappeared without an audience and with an uncharacteristic lack of fanfare. Because for years she had armed herself with the rhetoric of a death-wish so theatrical as to invite being shrugged off, the three of us were quite stunned that it actually happened.

For a while, we were lightheaded.

*Always a great one for the surprise gift*, my brother said. She had died a day before his birthday.

Her last earthly address was a retirement home called Madison Gardens. Outside of its frail care unit, it was more a residential hotel than a care home. My mother, refusing to be consoled by any of the kindlier platitudes of ageing, hated the other inhabitants for their infirmities, their inane conversation, their hearing aids and Zimmer frames. They provoked the uncensored, expletive expressions of her contempt, as though she were not one of them. Like a schoolgirl, she dallied with expulsion.

If the name of the residence was intended to transport its impermanent denizens—shroud them in pastoral dreams—it did no such thing for my mother. Neither did it placate the unsuspecting visitor. Smells of institutional food and disinfectant hung thickly in the lobby. There were long, neon-lit, carpeted corridors. Dining tables decked in sticky, floral plastic. Inside, the rooms were shrines to past lives.

In my mother's room, a few paintings she had rescued from home, several books, a radio. Her signature, dark blue, modernist Danish plates and bowls. As children, the three of us had loved these dishes, considered them to be our brand, so different from the old-fashioned tableware at our friends' homes. They made our parents distinct, modern. Pieces of chinoiserie, on the other hand, were vestiges of my mother's life before my father, first as a girl, then a young woman, in China. There were also numerous ornaments of mixed provenance. What is the point of an object conceived as an ornament, I asked myself when confronted with these, ashamed to be asking the question now that my mother was impervious to my provocations.

My mother's ornaments were mostly souvenirs from travel. She loved such mementos; not keeping the scratchy drawing torn off a paper napkin from that particular evening in Madrid but purchasing, instead, a miniature pair of lacquered castanets made for no purpose other than to ignite a generic memory of having visited Spain.

Lawrence Raab's poem 'After We Saw What There Was to See' perfectly captures the process of dutiful, self-improving travel and the concomitant acquisition of trinkets—fabricated memories—and how it might play out both in relation to gendered stereotypes and in the dynamics of a couple: the woman hungry for meaning and affect, the man happy to hang out somewhere, detached and lighting up by the car:

> After we saw what there was to see
> we went off to buy souvenirs, and my father
> waited by the car and smoked. He didn't need
> a lot of things to remind him where he'd been.
> Why do you want so much stuff?
> he might have asked us. 'Oh, *Ed*,' I can hear
> my mother saying, as if that took care of it.

But those souvenirs can do more than cynically point to their origin in a workshop or factory. Through being picked by an individual—Lawrence Raab's mother, say, or mine—taken home and placed somewhere else, somewhere visible, adjacent to other similarly pointless objects from other occasions, they become re-narrativised, things linked to a particular life. In his beautiful, plangent memoir *In the Dark Room* (2005), Brian Dillon recollects a small plastic snow-globe from the living room in his grandfather's house in Kerry in such terms.

> It partook of a modest and immediately decipherable narrative; it was a reminder of a place that somebody (my grandfather, my grandmother, or one of their daughters?) had visited. That place had vanished from my memory; I cannot summon the little landscape which the globe enclosed at all, or the inscription which I am certain was to be read on its base. But the globe still conjures up the objects with which it was surrounded.

Dillon's memory adheres not to the signifiers to which the bibelot points (a place, a time, a particular journey: all those are quickly lost) but to the quirky landscape of collected objects in a remembered room.

Also in my mother's room, on all available flat surfaces, were framed photographs of her children and grandchildren. Then, a deliberate, careful arrangement—an altarpiece—celebrating my father's life and death by smoking: a fanciful, marine-themed table lighter, a chunky orange and brown ashtray (1970s), and a large, framed photograph of Dad beaming and apparently in full health, dating from 1980, the year before he died of lung cancer.

# Fay

Once a party girl, queen of the *je ne sais quoi*, later aspiring to middle-aged graciousness, my mother had gradually whittled her expectations down to the barest bones of sociability. Her room exhibited, in all its details, reminders of Fay's unwillingness to spend money on herself, *there should be more left for the three of you*. Everywhere, signs of an old person's incompetence with hygiene. Feeling accused, my siblings and I exchanged looks. The mattress, now stripped, was soiled. Charred cicatrices testified to her dogged habit of smoking in bed. She had certainly never held back from balancing an ashtray somewhere on her duvet, her benign essential tremor ensuring that every flick of ash landed short of it. On the carpet, a large, ragged stain, a map of incontinence, later scrubbed with diluted bleach by a cleaner living far from her own mother, far from her own children.

That stain, obscene in being witnessed by her children, attested to the hours our mother had lain on the floor, immobilised by her crushed bone. I try to imagine her shallow, irregular breathing, wondering where she would have placed her arms, how she must have felt, and I experience a tightening of my rib cage. My mother spending the best part of a day

unable to move or call anyone. How long till someone would miss her, she must surely have wondered. How long till I, at a distance, started worrying: *why is she not picking up*? Was she frantic? Or was she oddly calm? She sometimes surprised us. She had always refused to carry on her person either a panic button or her mobile telephone. Anyhow, we doubted she would have remembered to charge it.

There was other evidence of recent habitation, as though she had just nipped out to the podiatrist or hairdresser. Inside the fridge, the remains of her last meals: repurposed ice cream tubs containing slices of cold meat and processed cheese; a bottle of peach squash and another of Bailey's Irish Cream; a tub of Clover Original Spread; a bowl of prickly pears that struck me as an odd choice of fruit; four small pots of yogurt of varied synthetic fruit flavours, of which one lid bore the inscription *buy 6, get one free*. On her bedside table, a reading lamp; a TV remote control; her wire-framed spectacles; a clean ashtray and a pack of Kent cigarettes, together with an orange Bic lighter. A note written in her quivering, all but illegible script: a telephone number and a word that, perplexingly, may be *Sotheby*. She would have had nothing of value to auction. I imagine her lying in that bed, with its bolsters and blankets, her hands struggling with the TV remote, leaving spidery notes to herself, smoking herself to sleep, half wishing to set the place on fire.

With her eyesight failing and an attitude of *what the fuck*, her clothes testified to the careless habits of those who smoke and eat alone. She enjoyed flaunting her amazing finds from the charity outlet at the Jewish Old People's Home, where she would volunteer once a week while she could still drive. The colours of her clothes were often bright. As we sorted her things, knitwear with snags or pills of caught yarn lay on the floor; patterned skirts and plain trousers, all with elasticated waistbands; large blouses; bunion-deformed sandals and mules; weathered handbags, flattened, with their mouths snapped shut, in an array of colours to match her footwear. Matching was always important to my mother, and she could never understand how a single black bag served me for all occasions.

By the time she died, my mother had lived in Johannesburg for over twenty years. This had been her second sojourn there, a reincarnation; her first ended when, a year or so after my father died, she moved back to Israel, where we had lived when I was a child. But back in Tel Aviv,

she got tired of rubbing along with people she considered ruder than herself. *No one bothers with 'excuse me' or 'pardon.' And don't they know what a queue is?* At that point, Israel had been her home for seven years. She had previously lived there between May 1949 and November 1962.

Tel Aviv was the city in which she and my father met and married, the city where I was born, and then, four years later, my brother. My sister was born in Johannesburg exactly nine months after we arrived there: my mother, my brother and I. Theo, our father, had gone a few months earlier—trailblazer, pater familias—to settle into a new job and find somewhere for us to live.

Johannesburg and Tel Aviv became, for my mother, two points on a map that traced a zigzagging trajectory; each a space of longing, each a locus of disappointment.

Arriving in Johannesburg in the early 1960s, we moved into the Anlar Residential, a low-slung hotel on a corner of the main road in Hillbrow, which was an inner-city area crammed with apartment blocks. Googling *Anlar Residential* now, I find it illustrated in the August 1946 number of the *South African Architectural Record,* and its appearance and description are as unprepossessing as I recall: 'A block of rooms. Construction is conventional reinforced concrete frame, with brick panel wall. Face brick is golden brown with plaster contrasts. The elevations gain much from simple repetition and the falling articulation of the structural masses.'

A hotel like the Anlar—indeed an area like Hillbrow—was not home to people who would become my parents' friends: well-heeled, white people, mostly Jewish, ensconced in sprawling houses set in landscaped gardens in the northern suburbs of Johannesburg. But Hillbrow had an urban energy that felt dangerous and exciting, the best book and record stores (Exclusive Books before it was a franchise, Hillbrow Records), and cool cafés. Later, as a teenager, ambling along those streets, I would imagine myself living in a metropolis. There were, already then, street vendors and vagrants, and more pedestrians than in other, sequestered residential areas; also a more diverse array of inhabitants than was customary in apartheid South Africa. It felt at once European and African. It was the backdrop to my first cappuccino, my earliest rehearsals of the bohemian life, usually in the company of my best friend Meryl, whose pale skin, crinkly red hair and interesting clothes made her look the part. The Skyline Bar on Pretoria Street was the first

gay bar I ever visited, and in Café Wien we would order genteel cups of coffee with Carnation milk, to the anachronistic strains of violins from Mitteleuropa.

The Anlar was cosy enough, but bleak. It was nothing like any place I had ever known in Israel, where we had had very little money, but where everything smelled piney; where dirt was dusty, not grimy. The Anlar was lit by 40-Watt lightbulbs and smelled of warm custard and floor wax.

Here, for the first time, I heard adults talking in slow, loud, condescending voices to other adults, calling them 'boy' and 'girl.' Here, I had my first English lessons with Miss Beira, soft-spoken, slim-hipped, wearing pencil skirts, filling ledgers with rows of words in a new alphabet. Here too, feeling I couldn't breathe, I had my first panic attack. Later, I would experience that same tightening of my chest, the chilly, dizzying rush in the head, sitting in the back of the car, returning from a Sunday outing when my parents were attempting to uncover the workings and pleasures of their new world, driving across the alien Highveld landscape with its too-big, all-or-nothing skies. A sense of what I would later learn to name alienation, and with it, anxiety would wash all over me. My parents took me to a doctor who showed me photographs and asked me to describe them and told me that I was suffering from *the altitude change*, it would pass. But separation anxiety would remain with me as a defining feature of my attachment style. With language proving to be a blunt instrument when it came to knowing my mind, it was my body—my lungs struggling to draw breath—that showed me, and performed for my parents, how much I resented having been wrenched from a life that, until then, had seemed indivisible; from a world that had unshakeably (or so I thought) belonged to me.

Years later, after my father's death, my mother no longer felt capable of living in Johannesburg, of inhabiting that milieu of pitied widows and cloying couples, who, to boot, had children who *cared*.

By then, I was married to J and living in Lisbon. My mother did not wish to continue occupying alone the spacious flat where, for the last two years of my father's life, she had finally felt able to settle into an uncomplaining life. Here, at last, was a place that had met her minimum standards of beauty and prestige. She experienced my father's death as punishment for her brief fling with contentment, a moralising

comeuppance. Her grief tunnelled through her, leaving her with a sense of affront, as though death had been an agent with a personal vendetta not so much against my father, but against her. Depression and rancour were scrunched together, never again to be disentangled.

With each of my mother's moves, papers were discarded, belongings pared down, things given away or sold. She could, contrary to her own belief, be exceptionally hard-nosed and unsentimental. There are almost no drawings, very few schoolbooks, a dearth of memorabilia from my childhood, or that of my brother and sister. The to-ing and fro-ing between Tel Aviv and Johannesburg, cities loved and detested in equal measure, was characteristic of her need to perform her restlessness, a physical and spatial expression of her discontent. She had little restraint: acting out was what she did best.

As she grew older and into the mother I remember, she immersed herself habitually, as if this were a tonic to her, in a cold bath of disappointment and resentment. She also harboured a fear of confronting the grittier challenges that life threw at her. I remember the terror she expressed at being left alone with my father after his cancer diagnosis, terminal from the outset. At that time—the early 1980s—doctors didn't always spell out the harsher prognoses directly to patients. My parents both pretended to each other that he was recovering from some lesser ailment, and she dreaded questions that might lead to her breaking down with him in intimate, mutual confessions of sorrow. But my father colluded with her; he didn't want to discuss his impending death either. There was never any talk of dying then, though after my father died, my mother would speak imperiously of a time *après moi*, when she wouldn't *give a shit* what happened to things and people that she held dear.

It seems astonishing to me, today, having also experienced the death of a husband, that my father's lung cancer should have remained a secret between my parents, each protecting the other from what mutual admission might bring to the party. He had the haunted look of many cancer patients, with the Thing territorialising his body; a look that avowed the secret and thereby made it oxymoronic and challenged you to examine your shame. A look that, as Anne Boyer puts it near the close of the account of her own survival, if survival is the right word, causes strangers to fetishise the suffering of those who cease to look like themselves.

It was not always easy to pinpoint my mother's shirking of responsibility, since gregariousness gave her the appearance of boisterous independence. Rage coloured her inability to face adversity, and this was matched by her desire that someone else, preferably a man, sort out her difficulties, whatever those might be. While he was healthy, my father bore the brunt of this obligation and the irritability it produced, but after he died, the duty passed onto my brother, who continued to live in Johannesburg after my sister and I left, and for whom the burden of care entailed being made to feel that nothing was ever good enough.

The short period of my father's illness was a limbo in which my mother—Fay—had no one to blame, and so it was then that she announced that she had stopped believing in God. I had not known that such a belief had previously existed.

## Legacy

Here I am, then, wearing my mother's clothes and strutting about her room. In my gestures of flamboyant femininity, I am performing her as she seemed to me, not the last time I saw her, or the time before that, but when I was six or seven and when she seemed impossibly, amazingly seductive. I am reaching past her deterioration to the period of her greatest allure, when, with her teased hair and flicked eyeliner, her beauty struck me as that of a certain kind of husky-voiced Mediterranean film star: of Melina Mercouri or Anna Magnani. This was a time when my longing for her—my sense of not having her—was as complete as it was ineffable.

In impersonating my mother—in occupying her body by wearing costumes in which she performed herself—I am both an errant and a loving daughter. As the show plays itself out, most of her possessions strike me as useless, already relegated to the past: the flayed, sloughed skins of creatures no longer alive, dingy reminders of that particular bundle of creatureliness that was Fay, *née* Fusia.

With all the predictable power of metonymy, in the absurd elation that sometimes follows a dreaded death, my mother's things hand me her fragmented corpse and demand of me that I do something.

We separate our mother's belongings into piles of items to distribute among us and items to give away: books, pots and pans, lamps, paintings.

Tablecloths and ornaments (that untranslatable Yiddish word *tchotchke*), packs of playing cards and bridge score pads, a box of costume jewellery. Jumpers, trousers, nighties. Always one for a bargain, my mother had, in her youth, countered potential shabbiness with both figure and flare. I remember shantung sheaths, the glamour of high-heeled peep toes, slim-hipped slacks (she always called women's trousers slacks), expensive silk *foulards* that my father bought on his business trips to Paris or Rome. Unlike her, he was never one to stint, a fact over which she held a grudge, as though it was those very extravagances that had prevented her from living in the style to which she wished she were accustomed.

I am struck, however, as I had been previously struck in other bereavements, by how the value of things shifts as soon as the spirit inhabiting the body has evaporated. How quickly objects become *stuff*.

In her film *50 Minutes* (2006), sitting in her kitchen with her young son, artist Moyra Davey talks about "never ending, proliferating piles of paper, clothing and toys, and how much we pad our lives with this stuff."

Stuff is how we describe things that have been devalued.

Stuff is what happens when possessions become burdensome to their possessors.

I am compelled to rescue some of my mother's belongings from the fate of being mere stuff. The salvaged items are objects that, to me, seem drenched in the particular ownership and pastness that is uniquely my mother's. Things of an uncanny personhood. I am aware, as I do this, that the selection I make amounts to a pre-organisation of future remembrance, a process of curating my own museum of memories.

Surrounded by my mother's belongings—things marked by leakage, use and making-do, breakage and repair, some already receding, others quickly thickening with meaning—I feel the need to record. I want to be disburdened, but at the same time, I am beset by the sense that to discard my mother's things would be to undermine the value of her life itself, her taste, her proclivities, her affinities. I feel I want to give meaningful souvenirs to people, but I can hardly identify anything here that would be of interest to anyone other than my siblings and myself. I remember reading, towards the end of *A Very Easy Death* (1964), of Simone de Beauvoir sorting her mother's belongings with her sister:

> We wanted to give keepsakes to her closest friends. As we looked at her straw bag, filled with balls of wool and an unfinished piece of knitting, and at her blotting-pad, her scissors, her thimble, emotion rose up and drowned us. Everyone knows the power of things, life is solidified in them more immediately present than in any one of its instants.

Yes, I feel my mother's life solidified in these objects, but at the same time, their dowdiness (*how glamorous she used to seem to me, how glamorous she once was*) brings me to the brink of shame.

I am not certain if that shame is on my behalf or on hers.

And I am unsettled, too, by the things that I do want to keep. Mostly, these are objects that expose my mother's frailty and vulnerability: a shapeless nightie; an ink-stained bag filled with miscellaneous stationery; a bowl of stale-smelling, worn down lipsticks. There is also a plastic laundry carousel to which are pegged several pairs of large knickers—stiff and thin from frequent laundering—and two pale, faintly yellowed, long-sleeved vests. These items have been so close to my mother's body, so intimate with her nakedness, they provoke in me the prickliest existential question: not what does it mean to be a mother, but what does it mean to have one? To be of that body, nourished by it, protected in it, then expelled from it? And, as a consequence, to inherit the world always as an outcome, the aftermath of everything that has happened before you, before me? In a profound and ineffable way, belatedness characterises our very beginnings in our mother's bodies.

I keep the carousel intact because it gives me a discomfiting memory of the body I came from. I travel back to England with it flattened in my suitcase.

In 2014, I pore over the work of Japanese photographer Ishiuchi Miyako, a body of work titled *Mother's* (2000–2005). I am overwhelmed by these images of her mother's intimate belongings, which include a camisole, a half-used lipstick, a hairbrush still snaring black filaments of hair in its plastic bristles. The title of this body of work with that possessive *s*, prompts my focus to oscillate between the person and her things, the photographer and her mother. I read that Ishiuchi's mother was born in 1916, a 'strong-willed woman who came of age in colonial Manchuria,' and I feel a frisson of affinity, since my mother was born in the former Russian settlement of Harbin, deep in what was then known as Manchuria (the current nomenclature favours the names of the Chinese provinces that constitute northeast China.)

Through their association with her mother's body, the personal belongings Ishiuchi has photographed exist in a regime of disconcerting intimacy. Relations between mother and daughter had been strained, I read, but Ishiuchi was deeply affected by her mother's unexpected death in 2000. She began photographing her possessions as though closeness might, finally, ensue through touching and positioning items that had been in close contact with her mother's body, reaching out to them with her point-and-shoot camera.

As soon as I see these works, I experience that shudder of serendipitous kinship that sometimes goes by the name of influence, since in 2012, without knowing of Ishiuchi's work, I photograph all of my mother's possessions before clearing out her room.

The few items of beauty or relative value—mostly objects from my mother's childhood in China or passed down to her by her mother— now unsettle me. For I am aware that my relationship with these things, and my relationship with objects in general, both material objects and those immaterial ones that are family memories—is necessarily shaped by the fact that I have no children; aware that passing things down— that vertical metaphor used to describe legacy—stops with me. Aware that the silver Shabbat candlesticks say something different to my sister than they do to me: for me, the nostalgic evocation of something almost lost; for her—a practicing Jew and a mother and grandmother—they encapsulate a potentiality, the possibility of a lineage, her daughter and her daughter's daughter, a pulsing, red, female line.

Since my mother died, I have been reading books by women about their mothers. For each, their mother's death served as a catalyst for thinking about that most primary and testing of bonds. Simone de Beauvoir. Adrienne Rich. Carolyn Steedman. Annie Ernaux. Nancy K. Miller. I also read Vivian Gornick's *Fierce Attachments* (1987), a book written while her mother is still alive; I read it twice in quick succession.

Anything written by Gornick merits special attention: her writing is fluent and candid and discreetly brilliant; its measured pace and wit draws me in and holds me right there with her. She presents herself as fallible, independent, humane; the writing is warm and lucid. Perhaps because of a particular way of inhabiting both her childlessness and her Jewishness, Gornick is the one with whom I most readily identify. I identify with the passionate irritation that ties her to her mother. 'My

relationship with my mother is not good,' she says near the beginning of *Fierce Attachments*, 'and as our lives accumulate it often seems to worsen. We are locked into a narrow channel of acquaintance, intense and binding.' Walking together in the streets of Manhattan—the daughter aged forty-eight, the mother eighty—Gornick's mother stops strangers and assaults them with: 'This is my daughter. She hates me.' Then she turns to Vivian and asks: 'What did I do to you, you should hate me so?' Gornick speaks of her mother's rage as burning, and she wants to let her burn. In middle age, she is still capable of feeling hurt, infuriated, humiliated, dismissed by her mother. Yet their connection is incontrovertible: 'suddenly her life presses on my heart,' she says near the end of the book.

My mother. Suddenly, her life presses on my heart.

Not reducible to formulae of loss, mourning and symbolic retrieval, these memoirs that I have selected, out of all the available mother-daughter literature, throw a light on the complex processes of identification with mothers by daughters who simultaneously—like me—cannot bear to resemble them. I can only walk in my mother's shoes, my exuberant performance tells me, as parodic mimicry.

As I write, I think about fathers and sons too, a relationship about which I know less, though I have witnessed the closeness between my brother and our father.

I remember a powerful moment in Philip Roth's *Patrimony: A True Story* (1991), a book in which Roth explores his relationship with Herman, his dying father. Herman, a ruthless and unsentimental chucker-out of paraphernalia, has held onto his own father's shaving mug. Philip Roth, the son, wants to rescue this item above all others as a keepsake after his father dies. The shaving mug and his *tefillin*—phylacteries in English. The Yiddish word is used to described the two small leather boxes containing Hebrew texts, worn by Jewish men, strapped one on an arm, the other on the forehead at morning prayer as a reminder to keep to the law. Both shaving mug and *tefillin* are gendered and each is, in a different way, a token of patrilineage that reminds Roth of his own status as a childless man. It occurs to me that while there is a word that describes a person whose parents have died (even as an adult, you suddenly find yourself an orphan), there is no similar word to describe a person without children. Similarly, *patrimony* has no opposite: it is a

word which, when feminised, acquires an altogether different meaning, a meaning that highlights the role of women as possessions.

Roth's epiphany about patrimony is not prompted by the shaving mug or the phyalacteries. It occurs, rather, when he finds himself cleaning up his father's shit in the bathroom, 'not because cleaning it up was symbolic of something else but because it wasn't, because it was nothing less or more than the lived reality that it was.' A memorable, terrible scene, which begins with Herman announcing that he accidentally beshat himself. The quintessential scene of patrimony, then, is for Roth one of paternal humiliation.

If it is the realisation of an Oedipal fantasy—the devastation and demotion of the father—Roth never lets us know. Rather, he describes this as an event in which a boundary of privacy is breached and the parent-child relationship reversed. Every child taking care of an ageing parent is faced with the actuality, or the dread, of such a reversal. But every childless child is, in turn, faced with a more starkly existential question: *who will clean up after me, when the time comes?* Commenting on this scene in *Patrimony*, psychoanalyst Adam Phillips says: 'it is not the act of incontinence alone that is humiliating: it is trying to live in such a continent world. We are not humiliated by our acts but by our ideals.' Sooner or later, we fall short of them. Sooner or later, we shit ourselves.

In a collection of short texts titled *True Stories* (first published in 1994, re-edited and augmented at regular intervals), artist Sophie Calle writes: 'On December 27, 1986, my mother wrote in her diary: "My mother died today." On March 15, 2006, in turn, I wrote in mine: "My mother died today." No one will say this about me. The end.' Her existence is poised at the end of that line.

This is true for me too.

Thinking of the entitlement authorised—in effect, authored—by lineage reminds me that with the death of my mother, my history turns back on itself, all dressed up and with nowhere to go. With me, the things inherited cannot find a route back into the family: they are on the way to becoming just stuff. And stuff is, as I have already noted, the word we use for our objects—our commodities—when they have ceased to be of material, aesthetic or sentimental value to us. As essayist Maurizia Boscagli points out, stuff is on the spectrum of subject-object interaction, and speaks of porousness, of the mishmash of objects 'at

the borders of commodified matter.' Such things testify to the effects of commodification, but also test its limits. *Stuff*, in short, is how we describe things that are liminal; things that exist between value and its erasure. As such, stuff expresses itself in particular verbal formulations: *I've got so much stuff.* Or: *what am I going to do with all this stuff?*

It's always *all this stuff*.

We pack our mother's clothes and trinkets in big plastic bags and pile the bags into my brother's car: just one carload takes care of the lot. A little smug, a little ashamed, we give the bags to charity. Here, they join other people's things, now stripped of context and narrative. Like these other people's things, our mother's belongings have undertaken a journey of disconnection and disassociation, of unravelling and detachment. Pre-loved they may be, but at the moment of reaching the charity shop, they are dispossessed, stripped of association, just plain unloved. Orphaned.

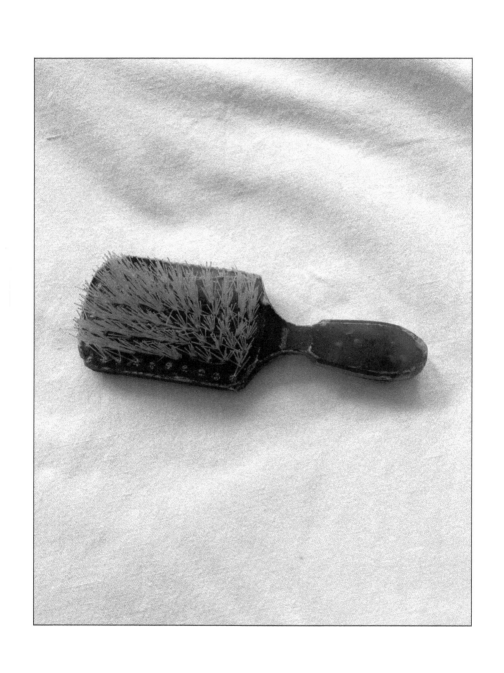

# Abject

When I was in my twenties, I began to realise that the link between objects and loss existed most acutely for me in things that some might consider disgusting, things marked by someone else's bodiliness. I remember the singlet of Jean-Pierre, a close friend for a brief, brilliant moment; a charismatic, flirtatious, ostentatiously camp man, a scholar of the Middle East. Jean-Pierre was a man charming in his extroversion yet harbouring something shy and discreet behind his flamboyance. His translucent blue eyes were disarming and almost childish in their candour, and there was a coyness in the way he raised his long-lashed lids to look at you.

I remember standing in the bathroom of his flat in the nineteenth arrondissement of Paris, crushing this singlet to my face, inhaling in its soft folds his scent of after-shave, cardamom, sweat. This was 1990. He had left scraps of his life in mid-flow. I was staying in that flat with J, who was still my husband then, as Jean-Pierre lay dying of AIDS at the Pitié-Salpêtrière Hospital in the thirteenth arrondissement. I remember the friend who gave us the keys, a soft-spoken, dark-haired young man wearing wire-rimmed glasses.

On our last day, masked and swathed in hospital gowns, we went to kiss Jean-Pierre goodbye, one at a time, each holding his delicate, waxy hand when he was already beyond our reach.

I realised then that items like Jean-Pierre's singlet—things that had once known physical contiguity with a person's body—had always intrigued me. I summoned examples. My paternal grandmother had a long stream of hair that had once been auburn like mine, but that faded and thinned over the years as mine has, in fact, also faded and thinned now that I am the age of a grandmother. When I was five or six, I would watch as she wound the long, wiry strands into a bun, securing them with hairpins that I would sometimes steal and press into my own scalp,

 https://doi.org/10.11647/OBP.0285.04

hankering for hair long enough to sweep into an elegant, grownup chignon. Later, perhaps aged ten or eleven and possessed of that substantial ponytail, I loved the lipsticks and eyeshadows my mother used. I now fancy this was not only because of their pearly colours, but also because they were messy with use, distinctly bearing the physical impression of my mother's touch. As I write this, I can see her small hands, their lacquered orange nails to which the word *manicure* adheres. Clandestine application of make-up and nail varnish in her bathroom meant I would not only get close to my mother, but also *be* her; could inhabit her adult life with all its secrets. And then there were my siblings' clothes, first my brother, then my sister. Lying on the bathroom floor like doll's attire, sticky with food or paint or mud, they were miracles of miniaturisation: had I, too, once been that tiny? These clothes actually fitted those animated beings that stole my thunder, creatures to whom I could minister in mummy-mimicry, or whom I could patronise, with my extra years for leverage.

I developed something of an obsession with such mundane, unclean objects. They were evidence of the physicality of living beings. And once such an object survived beyond the confines of a life, or outside of the palpable presence of its owner, it became a poignant reminder both of the ordinariness and of the singularity of lives lived. I remember the feeling I got when looking at the arm of a sofa left exquisitely unpicked and artfully threadbare by Ginger-the-cat's energetic scratching, after my mother had him *taken back* to wherever cats get returned to. Those threads filled me with something worse than sorrow: a terror at the randomness of power. If the scratching post of the middle-class cats of today had by then already enjoyed its advent, my parents were innocent of that knowledge. Until the sofa was reupholstered, its distressed arm remained a domestic monument to the arbitrary edicts of the powerful.

By the mid-1980s, when I began considering myself something of a serious person, or at least an earnest reader of theoretical texts, J shared with me his discovery of Julia Kristeva's book *The Powers of Horror* (1980). I open this book now and I see J's name scrawled across the frontispiece in pencil, and the date 1983. Clearly this is one of the books I kept after we divorced a decade later. Its subtitle is *An Essay on Abjection*.

The idea of the abject came into focus for me, and for many others of my generation, in this period—the early 1980s—as a category in which earlier notions of social liminality were explored in terms of the

individual body. In *Purity and Danger* (1966), social anthropologist Mary Douglas had spoken of the ways in which all social borderlines and interstices are fraught with danger. Kristeva's exploration of the abject takes up Douglas category of impurity as matter out of place, within the context of lived, personal bodies. Kristeva troubles the coherence of the social body by probing the physical boundary of the individual body, and in doing so, queries the very definition of self. I wonder, now, how such a theory holds up in the face of the feminist new materialisms that seek to undo the old impregnable borders between humans and the world surrounding them.

The separation on which Kristeva focusses is especially violent around childbirth, where *me* and *not-me*, once merged, are corporeally uncoupled. For Kristeva, the abject describes that division: it is bloody, the wound and the trauma, the border that encroaches, the outline that is breached, the stain. But the abject is also metaphorically transported into the realm of feeling, especially around breaches, abandonment and the end of love. Then, it is your supplication that is abject.

Its original event in childbirth stages the person's first narcissistic crisis, since the precarious emergence of subjectivity takes place as a struggle between an entity that is not yet a subject, and a mother who, for that child, is not yet an object. That mother, in eventually being rejected—pushed away, repelled—will also, Kristeva tells us, remain the original source of abjection, the instigator of an older child's spasm of disgust, considering that body that is at once desired and disgusting.

If the arena in which abjection is most nakedly, most existentially played out is in the relationship between mother and infant, the abject has been more broadly linked to things (or sometimes, to unformed not-quite-things) that transition between the body and the non-body, especially—viscerally—bodily fluids. The real place of the abject is at the point of annihilation, where your body comes into being or shucks off being, 'the pink place,' as Dodie Bellamy calls it, where you lose yourself in another body with its liquids and slime and orifices, lose yourself in your desire to be consumed and dissolved; and eventually—finally— lose yourself in non being again. Its signifiers exist in those things that transition between bodies, those places that separate bodies or break to pull them apart or together; but also in things that remind the living body of the corpse-to-be.

For artists, the abject has been associated with objects that cross the threshold of the body, and in this way obscure the separation between interiority and exteriority. Think of Tracey Emin's infamous installation *My Bed* (1998): worn slippers and a soiled, fluffy toy; cigarette stubs; remainders of food; tampons; used condoms and knickers lie in disarray beside a bed that has been—following these narrative pointers— vigorously played in, but that has also been the site of insomnia and distress. We also see the abject in Emin's later, visceral drawings, expressions of love's ending.

I am amazed and humbled when I see her drawings at an exhibition of Emin's works alongside those of Edvard Munch's at the Tate Gallery in 2021. Emin exposes the way, when a person is in love, boundaries tear open, the ego dissolving and merging so dangerously with another... till you come to your senses—or lose them; the overwhelmed feeling of abjection and humiliation in being spurned or ditched and its attendant bargaining or pleading; rage and dissolution in spilled or scratched reds and fleshy pinks. And the titles! *I Wanted You to Come All Over Me*; *Because You Kept Touching Me*...

If blood, excrement, semen, nail parings and hair are the boundary-crossing materials that signal the abject in the work of late twentieth-century artists (I am thinking of Robert Gober, Paul McCarthy and Kiki Smith, who probe liminality and abjection within the sphere of intimacy), other artists use toys to that effect. Human and animal dolls, with their weirdly simulacral realism, their uncannily mimetic qualities, appear to straddle the unbreachable division between the living and the unliving. In the works of artists such as Maurizio Cattelan, Cindy Sherman, Mike Kelley or Annette Messager, toys draw me in while at the same time making me feel uncomfortable, repelled. This is especially the case with the more overtly mimetic toys that, separated from the arena of play, so keenly appear to invite defilement or violence.

Yet with this discomfort comes a kind of fascination that creeps towards tenderness: haven't we all loved a teddy bear, a plush rabbit, a cloth baby?

Tenderness, for me, is the most seductive aspect of the abject. I feel such softness and anticipation in the hope that I might find a tiny thread of hair—an infinitesimal bodily remnant of my father, now forty years dead—in his hairbrush, which I have kept all these years.

# My Father's Hairbrush

My father's hairbrush seems smaller than I remember it. In my hand, it feels lighter, too. Like a jewel, its home is a calico pouch where it nestles, secured by a drawstring. After burrowing so long out of sight, it looks both familiar and strange. I don't remember a time when my father brushed his hair with anything else. In 1981, when chemotherapy made such styling redundant, this brush hung around the bathroom cabinet with my mother's long-tailed teasing comb, the two cohabiting like a quarrelsome, long-married couple.

I remember this brush in use. I see my father's face turned at an angle to the mirror as he flattens the wide waves of his hair. I see his hair's auburn gleam all but turned to brown, then to dun. I remember the oval tin of Yardley pomade, with its lavender fragrance, in the bathroom cabinet, one thing leading to another as I respond nimbly to cues from my eye, my mind's eye, my mind's nose too. As a child, I would lift the brush to the light, fascinated by the way its burgundy body would be transformed into a block of translucent amber or a huge lozenge. Its extruded, moulded plastic surface seemed to me to have been sucked and licked to smoothness. All its bevelled edges are now scuffed and chewed, as though one of my dogs had had his way with it. On its outer rows, the brush is as bald as a stressed hedgehog. The remaining bristles are crooked and yellowed, pointing every which way like bad teeth.

Objects I associate with my father found new homes in the weeks after his death. He was buried in his *tallit*, the fringed white prayer shawl used by Jewish men. Its significance is slightly obscure but lies in part in the numerical value of its fringes, reminding Jewish men of the central doctrines of the Torah. I think the *tallit* reminds Jewish men of their fathers too, of lineage and family; not so much a fringe as a temporal thread, back and back. Dad's *yarmulke*, his *tefillin*, his blue silk *tallit* bag, the *Kiddush* cup—a goblet used to bless the wine on the Sabbath and at other significant rituals—also go to my brother; Judaism is not unusual in being a patriarchal religion.

Other manly objects of consensual value moved down the male line: a fob watch, two wristwatches, gold cufflinks. My mother kept my father's wedding band. J received a gift too, but I cannot remember what it was, possibly a watch; my father owned several. I could ask J—my

first husband—now, but embarrassment restrains me. Would he, for a moment, imagine I might be making a claim on that object? We are affectionate and irascible with each other now; still locked in a game of provocation and annoyance, but still significant in each other's lives.

With my mother's death over three decades after my father's, I inherited two rings and a gold pendant I never wanted to wear. My sister inherited jewellery too. Such gender-biased distribution of booty happens in families, of course: fathers leaving meaning-drenched items to sons, mothers to daughters. Lineage and legacy along sex lines. There is something aspirational and discomfiting about such bequests: their passage from one generation to the next can be a gesture imbued with more symbolism than feeling. And in the exclusions they necessarily entail—I receive this, you receive that—they readily become the instruments of unspoken or deflected disappointment, anger, rivalry.

My mother's rings fill me with wistfulness, with longing. What especially touches me about them is not their style—reflecting my mother's preference for the modern (the idea of vintage or antique had little romance for her)—nor the precious stones they hold. What affects me is the very fact of their passage from her to me. The way their tiny circumference, which I had to have enlarged to fit my hands, reminds me how delicate her hands were, how small.

My father's hairbrush is physical in its address; intimate, private. It asks not to be seen.

I removed it from my parents' bathroom cabinet in their flat in Johannesburg when helping my mother clear away my father's possessions. I kept it, together with his Seven Star diary containing only ten pages from an insert dated 1966, in which Dad noted appointments around his own father's funeral. Reading these notes, I am moved by how spare they are, by my father's beautiful, backward slanting script, by the blurred memory of his father, my grandfather: a frail, softly spoken man with a shiny head and deep-set eyes. I also kept—I am a little ashamed to confess this—my father's dentures, set in a shiny, youthfully pink, gummy, death-defying grin. It seemed natural to me, even back then, to want to keep such a misprised prosthesis, something that, like his words, like his breath, like his kisses, had lived inside my father's mouth. A daughter does not often think of a father's mouth.

The dentures speak to me of the time when, addled with the effects of metastases in his brain, my father managed to extract—with a tweak of his feeble index finger and thumb—an actual tooth that had clearly already been loose in his jaw. The doctor had asked him to remove his dentures because of an infection in his mouth; after removing the tooth itself, he looked up with watery, confused eyes. Under the downy whisps of chemo hair, our father's head had become a skull, austere and ancestral. Still, my brother and I knew that if we looked at each other, we would not be able to stop ourselves from falling about in hiccoughs of uncontrolled laughter: we were highly strung with the anticipation of death. That same day, emaciated and delirious, destined soon to be a shade, our father had called for his father, whom he would shortly join.

I know that I wanted such things (the hairbrush, the all-but-empty diary, the dentures) more than the cut-glass paper weight or the Jaeger LeCoultre desk clock: the showy gifts he received after years of service as General Manager at Trutone Records in Johannesburg. These offerings seemed, at the time, more like jibes, in no way matching my father's devotion, his loyalty, his hard work, his inability to climb further up the greasy pole.

I love this brush now, in part, for the fact of my having kept it for so long, for its having-beenness. For its oldness, the use to which it was once put. I love it for its ordinariness. And its readiness, established years before I took possession of it, for the dustbin. That readiness— the point at which a utilitarian object loses its functionality—pokes my attention: the fact that this brush has serendipitously escaped the fate of trash, remaining intact, but useless. 'Why don't I just throw it away?' asks the diarist narrator of Heidi Julavits' engaging diary/memoir/ novel *The Folded Clock* (2015). She is thinking about a ring that seems jinxed. Instead of discarding it, she wraps it in black paper, then in tin foil and hides it in her wardrobe. 'I don't know why,' she says.

> For the same reason I could not, as a kid, throw away my broken lamp. One thinks a loved object is unique, unique to each human who loves it. But what is really unique is the unloved object. Or rather the unloved object confers uniqueness upon the person who fails time and again to love it and yet who still cannot throw it away.

The line between something repellent and something beautiful seems very fine to me, and it always tracks a route through the abject, enlisting a kind of delicate, precious repugnance.

The line between something loved and something unloved is similarly fine.

Perhaps that is why I have been so troubled each time I have had to participate in sorting the possessions of someone who has died. Being compelled to think of love and its opposite, its unmaking: the end of reciprocity.

Mostly, I keep this brush because it provides frank evidence of a past in which my father existed, in ordinariness, in everydayness; an item that would have been used without second thought, carelessly returned to its post in the bathroom cabinet, functional and boring. Now, it seems to me that his fingerprints are still on it, even as he has dwindled into remoteness.

My nephews and nieces were all born after he died.

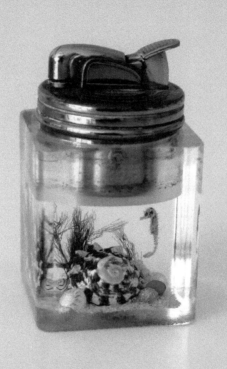

# Nature

The lighter is chunky. Within its cuboid, glassy body, it contains a tiny marine world. A sprinkling of pale sand with the glint of mica; a whooshing of seagrass; the nubble and opalescence of shells; a bright dollop of coral and—magically—a diminutive sea horse, perfectly suspended.

With its bronze duck head, its extravagantly implausible realism and its faint petrol odour, the lighter arrests time.

I love this object and I cannot remember a time in which it did not exist. It stands on a coffee table, just as it always did in the past; it glows amidst a small pile of books and several other objects, arranged in that casual combination of randomness and purpose that defines the contemporary, domestic still life. I am captivated by the simulacral world the lighter contains, a world in which nature is embalmed. But it is hard for me to tell if my captivation is current or if it is an entrenched remnant of childhood still lodged in me like a splinter.

The allure of the lighter resides in its combination of transparency, realism and miniaturisation. It is a fascination redoubled by the quality of a world arrested, preserved, as if in a snapshot. These are characteristics that the lighter shares with other transparent objects that both encapsulate and contain. I am thinking especially of snow globes and paperweights. In such objects, you might see—whittled and scaled down—a world preserved. As with snow globes and paper weights, the separate items inside the lighter are as untouchable as the moments captured in a photograph. Yet the lighter itself exists in order to be touched: without touch, it is not a lighter.

Snow globes and paperweights also exist in order to be touched.

A glass paperweight invites turning—we want to feel its weight and heft—while enlisting our amazement at the techniques of intricate filigree and *millefiori* wrought from brightly coloured glass canes;

 https://doi.org/10.11647/OBP.0285.05

molten crystal worked into extraordinary formations. The writer Colette collected paperweights, and after her, Truman Capote, who met Colette through Jean Cocteau. With the snow globe, there is a different kind of touch, the potential of animation through the agency to the viewer— the handler—a little like the activation of a ballerina, mobilised as soon as you open a musical jewellery box. When you shake a globe, all at once, the tiny, enshrined world is filled with a flurry of white, a spectacle of bluster and flux. But that brief resuscitation only throws the globe's state of de-animation—of stilled life—into sharper relief. The snowflakes settle, returning the objects in the globe to the condition of the photograph, a thing of sedentary focus, *nature morte.*

In his introduction to Walter Benjamin's *A Berlin Childhood around 1900* (2006), a book unpublished in Benjamin's lifetime, in which he brings to life the urban world of his childhood, Paul Szondi recounts how, as a child, Benjamin loved snow globes, a detail of his childhood as previously narrated by Theodor Adorno. Szondi sees these globes as reliquaries, sheltering and preserving something from the past: a scene, a moment coming to life, then dying down. He links those flashlit moments to the very structure of *A Berlin Childhood around 1900*, in which small scene-fragments accrue. These snapshots illuminate childhood, and with it, that hope in the past to which even the dead remain subject. And with the notion of past hope, the reader is presented with that most poignant of all conflations of projection and retrospection, premonition and knowledge.

But in that world of vitric arrest, time stands still, as if to shield those who view it from the inevitability of future decay. The sense of comfort produced by a miniature world retrieved from childhood—call it nostalgia—is infused simultaneously with sweetness and sorrow. That's of course no news to anyone. And sometimes, that sorrow stands for another, older sorrow. In *Citizen Kane,* the word *Rosebud*—an inscription on a child's sled fed to flames—is a signifier that gets transposed to another, later-acquired object, a snow-globe that Charles Foster Kane keeps, after destroying his wife's bedroom.

My table lighter must date to the 1940s or early 1950s. Butane was the principal source of fuel for cigarette lighters from the latter part of the 1940s, but lighter fetishists continued to love the distinctive odour of the older naphtha, which this lighter, with its saturated (now dried-out)

wick, exudes, at least in memory. Such storied table lighters are less common than the snow globes and paperweights to which I compare them, but mine is of course by no means unique: it is a mass-produced object, not one of individual craftsmanship. Googling *aquarium + table lighter,* I learn that Dunhill produced several so-called aquarium table lighters in the 1950s. The bodies are described by online antiquarians as being made of Lucite. Lucite, like Perspex or Plexiglass, is a brand name that has taken the place of the product name itself, the product being high quality, crystal-clear acrylic: polymethyl methacrylate. These Dunhill lighters are hand carved and painted in exquisite, art nouveau detail, with scenes of tropical fish and marine vegetation, and they fetch several thousand pounds at auction.

On Pinterest, I come across other, more geometric pieces dating from the 1970s, in which small objects—shells, insects, watch and clock parts—are held in acrylic resin. I also find, far more modestly priced, a tubular Perspex lighter and another hexagonal one, both presumed to date from the late 1940s or early 1950s, and both with contents that replicate those of my table lighter: sand, shell, miniature seahorse, starfish, coral and seagrass.

In its miniaturisation and realistic detail, this embalmed space is a perfect, artificial kingdom. That is the term—*artificial kingdom*—that Celeste Olalquiaga uses in her elaborate, baroque bid to describe and define the experience of kitsch. 'If the souvenir is the commodification of a remembrance,' Olalquiaga writes, 'kitsch is the commodification of the souvenir.' I am thinking again of the laquered castanets my mother bought in Madrid. And if, as Walter Benjamin has it, the commodity form is one that is (always) already permeated with sentimentality, with kitsch, we are at least twice removed from nature, stuck with fixed meanings, with consumable objects that present memory as always already pre-digested and pregiven. This lighter is to an aquarium what an aquarium is to the open sea.

Olalquiaga describes the domestic aquarium, along with pteridomania (the fad for collecting ferns), as a mid-nineteenth century mass phenomenon: the creation of an ostensibly organic scenario in miniature, one which enhanced but also reproduced the Victorian interior for which it was destined. In Victorian times, such aquariums encompassed 'the main aspects of modern popular culture, in particular

the inducement of visual pleasure through the scenographic images and the miniaturization proper to most souvenirs.' Olalquiaga compares the seabed and its deposit of marine life and forgotten shipwrecks to the human mind, the deep strata of the unconscious, 'here nacre, there emotion.' The seabed in an orb or block of resin works on several levels to invoke an inchoate intensity of feeling; its containment in glass or resin, and its miniaturisation offering an experience in which enchantment is coupled with a sense of mastery.

Since certain categories of kitsch—especially vintage kitsch—have become fashionable, it is hard not to see this lighter through an ironic, postmodern lens, or framed by at least one set of quotation marks. That postmodern prism accommodates and flattens out the differences between objects of high culture and those of mass or popular culture, especially if these have acquired a vintage patina through the passage of several decades. The adoption of *kitsch* as a term of affection is certainly opposed to its earlier uses in the time of high modernism (from the 1910s to the 1950s), a period which saw the growth of both mass culture and of what came to be known as the avant-garde. Kitsch is a by-product of mass production and was the term used to refer to aesthetic forms that aimed to please 'the masses' in opposition to the elite appeal of the art of the avant-garde.

Cultural theorist Sianne Ngai has suggested that in the age of social media, the adoption of certain new aesthetic categories such as *zany*, *cute* and *interesting*—categories of which *kitsch* is always a potential sub-category—reflects a world of speedy mass production and circulation and has become a way of processing the hyper-commodified, mass-produced, mass-mediated objects of late capitalism. This lighter is the product of new technologies in a similar context of heady and optimistic mass production: the utopianism that accompanied the invention of new materials in the mid-twentieth century, before anyone began thinking of the devastating effects of plastic pollution, which only began to be noticed by scientists carrying out plankton studies in the ocean in the 1960s and '70s. We are, of course, now well into the silent spring of plastic pollution.

The technology that made this lighter possible was the invention of Perspex (call it Plexiglass or Lucite), which occurred in the 1930s, the same decade that influential art critic Clement Greenberg wrote

his famous essay, 'The Avant-Garde and Kitsch' (1939). The aim of the avant-garde was to promote and defend purist aesthetic standards, while its opposite, kitsch, Greenberg proposes, is a cheapening or lowering of aesthetic standards brought about by consumerism. Kitsch, when associated with the nostalgia that was frequently present in the style of decoration of middle-class homes, might be considered a facile parody of the beauty in nature, offering the delivery of an already processed aesthetic effect. A little like sentimentality which offers pre-processed emotions, kitsch offers pre-digested beauty.

# Smoking

My parents loved smoking. My mother was a natural, an accomplished celebrant of the lighting up ritual. Even in old age when her hands shook uncontrollably, the practice was refined, almost liturgical. She knew the art of the long, easy intake and then the slow, insouciant exhalation, the plume curling out of her nostrils or the pursed valve of her coloured-in lips, her dark eyes narrowed. I do not recall in such pictorial detail my father's smoking, perhaps because he died so many years earlier. I am not sure why I never asked my mother when it was that she began smoking, since it played such an essential role in her life. My brother says he'd asked, and that both our parents smoked by their late teens, he in Palestine, she in China.

Many photographs of my young parents show them looking languorous, lit cigarette in hand. There they are, separately or together, seated or standing, returning the gaze of the camera lens, pausing between one drag and the next. Smoking made them interesting and alive. You never heard them saying: 'I do not want a cigarette,' as the unnamed narrator of Lesley Stern's *The Smoking Book* (1999) says, testing herself. Stern's memoir is at once a dissection of addiction and a paean to the sensuous pleasures of smoking. '*I do not want a cigarette.*/ To say this is terrifying. It is tantamount to saying: "I do not want."/To not-want: this is to be dead, or if not dead, then boring. Dead boring.' In the same vein, novelist and critic Gabriel Josipovici laments his dry throat and bloated tongue, but, he writes, 'whenever I try to imagine a life without cigarettes, without *any* cigarettes, *ever*, I realise it is a life I do not want.'

I think my siblings and I took our parents' smoking habit as a fact of nature. I feel a thrill of recognition reading, in *Nicotine* (2011)—Gregor Hens' terse memoir as the account of an addiction—that when he was three or four years old, he thought that smoking was his father's actual job. I would have been forgiven for thinking the same about either of my parents, except that worrying about their income constituted such a regular point of conversation and argument in our home that I knew by osmosis about my father's jobs and how, at least as far as my mother was concerned, he never earned enough. I knew, too, about my mother's jobs, mostly as a legal secretary. She made some good friends in those offices, and I associate her at her most efficient and friendly and normal with that environment.

For both my parents, smoking signalled a pause, an interruption in the flow of certain activities, or their cessation: eating was the most obvious example, but there were others, such as cooking for my mother— she was resourceful and efficient in the kitchen—or fiddling with tiny tweezers, a magnifying glass and old stamps on a neat bed of green baize for my father. Then, the lighting of the cigarette. And of course, I still cringe to think of my parents—in both of whom I saw qualities that other grown-ups must have considered quite sexy—lighting up after intercourse.

My father smoked while working, but as far as I know, my mother did not, neither did she use smoking to launch or celebrate an activity. This is something that various writers and artists have done—have performed—not least for the camera, turning into a moment of theatre the need for the abrasive vapour and the quick hit, jump starting the creative process, the mind wired and alert. The first images that come to mind are of male artists and writers whose persona leans heavily on the idea of a possibly charismatic, phallic machismo: Picasso, Jackson Pollock, Ernest Hemingway. Streaming in after these associations are mental images (confirmed by, or compared with, those thrown up by Google) of writers posing with cigarettes, as though momentarily disrupted from a steady flow of profound thought: Albert Camus, Samuel Beckett, Dylan Thomas. But not only men, not by a long shot: Virginia Woolf, Susan Sontag, Joan Didion and Clarice Lispector, all glacial. Patricia Highsmith. Fran Lebowitz, never without a cigarette. Ingeborg Bachmann, who died in a fire probably caused by her own

cigarette. And Jenny Diski, who wrote about smoking and died of it. I regret not having bought her quirky and beautiful book, *Stranger on a Train* (2002), with its evocative and meandering subtitle, *Daydreaming and Smoking Around America with Interruptions*, as a gift for my mother. I wonder now if my mother would have experienced a certain resistance in identifying with that narrator: a person for whom the point of a train journey was to puff away in the smoking carriage, the comfort of it as well as the relaxed, random social interaction among people previously unknown to one another, thrown together in an enclosed space by a shared practice. The fact that the practice became increasingly socially maligned was, for my mother, entirely irrelevant. I think she enjoyed those stuffy, hazy boxes into which—was it in the 1990s—smokers were banished, before even those facilities were banned from restaurants and hotel lobbies and airports.

So many images of smoking in photographs, in movies, in books. I want to excavate along this seam... Why do so, other than for the gratification afforded by taxonomy, for the pleasure of always connecting? But that, for me, has always been a satisfaction worth pursuing. My mind rattles along this track, knowing I shall return to it; first, I am alert to images of smoking in whatever I happen to be reading, then I hunt down things to read *because* they contain images or descriptions of smoking, paeans to it. And so, musing on my mother's smoking, recollecting how vehement she was in her desire not to give up, how she loved nothing more than a long hard draw after the first sip of morning coffee, I think of Fran Lebowitz, who describes smoking as her hobby and wonders, on visiting Seattle—one of the first cities in the USA to ban smoking—why you can find coffee twenty-four hours a day: 'I couldn't understand,' she muses, 'what was this coffee for?'

I also find a wonderful description of smoking in Elizabeth Hardwick's peerless novel-essay-memoir *Sleepless Nights* (1979), in which a character called Louisa is described as spending the entire day in a 'blue, limpid boredom.' All the characters in *Sleepless Nights,* etched in Hardwick's incisive, startling prose, drift into view, and then out of it again. They remain brighly lit and in focus for a few pages, but then we never see them again. Louisa uses cigarettes as a supplement to her boredom (an *addition* is the word that Hardwick uses). The boredom itself is described first as a narcotic, then as a 'large friendly intimate.'

Reading this section prompts me to wonder whether, for my mother, smoking was an accessory to ennui, and whether ennui itself was the real addictive substance. But her habit was not a jovial intimate. Rather, it was a demon made of frustration. More than a contribution to the opiate of boredom, I think it was the repetitive, ritualised aspect of smoking that my mother craved.

This is not to suggest that the tarry taste of nicotine and the hit were not in themselves lifelong incentives to her. But the gestural and cyclical nature of smoking—its repeated solicitations to begin again, hand lifted to lips; to inhale at a particular pace and rhythm—served as a kind of numbing reassurance that time wasn't really passing. From start to finish, the ritual had its rhetoric, its dramatisation and duration: first the promising crackle of cellophane and the peeling of foil, then the light smack of the unlit tip on a flat surface, and finally that same tip teetering and smouldering atop the diminishing shaft. And then the almost violent stubbing out, the ashtray filling with acrid butts.

When smoking became unfashionable and then downright frowned upon and prohibited, my mother continued to sneak fags into the bathrooms of public places, stepping out nonchalantly several minutes later, reeking and lying.

Knowing what is generally known today about passive smoking, about addiction *in utero*, about the effects on children of sitting in cars filled with the haze of their parents' habit, I am surprised that my siblings and I are not smokers. My brother smoked for a short while, my sister never. I managed around five or six a day through the decade or so spanning between, and including, two intense love affairs with men who belonged to other women, while I was between marriages, thus frittering away the time I might have been having babies or working harder at what others called my career. The smoking, especially with A in Lisbon, was also very much part of erotic play, since when I was with him, I never lit up on my own, preferring, Lauren Bacall-like, to put to my lips those *cigarros* that had been in his mouth, held and lit between his lips. During both those affairs, with R and with A, cigarettes also served as accomplices to solitary, agitated mooching. Waiting time. The time of someone else's predictable, endless lateness.

Nowadays, on very rare occasions, I cadge a cigarette at a party from someone who is enjoying gasping in that corrosive stuff with the frosty

night air. My last partner, P, who walked out of my life at the start of the second lockdown in 2020, witnessed this once outside a restaurant in Munich and I could see he found it a turn on. I knew it was really all about the hand gesture and the self-consciously smouldering look I gave him. I knew how much he would have hated being continuously assailed by the stale, burned odour that he associated with his mother and all her yellowed possessions.

On those rare occasions that I do light up, although the hit immediately makes my head spin and causes gall to fill my mouth, I know that if I had cigarettes at home, I would smoke them despite hating the taste and the aftertaste. I suspect that, without actually smoking, I have the personality of a smoker, a characteristic that Gregor Hens describes in his account of kicking the habit, for which immersing himself in the Feldenkrais Method was galvanising.

As I have said, I never heard either of my parents speak of giving up smoking. Never. Not for them the teasing, Sisyphean challenge of the last cigarette, an allegory that has enjoyed sublimely droll moments in fiction and memoirs alike. I am thinking of David Sedaris smoking his last cigarette three times in a bar at Charles de Gaulle airport; of Simon Gray smoking himself to death; but, also, of the hapless character Tom Brodzinski in Will Self's postmodern-postcolonial satire *The Butt* (2010). Tom flicks the smouldering butt of his last cigarette off the balcony of his holiday apartment, and it lands on the head of an ancient geezer on the floor below. Tom suffers *ad absurdum*—indeed he is the butt of— the moral and bureaucratic consequences of his action as the dark and hilarious plot unfurls. This all takes place in an unnamed country that is a lot like Australia, in which the rule of 'Anglo law' tussles with varied tribal customs. Lawlessness and pernickety legalism come face to face in Tom's journey to the heart of the country to make reparations to the tribe offended by the butt in question. Rather than romanticising local tribal customs, that act of reparation itself turns out to be a ruse thought up by a diabolical, Kurtz-like social anthropologist and his offspring, who, with shamanic perversity, turn out to have invented all the local customs. The literary resonances here are multiple and thrillingly enlist the knowing reader to crow: Kafka meets Conrad meets Graham Greene meets William Boyd meets Paul Bowles. With a liberal smattering of Evelyn Waugh.

The most celebrated performance of the ritual of the last cigarette is that of Italo Svevo's character, Zeno, repeatedly announcing his decision to give up to his psychoanalyst, and just as often reneging. As a student, Zeno had to repaper his room, having covered it with jottings of the dates of every single last cigarette. He speaks of the 'last cigarette' as the emblem of his desire both for activity and for 'calm, clear, sober thought.' And he understands that smoking has something to do with time:

> You strike a noble attitude and say: 'Never again!' But what becomes of the attitude if you keep your word? You can only preserve it if you keep on renewing your resolution. And then Time, for me, is not that unimaginable thing that never stops. For me, but only for me, it comes again.

For Zeno, last cigarettes have a taste all of their own. With self-delusion given free rein, Zeno's confessions bring to light the ways in which dependency curtails freedom. As Will Self pithily puts it in his excellent introduction to Gregor Hens' memoir, *The Confessions of Zeno* (1923) is a 'minatory portrait of the way habit crimps the psyche.' The reiterative performance of 'the last cigarette' is the trope that hyperbolises the enslaving effects of all habit.

My father was known to have two cigarettes on the go simultaneously, one in hand, the other with its long, heavy excrescence of ash, glowing on the lip of a heavy, jaundiced ashtray. But that never led him—as it had led Gregor Hens' father—to the thought that the habit had got out of control. The lung cancer of which he was to die at fifty-five was surely that alarm gong come too late, and it served as no such warning to my mother. I do not think she submitted to the truism that all smokers lie: she seemed proud of the addiction. She never regarded her smoking habit as a form of enslavement: she wasn't a political being and didn't express her concerns in terms of freedom.

Rather, for her, smoking blended the idea of permissible pleasure—it was certainly that when she was young—with the no lesser pleasure of annoying other people. A cigarette was something she could readily weaponise in the various threats she practiced, not least, that of doing herself in. Yes, she would give up the ghost rather than give up smoking. For the three decades that she survived my father, she dramatised her widow's grief—an acting-out of what were, initially, real feelings of

bewilderment and loss—by declaring her desire to join him. Smoking would help. She loved flirting with the association of smoking with death. With a smirk, she would ask to be buried, when the time came, with a pack of Kents so that she might continue to smoke in the hereafter.

# Lighter

The marine table lighter had been decorative rather than functional for some time before it came into my possession: probably the naphtha had dried up, the wick worn down. Together with a chunky, orange and brown ceramic ashtray dating from the 1970s and the grainy colour photograph of my father beaming, also from the 1970s, it was a secular shrine, the commemoration of a smoker's life.

In arresting time and encapsulating pastness, the object of nostalgia also serves as a memento mori, impelling us to consider our timeline, our brevity. But for Celeste Olalquiaga, the hermit crab embalmed in a glass orb stands not only for the immobilising power of death but also for an imaginative capability, the reversal of time's sagittal propulsion. It stands for what she describes as 'the slow intensity of amazement' that is entailed in bringing all dead objects back to life. Rebirth via artefact. This notion is of course not unique to the marine table lighter. I am struck by how simply the act of paying close attention to an object performs such a revival. In its resuscitation, the examined object becomes newly and differently available to thought, to connections, to association, to affect.

The first memories I have of this lighter are from early in my childhood, before we left Israel, just short of my eighth birthday. Our flat was on Weizmann Street, south of Bnei Dan Street in Tel Aviv, and a very short walk from the Yarkon River. On its banks in this part of town, there is a wooded park where my brother and I would sometimes play in the stippled shade. I don't remember who would take us there, I presume sometimes our mother, sometimes our grandmother

I can see us at this time and in this place: Tel Aviv in the early 1960s. Our flat is in a compact, white, modernist block with a patch of lawn in front, a small date palm planted in the centre. The architecture is typical Tel Aviv, with its Bauhaus legacy. The early buildings of the modern city were designed by German Jewish architects who immigrated there, but later ones like this (dating, I would guess, from the late 1940s or early

1950s) boasted a similar geometric style. In the 1960s and 70s, balconies were frequently—some have said too frequently, obsessively—closed in with plastic shutters on aluminium frames, submitting to a social pressure to extend the privacy of limited interior spaces. By 1960, some of our neighbours had installed an earlier system of asbestos shutter: I remember the heavy, wide slats positioned vertically, and angled in such a way as to close completely or to allow in some light and air. They were widely known by their brand name, Trisol, first manufactured in 1957. Our upstairs and next-door neighbours had them by the time we emigrated to South Africa in November 1962. But our balcony, as far as I remember, remained open to the elements throughout this time. My parents were pretty skint.

My brother and I shared the bedroom that gave onto this balcony; my parents slept in the living room that also had a door leading to the balcony, where we ate on those thrumming summer evenings; the memory of those evenings is now entirely wrapped, for me, in the gossamer of nostalgia. In the living room, a sofa bed, two armchairs, a coffee table, the upright piano, a large radio. Though they were not native Israelis, like most Israelis, my parents' preferred style was 'modern,' not 'traditional.' The whole ethos of Israel was opposed to the styles of the old country, of back then. The sofa was mid-century, clean lines and upholstered in a black and yellow fabric. On the coffee table, cigarettes and that lighter with its fascinating, suffocated seascape.

The lighter travelled with my parents from Tel Aviv to Johannesburg in 1962. In late March 2012, after my mother's death, its companions on the journey to my home in England included a stash of photographs from a cardboard box at the foot of my mother's bed; a small, red leather jewellery box filled with many pairs of inexpensive, gleaming clip-on earrings and other gewgaws; and that plastic laundry carousel with her underwear still attached to it. The carousel still hangs—shaming, unnerving—in my studio, repeatedly nudging me to decide upon its fate. The table lighter, however, is smugly sure of its fate: it stays with me. How could I do anything but keep such a strange, compelling object?

Small enough to pocket, more than the smell of naphtha, the lighter emits the ineradicable odour of childhood. The marine world it contains still exercises upon me the powerful, coercive attraction of *multum in parvo*: the sense of dominion won through the visual possession

of a world writ small. Such a teeny quotation of the real world tests the relationship between scale and meaning. There is no mimetic representation, just the actual presentation of something made strange by its scale and context. As a miniature *tableau vivant*, this lighter is not so much an image of vitality as its opposite: fossilised, mortified. Serving simultaneously to signal life and life's arrest, it is uncannily like a photograph, since photography too has played across that same vital boundary. Photography too dances around a line that both separates life from death and brings them closer together.

The lighter immerses me in the flickering, adjourned time of reverie. Like the temporality of the unconscious, reverie occupies an endless present tense. This too is the tense of free association, of associative thinking. And so, I see it in my mind's eye, occupying its place in my parents' several homes in Johannesburg, always on that coffee table. Near it, there is a wooden box holding cigarettes. The box has a tin intaglio copy of Rembrandt's *Night Watch* (1642) on its lid, and so, true to the contiguities that free association fosters, the lighter now also makes me think of Rembrandt.

Each time I encounter it—in other words, when I pay attention to it—this lighter instigates a particular episode of time travel. Into this temporal bubble, Theo and Fay float; both young, healthy. My father was to die of smoking twenty years later in Johannesburg, but in Tel Aviv, in the summer of 1962, smoking is still glam. I am transported to the time I run round and round the palm tree in the garden and step straight into a ground nest of bees, piercing the close late afternoon air with my screams. My father is still at work. My mother rushes to see what's wrong and helps me up the two flights of stairs to our flat. She removes the sting from my foot with her eyebrow tweezers and rubs the swelling with honey. 'This works,' she says, exercising her witchy, maternal brand of homeopathy. I feel cared for.

When, over five decades later, I write an email to my brother about this day, which I know he remembers since we've recollected it in mirth over the years, he replies: *Your bee sting was recognised as being a national medical emergency on that day.*

My mother has me lean into the deck chair on the balcony, my leg elevated and swathed in a turban of bandages, creating, if nothing else, an effect of analgesia. She brings me a tumbler of iced juice that

I sip slowly, watching the darkening world go by in the space sliced by balcony rails. She's inside the flat and I'm out, and I hear the clink-clink of ice in her tumbler and the clang of a whisky bottle and a quick blast of soda from the syphon, then a glug, and the clack of glass on table. I can almost hear these sound effects now, detect them as the work of a Foley artist for a movie, the movie of my life. Then the visuals come into focus. My mother steps back onto the balcony, a cigarette held loosely in one nonchalant hand, the marine lighter in the other. Click click. Then click again. Though in his email, my brother has also written *that lighter never worked*, I clearly remember the flame flaring blue, illuminating my mother's nose and mouth scarily.

She takes a deep drag and then exhales a slow, steady stream of white.

*You'll be fine tomorrow*, she says.

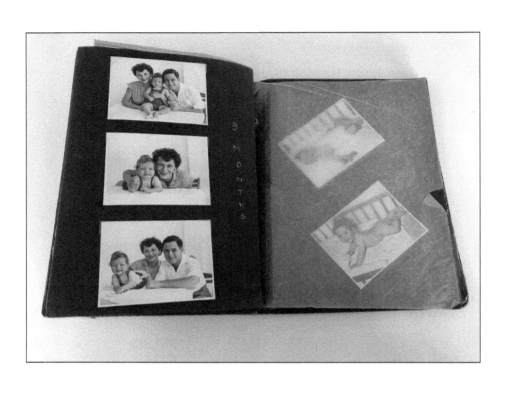

# Album

I'm looking at an album, card-bound, with felty black pages fading at the edges. Black and white—or sometimes sepia and ivory—photographs are tucked into brittle photo corners. The album cover is a soft, pale brown, lightly embossed, with a small, circular excision for an inset photograph, which has been lost. Because we live in Israel and this is an Israeli photograph album, the chronology moves, like the Hebrew alphabet, from right to left. Dating from the first two years of my life, the images exude parental excitement, delight at my very existence: a first child. On each page, my father's perfect script in white ink memorialises, in English rather than Hebrew, the day, the time, the event of *me*.

My childhood is a time that I generally examine in relation to my mother: her big personality, her moods, her self-involvement. Her famous legs, free of varicose veins, free of dimples or puckers. In my father's record keeping, however, I see a different kind of construction of that childhood, one in which my mother is adored; but also one in which I am centre-stage.

I am especially taken by a sequence of images covering four double spreads. They are purposefully arranged in twos and threes on the thick pages, and they span—absurdly to contemporary eyes, used to seeing grids of digital images captured within a single hour—a period of four months. Whatever is meant to be happening developmentally to a child between the ages of six and ten months—I could look it up, but I don't—it seems to be *all happening* for me. I look abundantly in possession of faculties and sensations, ready for call and response. Delight and displeasure too. I am in the thick of life. My hair is coiffed into a sprightly arrangement of curls with an avian crest, wild atop my head. I am solidly built, with huge eyes and curling toes and, damn it, rolls of flesh on my thighs. I am alert and engaged: whoever it is catching my attention—*look at the birdie!*—is doing a fine job.

     https://doi.org/10.11647/OBP.0285.06

Bizarrely, I recognise myself in these photographs: I identify with that baby, especially in the ones where hilarity gets the better of me.

When I look at this album dating from my early infancy, my attention oscillates between interest in the conventions deployed (down to the diagonal placing of photographs on the page) and the uniqueness of their subject: *me*. On the page that I have opened here, the family trio is at a table.

## Digression: My Parents

This is how my parents converged at this point. I am not one for genealogy websites, for visiting eroded sites of possible familial meaning. Although more than half my professional life has been in the field of art history, I do not have the makings of what I think of as a 'real' historian. And so, my parents' lives remain mostly unresearched. I have been a lazy custodian of the family archive. What I know: in the mid-1930s, my father's family escaped Riga, Latvia, where Dad—Theo—had been born in 1925. His father, Boris, had been one of ten siblings born in the last quarter of the nineteenth century in Liepāja, a city on the Baltic Sea, and the third largest in Latvia. Two of the siblings died in childhood, while a few eventually emigrated. Those who, with their families, remained in Latvia until the German invasion in 1941, perished under the Nazis. The brother who was to become most successful financially, Gutmann, and his wife Berta and their two children James and Eva, moved to London, establishing a lucrative veneer business in Shoreditch. Boris and Mary—my father's parents—decamped to Hadera, a small, dusty town in Palestine, approximately midway between Tel Aviv and Haifa, where Boris was the foreman of an orchard belonging to his brother, Gutmann.

All his life, my father regarded London as the seat of the good life. It epitomised the pleasures of refinement and an abundance of that incalculable attribute of prestige: *quality*. London, where my father failed to complete the degree that he began in aeronautical engineering in the second half of the 1940s, had become, by the time I was in existence, a mythical place for him, and then by extension, for me. The cornucopia of gifts he brought home from his visits, and the bequest of abstract gifts too, in the form of words like *Savoy, Aquascutum, Liberty, Stanley Gibbons,*

*Hamleys, Wheeler's of St James, Foyles,* reflected endeavour, longing, and the borrowed gleam of his cousin's affluence.

While my father's family arrived in Palestine in the mid-1930s on an early wave of Zionism—the term was not then perjorative as it is today—like many Russian Jews living in China, my mother Fusia (already in China, her name was sometimes anglicised as Fay) arrived in Israel in 1949. She was twenty-one. Harbin, where she was born, was a provincial capital in north-eastern China, famous for its frosty weather and Russian architectural legacy. Harbin is closer to the eastern reaches of Russia than it is to Beijing. But Fusia lived most of her young life in Tientsin (now Tianjin), another north-eastern city 130 kilometres south of what was then Peking. She spent the year before emigrating to Israel in Shanghai with her friend Rosa.

Shanghai was where Fusia had always yearned to be. Shanghai was an open city and had, at that time, offered refuge to Jews escaping the Nazis; the neighbourhood of Tilanquiao especially served as a safe haven for Jewish refugees. Fay's stories of the last few years spent in China, in Tientsin and then in Shanghai, were filled with the breathy excitement of picnics, glamorous parties and balls, the Jewish Club, as well as descriptions of occasional military drills and having to learn the Japanese national anthem, as though the war had been merely a thrilling backdrop. Most exhilarating of all the distractions for a popular, outgoing girl, had been the presence of the American marines, part of a large corps deployed to north-eastern China between 1945 and 1949 for Operation Beleaguer, whose mission was to repatriate the hundreds of thousands of Japanese and Koreans who had remained in the country after the end of World War II, while keeping the resident Americans safe.

These marines were handsome, tall boys whose accents reflected the movies my mother loved, and who surely fortified her already exuberant confidence, her sense—or at least, so I imagine it—of her own desirability. She used to gleefully describe the gifts of chocolates and flowers. And stockings to sheathe her fucking legs. Many small black and white photographs bundled into the box that my siblings and I would often rifle through, were of young men in uniform. In one, she is standing, radiant and slender in a floral dress, surrounded by three uniformed men. All are smiling, one has his arm around her shoulders.

Many of these photographs carry written messages on their verso side; I considered them mysterious and steamy when I first read them. They are signposts to a network of relationships forever buried. They confirm my mother's reputation, the alpha status that she used as salt for her daughters' wounds. I hardly understood her injury, since her places of hurt remained hidden by her flamboyance and exotic beauty. *Remember me is all I ask*, written on one photograph; *hoping to be back with you soon*, on another. And, most intriguingly and nauseatingly, *hot kiss from top of cold snow.*

She clearly loved a man in a uniform: my father was in the Israeli army when they met, introduced by a well-meaning friend of a friend. Although they were both fluent in other languages (my mother spoke Russian to her family and had a smattering of French, my father spoke Russian, German and Hebrew), English was usually the language in which they spoke with each other. I remember English and Hebrew at home in Israel, but my sister, born nine months after we moved to Johannesburg and living all her adult life in Israel, now speaking Hebrew fluently, was brought up in English.

My mother travelled to Israel possibly a little earlier than her parents, in 1949, precisely a year after David Ben Gurion proclaimed the establishment of the state. As a child, I had no sense of the vexed, pained history of the place; like most children, I was physically and ideologically located in a habitat that seemed natural and obvious and that incontestably belonged to me until I was made to leave it.

In Tel Aviv, Fay found a job as a secretary for the American company Trans World Airlines, which was in business from 1930 to 2001. It was at the office of TWA that, as a young divorcée, my mother awaited the arrival of my father for a blind date. My siblings and I had heard nothing about her first marriage and would have continued to be ignorant of it, had my brother not come across a document while helping my mother with admin and paperwork in the mid-1980s, after our father's death.

Theo arrived at the TWA office bearing two *Life* magazines, a gift I know Fay would have loved. I can imagine how dapper he must have looked: trim, mischievous and shy. He had a large, auburn moustache. My parents got married in Tel Aviv on Christmas Day, 1952. The bride did not wear white, and there doesn't seem to have been a party.

# Photographs

I am dressed in a pair of dungarees, and though the photographs are in black and white, I know the dungarees are red, with blue and white trimming. I don't know how I know this. My parents look impossibly young, good looking and insouciant, smiling in a posed way that gives nothing away, but I can't help thinking that they look genuinely happy. In the bottom photograph, my mother's fingers peep around the top of my father's white-clad shoulders: a detail that I notice now, would it be for the first time? It is certainly, for me, the punctum of that photo, the place through which the photograph reaches out and pierces me. And then: *we all have curly hair,* I think, looking at the familiar image this time round.

In all three photographs, I look unusually disgruntled. I say 'I,' but there is a disconnect between this aged self, writing now, and that small infant speechlessly negotiating boundaries with her parents. A disconnect, but also a continuity, created by repeated visits to the album over the years, so that the photograph itself lodges in my brain as a memory. In the picture in the middle of the page, I am held in place—there is the visible pressure of her hand on my shoulder—by my smiling mother, but clearly, I am on the verge of squalling.

I discern as entirely and recognisably mine the irritability that I see scribbled on the child's face.

I am interested in how, finally in the third image of the sequence, the infant breaks away from the desired pose—wedged between her parents in a perfect image of beatific triangulation—and expresses, instead, a wilful irascibility. Tearing away, she de-centres the image, introducing a dynamic diagonal into the composition, messing things up. She introduces noise, too, I can almost hear it. In that last photograph, my father is touching me, gently restraining, but I whine and pull away from both my parents. *Leave me alone.*

*You were teething then*, my mother always explained, as though to ensure I did not misinterpret my fretfulness. Words have cushioned the photograph and offered it to me in a particular way, in the way my mother wished me to see it. And indeed, I cannot look at this image now without the word *teething* popping into my head. *I was teething*.

Photograph albums are, after all, resources not only of visual events, but also of verbal ones.

Because of my interest in family photographs and documents and in what it means to keep records—my interest, in other words, in the technologies and practices that construct and narrate family memories—I have become the family archivist, partly conscripted, partly self-appointed. My brother and sister and their children expect, one day, to receive ordered, digital files containing all these images, all ephemera pertaining to our small group of kin. The task of scanning and sorting is, however, endless and daunting. I fail at it repeatedly. I change methodologies, technologies, forms of tagging, systems of storage. I save to hard drive, time machine, cloud. I think of the misleading metaphor of the cloud as the place that holds all my information. I winnow duplicates. I start again.

My need for order—I am constantly chasing it down rabbit holes—is as great as my sense of its encroaching opposite: randomness, unpredictability, chaos. To be obsessed with indices and tags and filing and keywords and systems is to acknowledge the messiness of experience, its obstinacy in eluding just those categories that we use to contain and frame it. And then there is this: clearly, if you think about it, you know that a photograph is more a thing *made* than a thing *taken*, an artefact and a fiction. Yet still, to be obsessed with photographs as records is to recognise the special status of photography among all the technologies of image production. That status originates in the imagination and technologies that brought photography into being in the nineteenth century: the capture and fixing, through the medium of light, of something fleetingly out there—seemingly empirical—onto a chemically prepared, photosensitive surface.

Regarded as a photochemical trace of something that once existed in the world, photography enjoys a special relationship with place, with things and with time. Photographs have been, and continue to be recruited as evidence, as proof of what has been and gone. Michelangelo Antonioni's celebrated film *Blow Up* (1967) hyperbolises this notion and vexes it, leaving the viewer in doubt as to whether the photograph in question, enlarged into granulated, pointillistic eddies of dots, confirms the occurrence of a murder. At the heart of the blow up, nothing is

visible. The film invites us to probe our deeply held belief in the truth-value of photographs.

Of all the evocative objects that people keep, photographs are the most cherished. They have become our quintessential memory objects. In the so-called developed world, most of our images are held and circulated digitally.

As material objects, however, photographs continue to carry a weight in excess of their frail materiality. We might find them in boxes, in envelopes, in bags, in lockets; framed and displayed on desks and mantelpieces; pinned on walls or arranged in albums; held singly in wallets or bags or pockets. Muhammed Muheisen's *Memories of Syria* and Adi Safri's *Home and Away* (ca. 2015–2017) are photographic projects illustrating how important actual, material photographs are to people who have lost everything else. Those photographs serve as testimonials to lives lived, links lost. Photographs ratify the past, as though in them, memory itself were lodged and embodied.

And yet, what sort of memory object is a photograph?

Although photographs serve as prompts, their static nature (particularly in the posed photographs that were the norm before cameras were more portable and shutter speeds quicker) represses or occludes much of what constitutes a remembered person or scene. A fugitive expression, an idiosyncratic gesture, the timbre of a voice, a particular tactile pressure, the smell of cloth or skin or breath, the air whipping the hair about her head and causing his shirt to billow, the sound of a step, the little tick at the corner of your eye when you feel observed, turns of phrase: few of these make it into a photograph. Roland Barthes finds that he can only pinpoint the fugitive resemblance of his recently deceased mother in an image of her as he never actually knew her, a photograph that long predates his birth. Captured in 1898 in what Barthes calls a winter garden (in photographic theory *the winter-garden photograph* no longer requires the name of Barthes to be recognised as a signifier), when his mother Henriette was five years old, the photograph reveals to Barthes a recognisable image of the essence of his mother. This suggests that in the ways that a photograph activates you, its viewer—in its capacity to work you up—it is capable of replacing the inert certainties of history with a thrill of fleeting sensation.

I have, similarly, found something poignantly recognisable in photographs of my parents as children, and indeed, of myself as a child, in the occasional image that breaks out of the familiarity established by the ensemble of photographs contained in the album or box, knocking down the walls of viewing habits that I have formed in relation to a finite set of images, seen many times over. Mostly, I know myself in childhood from these frozen tableaux in which I have been enshrined; but not only from these static tableaux, also from the word-textures woven around them.

It is as though a photograph—and especially one I have looked at many times—gave me the past as always-already *déjà vu*, but occasionally, one of these photographs will reach out to grab me, tantalising me with the promise of something new.

## Photograph Album

Analogue photographs—photographs made using a technology that preserves a photochemical trace—were imbued with a past tense that transformed them into the perfect vehicles for nostalgia: a longing for a past that never existed in that crystallised form, but that came to be remembered through that form. Once selected, ordered and stashed in albums, the individual images became constituent parts in the construction of personal, family and group narratives. The album tells a story through and in time. Until the digital age, albums provided ordinary people with a physical site for the production, in images and words, of an autobiography. For parents making albums around their children's lives, the storyline would begin perhaps with the maternal bump, and then track the little triumphs of child rearing. It would accompany the child through outings and landmark dates, and perhaps be continued after the arrival of a sibling or several, splitting into distinct but interlinked biographies and leading up to weddings, which might, especially as the twentieth century marched on, merit their own separate album. At this point, the next generation would take up the genealogical baton, and new albums would be launched.

An album is, in the first instance, a blank book: etymologically, a white tablet. As a *tabula rasa*, the album has a long history originating in florilegia or commonplace books: handwritten ledgers containing

collections of quotations, poems, lists, recipes, letters, tables and personal reflections. The Greek version, with precisely the same meaning as *florilegium* (both refer to gathering flowers) is *anthology*. Commonplace books, which are personal anthologies or compendiums, date back to antiquity and became popular in fourteenth-century Italy, where they were known as *zibaldone:* hotchpotch books, or *salads of many herbs*. They enjoyed more widespread popularity from the Renaissance (Dante, Petrarch, John Milton and Francis Bacon kept such books). Arguably, all writers' notebooks are a version of commonplace book, especially if they included gathered fragments of other writers' texts. Collected fragments and quotations can and do, together, constitute a biography of sorts—or at least the self-portrait of a sensibility—as with Walter Benjamin and W. H. Auden's famous published versions. *The Hundreds* (2019) by Lauren Berlant and Kathleen Stewart stretches the concept, grafting excerpts to create what they call 'the new ordinary' which is 'a collective search engine, not a grammar' of blurred authorship. In the history of commonplace books, engraved images appeared after citations, and then photographs.

The dedicated photograph album originates in the nineteenth century, where—though photographs play the principal role—other materials (postcards, newspaper clippings, memorabilia) were incorporated. Verbal annotations and captions play an important part too, and their material and graphic qualities contribute to the aesthetic of the album. I wonder about the changes in sense from *commonplace* in its archaic meaning—something notable or striking, to be copied or incorporated—to its opposite, something trite and ordinary. I wonder if it is linked to the idea of 'the pose,' with its undeclared normativity, extracting and distilling something from the exceptional, and in so doing, rendering it banal.

Photograph albums share with scrapbooks—also heirs to the commonplace book—a commemorative function in a prospective construction of nostalgia: *so that we might remember* would be their collective motto; *making memories,* in that annoying tautology that some people now seem fond of using, as if one could channel and direct the paths that memory chose and control the unexpected and possibly unwanted eruption of fragments not incorporated into those fabricated mnemonic artefacts.

Still, it is no surprise—given that memory is mercurial and its anticipation widespread—that a photograph album is something onto which we project fantasies of wholeness, idealised formulations, continuities. From an elaboration of the past in brief bursts of light and shadow, we piece together a storyline. Photographer Rosy Martin writes about being struck

> by how photography and memory relate in a poignant and perverse way, through a sense of loss, predicated upon the unconscious wish to somehow arrest the passage of time by holding it in fragments of a second. How much are the images from the past that I visualize in my mind's eye constructed and mediated through the few photographs that have survived in my family album? How else might I aim to re-connect with my memories?

In the photograph album, individual images are sequenced into desired narratives, and in the invisible cracks between those narrative stations are secreted un-memorialised events; events deemed unimportant or unpleasant or simply unrecorded and suppressed from memory. For many of us, the album's association with an inexorable chronology— excisions and deletions notwithstanding—is precisely that which is reassuring. The album becomes a tangible, intimate memorial to a chosen past and a bulwark against time's indefatigable, corrupting work.

I am in possession of three photograph albums charting my life from birth to the age of eight. At eight, my removal from a familiar world by emigration, from Israel to South Africa (or, as I experienced it, from Tel Aviv to Johannesburg) put an abrupt end to any cohesive sense of my world. With this rupture, the albums devoted to me alone ended and I was frogmarched into the postlapsarian phase of the collective family album.

On the open page that I have chosen to reproduce here—this is from the first of my three albums—veiled by a thin film of tissue paper, I am, at six months old, lying clothed and supine in the one photograph, rattle in hand; naked and prone in the second photograph, and holding what looks like a percussive toy and a plastic ring. My gaze is fixed on something or someone beyond the frame—probably my mother trying to catch my attention while my father is, I initially presume, responsible for the capture.

But it occurs to me that my parents may have employed a professional photographer for these artefacts. The images are crisp and purposefully framed, and I seem surprisingly biddable. I remember something written by Geoffrey Batchen, a historian of photography whose impassioned writings have brought vernacular photography into the frame of photographic history. Writing of family albums in *Forget Me Not: Photography & Remembrance* (2004), Batchen notes that professional photographers are given the task of 'making a recalcitrant baby appear to be the ideal child.' The element of idealisation—I am thinking of the photographs in which Baby Me is the protagonist—is at once behavioural and formal. I am my best self, and also my best-looking self. The debt to the iconography of babies in the history of painting is often manifest in family albums of the early to mid-twentieth century. The positioning of Baby Me in the cot is conventional for that period. I remember one of these poses, the prone one, in British photographer Jo Spence's re-enactments of her own baby photographs, and I now search for that.

With Rosy Martin, Spence developed a practice of collaborative phototherapy in which difficult or traumatic moments from the subject's past (childhood abandonment, poor body image, libidinal anxieties, illness) are turned into performances staged for photographic reconstruction. Spence's adult body, inscribed and contained by gender, class, race, illness and trauma, becomes the site of self-care enacted as politicised therapeutics. Her practice shifts over time, and especially in response to her ordeal with breast cancer and then the leukaemia that would eventually kill her. In these early works, the subject inhabits her past skins, while the photographer takes on the role of therapist, watching the scene, activating it, coaxing it into being. In the sub-series *Beyond the Family Album* (1978–1979), Spence skewers the viewer's expectations founded on the notion of the album—and the individual photographs within it—as a site of ideology, embedding the gendered and classed expectations that underpin the very notion of 'the family.' There she is as a fleshy adult, shockingly naked, prone on the blanket like a baby, learning the strength of her arms by performing a yoga sphinx pose, just as I am doing in my baby picture. As an adult mimicking poses from her family album, Spence invites the viewer to recognise how conventional family photograph albums are, while simultaneously cracking open

their clichés of cuteness. The violence of these images, presented both as re-enactment and as surface disturbance created by montage and double exposure, throws light on all that remains undocumented in family albums, all that is stuffed into dark corners under the brightly lit facade of the album's self-affirming tautologies.

In thinking about albums and the sequencing of photographic images within them, I wonder if one of the significant functions of conventional—that is, material—photograph albums is to foster communality, camaraderie, membership in shared acts of viewing. Family albums are central elements in the cultural construction of the family, and they also serve as focal points and conversation pieces for concentric and interlocking circles of family members. *Look at this! Remember that? You have her eyes! Who's that?* These queries and exhortations secrete a social glue; they generate interaction and in doing so, they are arguably the connecting nodes in an oral history, seminal to the collective memory of a family.

And then, groups other than families—political movements, school classes, teams, peer groups, professional units and sporting or cultural associations—function in similar ways. Anthropologist Terry Dennett has written about the importance of albums for the labour movement in Britain in the late nineteenth century when photography was beginning to be developed on a collective basis. Before the invention of the box camera, few working-class people could afford what Dennett calls the 'nonpolitical album' and photographs of individuals or families were staged in studios on special occasions. Albums of workers and clubs served as important symbols of social cohesion.

In her beautiful book on the album in the age of photography, Verna Posever Curtis incorporates a mesmerising collection that expands the remit of the album yet shows that most albums operate according to coherent principles of grouping and mnemonic prompting. Here is one chronicling a scientific expedition to Alaska in 1899; another charting the six-month locust invasion in the Middle East in 1915; an album from the Philippines Bureau of Prisons dated ca. 1916; three albums charting drought refugees and rural rehabilitation colonists in California in the 1930s; Leni Riefenstahl's album of the eleventh Olympic Games in Berlin in 1936; an album of contact sheets recording life in Pittsburgh in the 1950s; a guest register dated 1977 from a hotel housing homeless and

destitute people in San Francisco. Albums as miniature social histories, narrations of self-defined bracketed groupings or events, *this* not *that*.

As they invite the turning of pages, albums prioritise not only looking, but also touch. And then, as material objects, in their individual and idiosyncratic design and execution, albums also bear the haptic imprint of their maker. One of my childhood albums has a ruched leather cover; its distinctive texture under my fingers opens the door to unsolicited sensory impressions from childhood, and reminds me, if I need such prompting, how entangled sight is with touch. And as unique repositories of group narratives—photographs might be reproducible, but albums are usually not—albums are nothing short of miniature museums *filled with skilfully stuffed memories,* as one of my favourite poets would have it.

Since the album is a material residue of existing, changing or already-dissolved social bonds, the loss of a photograph album would, for many, be a source of significant heartache. There is a haunting paragraph that I read some years ago, then copied and quoted in my own writing more than once. In Croatian writer Dubravka Ugresic's fragmentary novel *The Museum of Unconditional Surrender* (1998) the unnamed narrator recounts:

> There is a story told about the war criminal Ratko Mladic, who spent months shelling Sarajevo from the surrounding hills. Once he noticed an acquaintance's house in the next target. The general telephoned his acquaintance and informed him that he was giving him five minutes to collect his 'albums', because he had decided to blow the house up. When he said 'albums', the murderer meant the albums of family photographs. The general, who had been destroying the city for months, knew precisely how to annihilate memory. That is why he 'generously' bestowed on his acquaintance life with the right to remembrance. Bare life and a few family photographs.

The bequest of the right to remember is enlisted to speak for itself.

Ugresic then contemplates her mother's selection and ordering of photographs 'according to principles of a chronology of events and their importance,' describing how these settle into a fixed placement in an album. But ongoing time also intrudes. Her mother adds scrapbook bits: newspaper cuttings; scraps of paper with phone numbers scrawled on them; postcards filling the empty spaces between photographs. 'When

the genre of the album threatened to turn into the genre of collage,' the narrator observes, 'she would tidy them, throw out the "rubbish" which, escaping her control, had crept into her albums and disturbed the construction of her personal history.' Personal history, in this sense, may be described as the selection, by the subject—by me—of salient plot points in the development of a narrative, using those chosen traces of the past as evidence. Where do imagination and memory join? At which point do they part ways?

I am fascinated by the phenomenon of the album as it straddles the shift from analogue to digital. The physical photograph album is intimate and palpable. Its tactility is part of its attraction. 'Handling an album satisfies a shared human urge to touch and come in close contact with the representation of human experiences,' writes Posever Curtis.

Platforms of digital image sharing, by nature immaterial, obviously eschew the tactile. But they continue to employ the vocabulary and tropes of the old materials and technologies down to filters that simulate the ageing and physical degradation of analogue photographs. Image content is gathered into 'albums' far more capacious than the material album ever was, and these are easily shared with other physically dispersed members of a group on platforms such as Google Photos and iCloud Photos. On platforms such as Flickr, Facebook and Instagram, the members of such a group may or may not be known to the subject, while on Google album archive and iCloud Photos they generally would be. The group might have boundless capacity, yet the digital album shares with its physical prototype the availability of images to a collective and the construction of a sequenced narrative, whether of an individual, a family, a social body or a group linked by profession or interest.

In some respects, however, the virtual archive operates differently from the physical album that it simulates. It is at once more ephemeral and more indelible; both immaterial and resistant to erasure, it remains stubbornly present through the proliferation of channels of circulation. Dates and tags are the categories through which individuals, now all photographers, also all become archivists and data miners. The occasional tropes—by which I mean the tropes characterising occasions such as birthdays or weddings and other celebrations of social and professional success—multiply. These albums and their content circulate among larger or smaller groups, inhibited or not by privacy settings,

generating comment that itself follows conventional lines. And unlike the material album, these are potentially infinite: capacious repositories of future memories.

Returning to this finite, limited resource that is my first photo album, I look at the very first image. It is blurred. At five weeks old, swaddled in pale flannel, I am laid on a checked blanket on the ground. There is nothing distinguishable in the background. The month is January and, though it is winter, it is a sunny day in Tel Aviv. The light is harsh and bleaches out half of my little face; the other half is cast in deep shadow, which also bisects the photograph diagonally. This stark play of light and shade erases all detail: not a single feature is visible. Inauspiciously, this image marks the beginning of my narrative.

Looking at it now, I think—as I have thought many times before—that just as this is the first photograph of me, there will be a last. There is a date on the calendar that will mark my finale, an anniversary to come. The end towards which every biographical photo album moves—its unspoken *telos*—is death. While Roland Barthes identifies death as the essence of photography, it seems to me that, more even than the individual photograph, it is the album, in its sequencing and forward momentum, that holds future death in its pages.

What will happen to these albums when I'm gone? Without descendants to take a glancing interest in my life's itinerary as it is laid out in ageing objects, this album becomes, at best, a piece of vintage ephemera (surface rather than meaning, borrowed from the past) for a new generation of collage or assemblage artists and purveyors of found photography.

Brian Dillon expresses a similar feeling in his memoir *In the Dark Room.* At first embarrassed by his small hoard of family photographs—by the sense that 'the world they depicted was no longer a part of me'—and then uncomfortable with the idea of the album as their repository, Dillon asks 'what unimaginable reckoning has taken place that allows a person to act as if at home with the archive of lost time?' He writes of family snapshots 'slipped into crackling albums, chronological depositories which assure the viewer of a frictionless unfolding of previous homes, notable occasions and beloved physiognomies.' Dillon considers the album not as a site of memorialisation, but, along with Barthes, as marking the failure of memory. Faced with the temporal

momentum intrinsic to the album—first this, then that—he finds himself horrified, unable to identify with 'this calm acceptance of time's implacable advance.' The album, in other words, spells out a kind of macabre annunciation, a death foretold.

Not usually incorporated in the narratives of family albums, death has commandeered its own albums. Duane Michaels' *Death Comes to the Old Lady* (1969). Jeff Wall's *Faking Death* (1977). Jo Spence's *The Final Project* (1991–1992). Stéphanie Baudoin's *Je Suis Morte* (1993–1997). Christian Boltanski's *La traversée de la vie* (2015). With historical roots in other types of records of the dead—painted portraits and masks, for example—the death album has occupied a special place in the history of photography, both in physical images and in the virtual album constituted by blogs and other forms of self-narrative online. Many of us in the UK watched, uneasy and spellbound, as, at the age of twenty-seven, media celebrity Jade Goody died of cervical cancer on camera. Blogging photographers have followed their loved ones publicly to the grave. Many documentary photographers and artists have recorded the last days of a parent, a spouse or lover: Peter Hujar, Nan Goldin, Hannah Wilke, Sophie Calle, Nancy Borowick. There is a stirring archive out there, images both literal and metaphoric, and I hunger to work on these mortal constructions.

One day.

Or maybe not.

But for now, here is this photograph album, put together by my father, who assumes the role of the narrator of our family. The album contains his handwriting. The signature marks of his patience—the style of his love, which was in *doing*—transports me to an inner place of sorrow that I seldom access. A cemetery of imagined images, unrecorded. It presents me, as I am today, and in my *unburthened crawl* towards my end, with this unremembered me: this chubby, lively baby, a baby with whom I absurdly fall in love as if she were my own child. In doing so, this album also suggests a progression of ghostly afterimages. Doors closed. Roads not taken. It prompts me to think not only of my unwritten future, but also of all those photographs not taken, the tableaux of all my living and my dead, and of the one or two who, though desired, remained unborn.

Shanghai
The day of
departure
Israel
May 5, 1949

# Photograph

Like many of the Russian Jews living in China at that time, my mother Fusia left in 1949. She flew west over several days to make her home in the newly established state of Israel. She was twenty-one.

Both of my parents were of a generation of Jews that experienced the establishment of Israel with optimism and relief. By the time she arrived there, Fusia was already Fay, later regretting not having added what she considered a film-starry *e* to the end of that name. She would claim that the move to Israel was part of Operation Magic Carpet, but a quick scroll through a Wikipedia entry clarifies that this term was used only for an operation, contemporary with my mother's arrival in Israel, also known by the more ideologically charged moniker *Operation On Wings of Eagles*, bringing 49,000 Jews from Yemen and Aden to Israel.

When I think of the stories I heard as a child—a limited repertoire of set pieces—snapshots come to mind; mental images that replicate the photographs that Fay kept in the big box at the foot of her bed. The photographs in the box seem like degraded versions of some loftier imagined originals, a little like the deliberately photocopied effect of the photographic illustrations in the books of W. G. Sebald. It is as though some mental image preceded the photograph, a Platonic ur-photograph, an image born, no doubt, of my mother's words.

I cannot imagine my mother's Chinese childhood in colour.

Many of the photographs I brought home after my mother died were already familiar to me. My brother, sister and I had often looked through that photograph box she kept. But returning home with my mother so recently buried, I examine these photographs anew and in doing this, I am meticulous as an archaeologist. They are time capsules holding long-vanished moments in my own prehistory. They also hint tangentially at broad historical upheavals: the world my mother inhabited as a child was buffeted and reshaped by revolution, war and mass migration.

  https://doi.org/10.11647/OBP.0285.07

I comb them for clues, for physical similarities, for differences, and—even now, despite having examined them many times—for surprises. I search for accounts of life before me; but also, for accounts of my parents and my siblings, my grandparents and family friends, buoyed in narratives that flow outwards and inwards, away from and towards myself. My past selves (the small girl, the young or middle-aged woman), the persons my parents were before I was born and before they knew each other, become characters, introducing themselves unapologetically, addressing me from prehistories of loss and bereavement.

In the winter of 2010, shortly after Ian died, I felt the need to make works using family photographs. Ian's death was not tangential to this, since my project began with a wish to find—to grasp and articulate—a relationship between the first and last ever photographs of him: as a baby held by his petite mother, and the final image of his inert, imperial profile, his eyes tightly seamed, the knownness of him already in retreat and with it, my status as beloved receding.

That last time I pointed my camera at him in Addenbrookes' Hospital in Cambridge as he was dipping in and out of consciousness, pumped up with disavowal, I asked the nurse why he kept falling asleep. *He's not really conscious*, she said, blunt as I would have wanted her to be, yet a harbinger of the unthinkable. To continue to objectify him, I thought that day, would be an intrusion. His lack of consent pressed itself upon me. I do not know how Annie Leibovitz allowed herself to photograph Susan Sontag; nor how Angelo Merendino or Nancy Borowick or the many other photographers and bloggers who have recorded the trajectory of the terminal illness of a loved one, did it. I couldn't.

It was then that I returned to the photographs of my family, photographs that I had earlier explored in a body of work titled *Verso* (2010–2011). In re-examining my family's photographs—the need to re-enter the archive is cyclical, recurrent—I was interested not only in my belief in their evidentiary promise, but also in what they concealed. I noted the conventionality of poses in so many of them. I was intrigued by the mystery of the unidentified people and places in backgrounds, forever arrested within my family's narrative, unknowable to me. If the word *photobomb* was already in circulation, I was not familiar with it, but anyhow, rather than lamenting the unexpected or unintended

appearance of people within the frame of family shots, I welcomed it as a clue, the inadvertent portent of old and buried news.

And then, there were those images that I often returned to, as if to unearth a secret about myself: my mother as a child in China; as a confident, beautiful young woman in Israel. My father with his tender eyes, as a boy in Latvia, a young man in Palestine. The first photographs of them as a couple in Israel in the early 1950s. Honeymoon in Tiberias. Their move to South Africa in 1962. Their story in a nutshell.

All of these photographs are from a time—a *back then*—when it was customary for a single image, or at most, several, to stand for a whole event: an arrival, a picnic, a bar-mitzvah, a wedding, a departure, a funeral. My mother's momentous departure from China, where she had lived up to the age of twenty-one, is marked by one photograph.

In wanting to bring these small family photographs into my work, I thought a great deal about how family narratives are shaped by images and words, distilled and also transformed through photographs and the words used to frame them, in albums but also on the reverse side of the photographs themselves, when these were material objects. I decanted myself into these photographs. I re-photographed and scanned them, front and back, zooming in for clues, for details that—once fuzzy in grain—now shattered into tiny pixels.

Sleuthing for signs, I became aware of a desire that so many people project onto photographs: a hunger for meaning fixating on the photograph's claim to truth. I also became transfixed by the materiality of these photographs as physical artefacts: the flimsier the artefact, the more significant. In an age of digital snapping and sharing, this notion of the photograph's materiality has all but been lost. I came to recognise the fact that the thing we called a 'photograph' consisted not only of an image, but also of its material realisation, a manner of printing that entailed choices, a surface scuffed or faded, a front and a reverse side. As objects, such old photographic prints bear the traces of their own passage: through frames, envelopes, boxes, albums. I began to focus on the distressed surfaces of the verso sides.

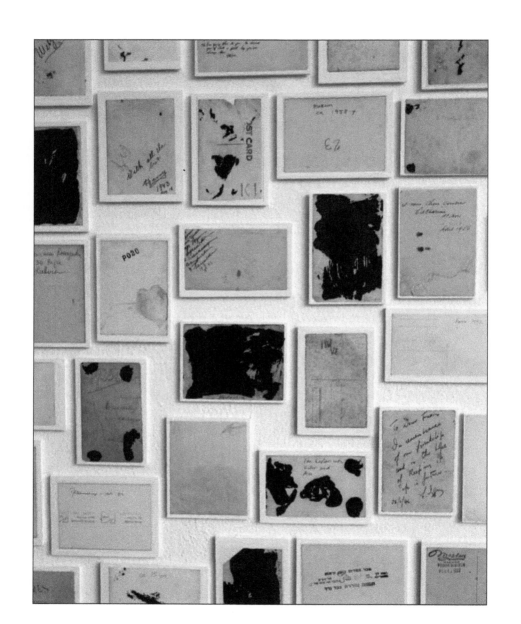

In their mottled painterliness, they have an ethereal beauty resembling gesturalist painterly abstractions or Rorschach tests. Remnants of dried glue or black album paper, unintentional folds and inky text attach specific meaning onto the images: names, dates, places. Those meanings, however, are often ambiguous or contradictory. Sometimes, different coloured inks and varied scripts on the back of photographs attest to multiple and possibly disparate interventions in the verbal framing of an image. Sometimes, the handwriting is my own: 'ca. 1947??' or 'who is this?'

In thinking about this, I read Annette Kuhn's essay 'She'll always be your little girl' (1995), in which, with hair-splitting focus, she analyses her responses to an image of herself as a child. 'On the back of this photograph,' Kuhn says, 'is written in my mother's hand: "Just back from Bournemouth (Convelescent) [*sic*]". In my own handwriting, "Bournemouth" has been crossed out and replaced with "Broadstairs", and a note added: "but I suspect the photo is earlier than this."' The photograph, then, is the site of conflicting memories. 'Whose memory is to prevail in the family archive?' This question is also addressed in *On Chapel Sands* (2019), art historian Laura Cumming's circumspect, tender account of her mother's kidnapping, as a toddler, from a beach in Lincolnshire, her reappearance some days later, and the 'acts of communal silence' that shrouded the mystery at the heart of her mother's life. Cumming explores the possibility of a truthful account that was forcibly removed from her mother, an act of violence by silence. Photographs play a seminal role in the daughter's attempt to uncover what happened in the early years of her mother's life, wrapped in the untruths and omissions of its verbal accounts.

The autobiographic explorations of both Kuhn and Cumming rest on an interplay of truth and lies that photographs are recruited to uphold. The fact that they are requested to play such a role rests on the link held to exist between a photograph and reality, a form of empiricism that, even in the digital age, has remained entrenched in the collective imagination. This has been the case even when we know that analogue photographs too can be altered, cut, doctored, reframed, airbrushed. The history of photographic faking is as old as that of photography itself. Dated 1864, for example, a celebrated photograph by L. C. Handy of General Ulysses S. Grant on horseback in front of a group

of Confederate prisoners is, it has been shown, a composite of three earlier photographs. Famously too, Stalinist censorship—the complete expurgation of individuals from photographs—was part of a broader, systematic falsification of history. But its operating principle, its bid for legitimacy, resided in the underlying presupposition that a photograph never lies. It was, of course, proof of the very opposite.

While simulating photography, electronically encoded digital image capture offers a range of technical capabilities that alter the relationship of the photograph with reality. If, historically, a photograph was considered magical for being a luminous trace of the real, digital photography has extracted itself from this evidentiary assumption. The clusters of information that digital imaging contains may—though need not necessarily—be linked to the real. Technically, continuous tone imprint has given way to binary codes, and smooth grain has been replaced by pixel mosaic. The resulting artefact, while resembling a 'photograph,' is a simulacrum, since what appears to be a capture through light could just as readily be invention: an image generated by a computer, or transformed by digital painting tools, filters and montage. Strictly speaking, digital images are not photographs at all. Pixels can be combined and synthesised smoothly in ways that blur the old distinction between photography and other forms of representation such as painting and drawing. And in the digital darkroom of Photoshop or other editing software, inventiveness can peel away from truth. Contrasts, filters, excisions, dilations, chromatic distortion, cutting and montage: all these can be pressed in the service of idioms that range from a simulated realism to dream-like surrealism or painterly abstraction, and all can appear seamless, without the bumps, cuts and textural modulations that characterise material collage.

Nevertheless, significant cultural continuities bind the new digital images to old analogue photographs and the habits of viewing they fostered, prompting certain expectations on the part of viewers. Not least of these is that old, prevailing faith in the evidentiary power of photographs. Gym-toned selfies or snaps at parties and other celebrations that bolster prestige through popularity, garner comments on social media, exposing a sustained belief in photographic truth. *Here is a slice of the real*, they seem to say. *This is how it was. Look at me!*

In photographs considered this way, time appears to be actualised: a portion of the past intrudes into the present, like a ghost. But the capability of the photograph to hold onto lost time comes, as many have recognised, at a cost. In arresting time, the quintessential photograph not only acts as a form of resuscitation; it also serves as a premonition. It says: *because this once existed and has already disappeared, so too will you.* It is in the past existence of things and people that photography reveals their future non-existence.

Few have formulated this dispossession of the self and vital erasure of others as memorably as Roland Barthes in *Camera Lucida* (1980), published not long after Barthes died in a traffic accident. And no one is more frequently cited as forging that association. Yet that link existed earlier. In *The Guermantes Way* (1920), the narrator, Marcel, returns to Paris unannounced and catches sight of his grandmother without her seeing him. Proust links that feeling—a sense of tiptoeing into a scene as its unobserved spectator—to the objective vision of the camera lens (the term *objective* is richer in French, since it is directly associated with the word for *lens* as well). Marcel describes the vision of his grandmother going about her business as a scene captured in a photograph, as if his eye were disembodied and turned into an impersonal, mechanical device. In this erasure of the association between eye and body and between the lens and the object of vision, photography augurs death as future non-existence. But more than this, it also underlines 'the nonnecessity of our existence' as literary scholar Dora Zhang puts it. It offers us, in other words, an opportunity to experience a life in which we do not exist or might not have existed.

How easy it is to identify the link between photography and non-being—or more simply, between photography and death—when we look at old family photographs! Recognition and misrecognition hold hands. I come upon just such a world as Proust evokes, one in which I have no place, into which I have not come into being, remaining unknown and unimagined. From the point of view of that image, I might never come into being. My mother, my father, before me: before the idea of me, before, even, the idea of themselves as a couple.

But these associations between objectivity and photography on the one hand, and between death and photography on the other, are born of the fantasy of a technology competent at providing users

with unmediated access to reality, a capability of direct transcription. Considered as a trace of the real, an analogue photograph might be thought of as having been *taken* rather than made. And yet, that word 'taken' obscures a range of choices that has always been present: point of view, framing, composition, depth of field, focus, visual tension, tone and so on. Long before the digital era with its overt and daring inventiveness, photographer Ansel Adams stated that a photograph is not taken, it is made. Famous for his dramatic landscape photographs that are apparently steeped in reality, Adams nevertheless underlines the constructed nature of all photographic images: the distance between the thing seen and a representation of it.

Such a separation between empirical experience and constructed image is now more manifest with digitisation, with the ways in which you do not need to be a professional photographer to be creative when photographing, or to manipulate an existing archive of photographic images; everything in our image-capture technologies facilitates such manipulation. And various contemporary artists, like their surrealist and dada predecessors, have capitalised on the reality-warping capabilities of photography. In a series titled *Photogenetic Drafts* (1991), German artist Joachim Schmidt created a cluster of photographic prints out of torn or shredded negatives. These were images of strangers that were donated to The Institute for the Reprocessing of Used Photographs, founded in 1990 to dispose of photographic prints ecologically. Each print is a montage of features, an imaginary portrait with no relationship to any actual human being. Swedish artist Eva Stenram uses found photographs in another reality-bending way. The series *Parted* (2010) came about when she had been buying large amounts of old 35mm slides. Choosing images of groups of people, she separated the subjects digitally and displayed each alone in an image. A photograph of three people on a sofa becomes three photographs of isolated individuals on the sofa, as if captured at different times. For Stenram, this form of deconstruction invites closer inspection of each individual body, its gestures, its forms of expression or reserve: communicative gestures now seem parodic or crazy, a person enclosed in solipsistic isolation. Any reading of these works becomes more melancholy in the global context of successive lockdowns.

For both Stenram and Schmidt, 'photographs' are instruments of a knowledge that extends beyond the empirically verifiable. Yet while recognising the truth of this, many of us still find ourselves transported (if not downright duped) by the reality effect of photographic images, no matter how they were produced. Because in many crucial ways they resemble 'real' photographs, digital 'photographs' reach us already embedded in the cultural practices that characterised the production of the old analogue images that they simulate.

## Dear Fusia

In *Verso*, I focused on how the family album plays itself out as a kind of enchantment, a haunting. I re-photographed or scanned many of the photographs from my mother's youth, front and back in equally high resolution. The original photographs are mostly very small. I printed and block hung postcard sized reproductions of the verso side of these photographs, accompanied by the same number of pencil drawings—much larger than the photographic prints—sketching the image on the recto side of each. Photographs and drawing together constituted 'meta' versions of the back and front of the original photographs. The style of the drawings is flat and affectless, leaning on the relationship between light and shadow that characterises photographic images. These drawings are a little reminiscent of illustrations in school textbooks from the 1950s and '60s, when I was a small child.

For *Dear Fusia* (2015–2016), I again mined my mother's collection of photographs, this time using only ones which bore dedications to—and occasionally from—my mother. These were objects of exchange between her and her mother, her cousins, her friends and boyfriends, and finally her husband-to-be, my father. These inscriptions not only authenticate an experience with the *I was here* stamp of validation, but also spell out an exchange between two people. *Remember me*, they say, attempting to claim their tiny corner of immortality, but in fact showing how quickly people vanish, and how, across only a couple of generations, the memory of them evaporates. *Who's Harry?* I ask my mother. *Who's Lily? Who's Singh?*

The photographs track one person's geographic dislocation, over several decades, from China to Israel to South Africa, and with it, the morphing of her name from the Russian Fusia to the anglicised Fay.

I chose forty photographs and worked with their reverse side, enlarging them digitally and making sure to retain their deckled edges as I floated them on white grounds. To focus attention on the mnemonic haunting of these readymade photographs, I superimposed on the prevailing verso side the faintest ghost of the recto side, thus transforming both. In this conflation, the photographs tell another story, a nomadic narrative of material objects and affective engagements, of which each individual image is a fragmentary, constitutive part. The conflation and flattening of back and front granted both recto and verso sides simultaneous visibility. I had large prints made of these new images on beautiful, heavy, matt watercolour paper.

I am especially attached to one image that remains, to me, emblematic, despite not having made it to the final edit of this body of work, since the text wasn't properly speaking a dedication. My mother is the central axis of a monochrome image. She stands upright and smiles at the photographer. Who is the photographer? I cannot know. Her shoes—probably wedged platforms, going by other photographs of her from that time—are cropped by the frame. She's wearing a pale raincoat and holding a large, dark clutch bag in one hand; her other hand is deep in her pocket. Under the square-shouldered coat, she's dressed in a dark suit and white shirt. Earrings peep from under a framing mass of dark curls.

I am used to not finding anything of myself in my mother, in her physical appearance.

Fusia is surrounded by other people. There had clearly been rain earlier that day, or the threat of rain to come, but it's not actually raining at the time that the photographer captures my mother, who has been framed to stand out of a busy scene. Men wear raincoats and some are hatted; women are attired in head scarves. To my mother's left, a man is smoking, a furled umbrella hooked over his arm. To her right, a small boy in a sailor's cap. He's wearing an oversized, pale trench-coat. His shoes seem anachronistic, almost trainers from our own time. Who is he and whose garment is he wearing? He looks neat. The coat is belted and clean. It's almost as though someone else had dressed him as a miniature adult. We have no narrative moorings, no verbal anchor to identify him, and so, he must fade into the background. But I am aware that he could, conceivably, still be alive. He is stepping forward and his eyes

To darling
Fusichka.
with love
forever
Ve

Shanghai 27/x/47

Dear
Fusia,

don't

forget

me

Nesia

P. 14/45
Tientsin

To "Fatso" Brown
"Stinko".

In cherished memory of
a most wonderful weekend
Together.
May we remember and never
forget!! . x

m.

HAIFA- ISRAEL.
12. 7. 52.

To dear Jean

In remember
ance of our many
days together

Love Ina

are downcast for just the fraction of a second that it takes for the shutter to click. I have wondered about this boy, the random intersection of his life with my mother's, not a photobomb exactly, but how he has been serendipitously caught in her story. This is *Shanghai, the day of departure to Israel. 5 May, 1949*. My mother's cursive script in pencil, diagonally across the back of the photograph, is familiar to me. Obviously, this inscription postdates the photographic moment; but tracking changes in my mother's handwriting over the decades of her life, it seems to have been written quite a long time after the event, perhaps ten or fifteen years.

Shanghai was then home to several Jewish diaspora communities. Perhaps influenced by photographs of scenes of farewell—refugees dating from around World War II leaving for the USA from Shanghai Harbour after 1945—I had always thought of this as a quayside scene, despite knowing that my mother did not travel to Israel by ship. Conflicting pieces of knowledge can so easily cohabit in the mind. I realise now that I also filtered this notion through a fantasised Shanghai played out in the chiaroscuro of Orson Welles.

Fusia lived in Shanghai with her close friend Rosa for her last year in China. In May 1949, the month in which Mao's armies marched into the city, she left China for Israel, which celebrated its first anniversary as a nation state on the month of her arrival, an anniversary that was never discussed in my childhood (either at home or at school) in terms of its effects on the then-inhabitants of Palestine. Five months after she departed, on 1 October 1949, Mao Zedong declared the creation of the People's Republic of China. China was now *for the Chinese*. Fusia's flight took place between two new states, two sets of ideologies. She travelled with her clothes and a suitcase full of sanitary towels. I am fascinated by what mattered to my mother—her reproductive body, her hygiene, her femininity—iterated in the context of a migration to a strange place with unknown amenities, a place viewed in terms of adventure and new beginnings.

In 1949 in China, private ownership of property was abolished and families had to clear heavy taxes before they could leave the country. Historian Irene Eber has documented the lives of families of Russian Jews who, for that reason, were not able to leave until the early 1950s. My mother and her family were among those who, moved by the Revisionist

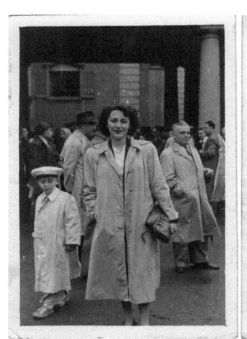

Shanghai
The day of
departure to
Israel

May 5, 1949.

Zionism of Russian Jewish writer and orator Ze'ev Jabotinsky, had managed to avoid getting stuck in China. The 'Chinese Jews' who landed up in Israel were essentially Russian Jews from Harbin or Tientsin, the cities in which my mother and her parents had lived. For the rest of her life, in Israel and in South Africa, my grandmother would subscribe to a Russian-language magazine for such Chinese Jews, a virtual émigré community in Israel, the USA or Australia, keeping up with marriage and birth notices and obituaries.

Leaving my large photographic print with its ghostly image, its textual emplacement, and returning now to the small photograph—the original, if you can call a photographic print an original—I draw my face closer to my mother's, but her skin dissolves into grain, her eyes remain dark, inscrutable points. The smile is as it was in my childhood: knowing, sweet, a little cruel. She looks optimistically out of the photograph into her future.

I know that there, in the future, this beautiful, apparently confident young woman will not be a nurturing or reliable parent, but that friends will often comment on her great personality. *Your mother!* they will say. *What energy! What fun!*

I know that her life will have turned out to be lesser—smaller—than she will have hoped, but that she will do very little to broaden its scope.

I know that she will marry two men, the second of these my father; the first marriage an unsuccessful ruse to escape her mother and live in America. Her mistake will dawn on her when she and the hapless Mike move not to New York, but in with my grandparents in their small flat in Tel Aviv. The road always led infuriatingly back to Mama. Fay will quickly ditch both Mike and his memory. Years later, my brother will find her second marriage certificate with its matter-of-fact details (*divorcée*) and confront her with it. Until then, the first marriage remains a closely guarded secret.

I know that Fay will love the second husband, Theo, my father. But still, she will blame him for everything that frustrates and angers her, not least, his death at fifty-five. She will never manage to be permanently or even fully saved by a man, as she had hoped she would be.

I know that one day, my tummy—round and otter-like—will rub against her dark curls as she holds me aloft for my father's camera, and, at six months, I will laugh at this most hilarious and ticklish of all things.

I know that she will consider being cantankerous in old age as both a right and a badge of honour. And that in the misery stakes of competitive viduity, she will beat me, since her husband will die more than a decade younger than mine—than Ian—was when he died. Who else could think of such a criterion for rivalry?

I don't remember if or how my mother comforted me when Ian died. I remember no consolation, only reiterations of the embittered memory of her own bereavement. There are no albums, no photographs capable of holding onto the memory of such affect. Fusia, Fay—my mother—is a hole in my memory all around the time of Ian's death.

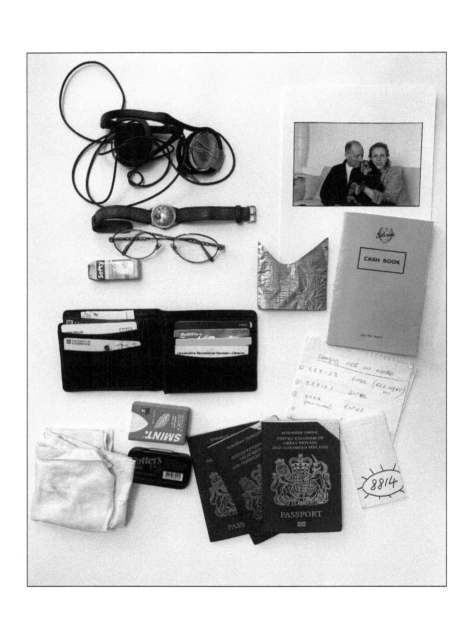

# List

A shopping list and record of expenses in Leonardo da Vinci's mirror script includes not only eels and apricots, but also a sword, a knife, a visit to the barber and a visit to a fortune teller.

The first entry in Susan Sontag's earliest published journal, dated November 1947 (she is only fourteen) begins with an earnest list of her beliefs. Ten years later, an entry written the day before her twenty-fourth birthday includes a list of *rules + duties for being 24.*

Poet Eileen Myles makes an inventory listing her dog's possessions, which include a plaid bed (two, with cat)—few dogs beds are not plaid, she tells us in an aside—cone, bowl and drugs (Rimadyl).

Marguerite Duras makes a long list, with no apparent intended irony, of the stock of things that a house (a home, actually) must always contain. It includes—among other things—wine, coffee, sugar, flour, eggs, bread, cheeses, *nuoc mam*, window cleaner, Scotchbrite, Ajax, steel wool, coffee filters, fuses and insulating tape.

In her poem 'Still Life with a Balloon' (1957),' Wisława Szymborska lists the lost objects she would like to see as she is dying; she wants the things that have gone missing over the years more than she wants a rush of returning memories. She wants to see coats, suitcases, umbrellas, and also 'safety pins, two odd combs/a paper rose, a knife,' and also permits and questionnaires and affidavits, and finally a lost balloon that floats outside the window and 'into the wide world,' an analogy, I think, for her departing soul.

I'm trying, in a list consisting of bullet points, to work out why I like lists. Ian, over a decade dead, used to like them too: their practicality (and sometimes practicability) reassured him.

But, actually, who doesn't like a list?

'A list,' writes Maria Stepanova, 'creates the illusion of possession: the exhibition would pass and dissolve in the air, but the piece of paper

 https://doi.org/10.11647/OBP.0285.08

held the order of sculptures and pictures, as freshly as when they first saw them, long after the actual images had faded.'

Now I abandon the bullet points and sum it up like this: if retrospective, lists impose order on the past; if prospective, they seem to organise the future. In other words, lists make the passing of time manageable. Things to do, to see, to buy, to *not* forget; things seen, done, bought, remembered.

But there are other lists too: inventory, information. War casualties; mortalities from Covid on any given day or week; names on an electoral register; churches in a town; forensic traces of fatal injury; exhibitions on show at any given time, ingredients in a recipe. And so on. Ad absurdum: Gertrude Stein's tiny play *A List* (1932) includes six characters, whose names (all beginning with M) appear as a vertical column along the left side of her script, and the action (speech acts) is punctuated by listings of the words *a list*. Verticality is the list's most prominent formal feature.

Each item on a list is equal to any other item, the first and last not necessarily hierarchically determined, unless we have decided to re-list our list (initially made as free association dictates) by a list of descending or ascending importance. Lists pare things down. They require us to forsake complex grammatical forms: to abandon all verb tenses but the present imperative (though the future perfect might be the tense of the bucket list: *will have visited*) and to leave aside adverbs, and usually adjectives too. It might go without saying that we want to buy *delicious, really hard, medium-sized Pink Lady apples*, but those extra attributes usually do not make it into the abbreviated form of the list. We'll remember the details, choose from what is available.

Lists appear so frequently in literature, we almost trip over them. They come embedded in text, separated by commas or stanzaic arrangement. Nuance too, adding emotion and filling out the scaffolding of enumeration. Elizabeth Barrett Browning lists the manifestations of her love, 'to the level of every day's/Most quiet need, by sun and candle-light [...] with the passion put to use/In my old griefs,' and much more. In *Library of Exile* (2020), Edmund de Waal lists the libraries destroyed through history, and in that circumspect, objective itemisation, we intuit—or into it we project—grief at the loss of historical records and provenanced trails of truth: the libraries of Nineveh, Alexandria, Antioch, Nalanda, Mosul. Similarly, when in W. G. Sebald's *Austerlitz* (2001),

we encounter a list of looted and expropriated valuables—'everything that civilization has produced, whether for the embellishment of life or merely for everyday use'—history streams in to fill the gaps left by those objects.

American artist and poet Joe Brainard leaves us with a picture of growing up queer in Tulsa in the 1950s through a book-length list of incantations, each beginning with the phrase *I remember*. Its sensuousness and specificity serve as a mnemonic prompt of growing up otherwise, elsewhere. The list of things he remembers includes Liberace, dust storms and yellow skies, his collection of ceramic monkeys, a boy who told him a dirty pickle joke, and the first time he saw his mother cry.

The poet Tishani Doshi turns what the sea brought in into a lyrical, plangent evocation of loss, for amidst 'brooms, brassieres, empty bottles/of booze [...] Bulbs, toothpaste caps,/instruments for grooming' and 'keys,/spoons, singular socks,' she finds also 'virginity returned/ in a chastity box. Letters of love,/letters of lust, the 1980s, funeral dust.' Indeed, what the sea brought in was enough

> to fill museums—decapitated marigold,
> broken nautilus, a betrayed school friend
> stuck in the dunes like the legs of Ozymandias

She finds solace in the knowledge that barnacles comprehend entire empires and that 'the feral creature of love' grows from 'gravestones of breakers.' And Austrian poet Ingeborg Bachmann shows us just how personal and devastating lists can really be, in a poem that begins like this:

> Everything is lost, the poems first,
> then sleep, then after that the day,
> then everything else, what belonged to day
> and what belonged to night, then when
> nothing more could be lost, more was lost, and then more
> until there was less than nothing, not even myself,
> and there really was nothing more.

'There really was nothing more' is the hypothetical ending of any list; sometimes it is a formulation perpetually deferred by the additive logic of the list, a structure that enables infinite inclusion.

The material of listing is the random stuff of the archive: a history of the everyday in the making. As a visual thing, a list is a *cadavre exquis*, that surrealist visualisation of a game of consequences, where one line might have very little to do with the line preceding it, or the one following, yet each is consequential in the details of follow-up. In this sense, the list is a piece of surrealist poetry, the chance encounter on a dissecting table of a sewing machine and an umbrella.

Other lists will more readily suggest narrative threads. One of my Instagram buddies, artist Vicky Hawkins, recognises this when she posts iPhone snaps of her husband Tone's shopping lists, hilarious and disconcertingly grisly. These lists seem to have been staged at least in part for the amusement of Vicky. Eventually, we learn that Tone has become an enthusiast of DIY plumbing, but for a while, Vicky keeps that knowledge from us, allowing the lists to suggest compelling narrative readings. Here is one: 'cherrys/plain flour /sledgehammer/ baking powder/cement mixer/rope/gold leaf/dustpan and brush/ski mask/ plastic dustsheet/gaffer tape/hacksaw.' And another, because they are so irresistible, written in Tone's large, looped, pencilled letters: 'frozen prawns/6 MCB type B/large pot/caustic soda/builder bags/hand cream/chap stick/wire—6m. cable/head-size Tupperware container/ scented shoeliners/fresh airspray/boiler suit/low fat cheddar.' If a murder has not already taken place, it's about to, followed by a clean-up job and a snack.

A list might tell others something that is not otherwise evident. Once recorded and later re-encountered, it might reveal something I have forgotten about myself. Adrian Henri's poem 'Me' with its arch subtitle 'if you weren't you, who would you like to be?' consists of a list of names with line breaks but no commas, beginning with 'Paul McCartney Gustav Mahler/Alfred Jarry John Coltrane.' It runs through many names including 'Marx Dostoevsky/Bakunin Ray Bradbury/ Miles Davis Trotsky/Stravinsky and Poe' and ends with 'Hindemith Mick Jagger Dürer and Schwitters/Garcia Lorca/and/last of all/me.' I find this poem in a copy of *The Mersey Sound* (1967) snug among my books, well-thumbed in the distant past, but not touched for years. In it, I see that, at age sixteen, using a blue pen, I ticked the name of each artist, philosopher, writer and musician with whose work I was then familiar directly or by hearsay. This list-poem was, for me, more

than someone else's display of knowledge, it was my own crowing self-portrait in names.

Years later, I kept every ticket that I had been issued from 2002, the year of my move back to England to marry Ian: cinema, theatre, exhibitions, transport, parking: everything. A list materialised. In my studio, I make collages that are visualisations of lists.

In February 2022, while editing this book, I finally discarded every last one of these tickets. The completist fantasy of these transit passes as manifestations of some part of myself had dried up. Collaged onto a huge, hypothetical surface, I once imagined, they would map out the intersections and digressions of my trajectories over a long period of time, but the tickets huddled together in boxes in my studio, forever unrealised as anything but themselves.

Now I regret having thrown them away: is it possible ever to rid oneself of possessions and feel only the lightness of it?

Here is Marguerite Duras (whom I first read too young and who finally speaks to me now) pondering the same thing. Talking of housework as the domain of women (it is, for her, as though feminism had only the slightest effects on the gendering of social and domestic

roles), she speaks of women who are naïve enough to think they can put off the tidying-up till some later date:

> They don't realise the disorder, or in other words the accumulation of possessions, can only be dealt with in a way that's extremely painful. Namely, by parting with them. Some families with big houses keep everything for three hundred years—dresses, toys, and anything to do with the children, the squire or the mayor. I've thrown things away, and regretted it. Sooner or later, you always regret having thrown things away at some time or other. But if you don't part with anything, if you try to hold back time, you can spend your whole life tidying life up and documenting it.

Welcome to my life. Tidying and documenting clog too many of my days, Sisyphean in scope and pointlessness.

And yet. The archivist's regret: now I wish I had kept every shopping list I ever made, reminders of what I once wanted. I also particularly enjoy the lists of materials used by contemporary artists in their works. They speak to me of plenitude and bottomless invention, but without the filtering, stifling language of art-speak, a language I myself have sometimes used.

A collection of such materials-of-making would constitute a not-entirely-ironic work, a kind of commonplace book of citations and appropriations:

- polyurethane model of three-storey office building
- cardboard, plastic sheeting, packing tape, aluminium foil
- slide projection tape and cardboard boxes
- oil paint, straw, ash, clay, shellac audio and video installation, painted iron pot, paper bag, dried flower
- taxidermied sparrows in knitted sweaters
- steel, tapestry, wood, glass, fabric, rubber, silver, gold and bone
- metal tokens for dispensing machines, telephones or transport, empty matchboxes, clay
- oil-based house paint, wax crayon and lead pencil on canvas
- wooden broom base, cotton thread
- framed photocopies and filing cabinet

- latinum, diamond, human teeth

- oil, paper, fabric, wood, metal, sandpaper, tape, printed paper, printed reproductions, fragments of a man's shirt, handkerchief, handheld bellows and found painting on two canvases conjoined by wood ladder.

I am aware that this does not make compelling reading for everyone; but there will be those who, like me, are enchanted by the poetry of random adjacency. I want to go on, until I really can say *and there really was nothing more*, while at the same time, I do not really want to reach that end point, that hopeless barricade to continuity.

Lists have always been, for me, forms of incantation. My mind, which is in many ways the mind of a librarian, enjoys collecting lists of lists, essays that essay lists. In 'The Analytical Language of John Wilkins' (1952), Jorge Luis Borges famously includes a fabulous entry in a fictional Chinese encyclopaedia, tantalising the reader with a list of categories of animals. These include, among other things, animals 'belonging to the Emperor, embalmed, suckling pigs [...], included in the present classification, frenzied [...], drawn with a very fine camelhair brush [...], those that have just broken the flower vase' and so—apparently randomly—on. The list is fantastical, and its arbitrariness punishes a reader's desire for categorical comprehension and comprehensiveness. In *The Order of Things* (1966), parsing this taxonomy in a reading that has become as celebrated as the original text, Michel Foucault finds all the familiar landmarks of his thought shattered. He observes that this fabled listing demonstrates not only 'the exotic charm of another system of thought,' but also, crucially, the limitation of our own systems, 'the stark impossibility of thinking *that*.'

Attending a writing workshop a few years ago, I was pleased to tackle an invitation to list the contents of something—anything—and then to proceed from there. I understood the logic of this exercise, for objects co-existing in a determined space constitute an order and an invitation to narrate. The objects engineer themselves into remembered times and places. In the proximity of things and the words that name them lies the lyricism of happenstance and contiguity. First this, then that, but in no hierarchical order other than the inchoate urgencies pressed upon

me by thoughtless thought, unconscious meanderings that coalesce and want to be caught just before they evaporate.

Listing the contents of a chosen space, I recognised that the magic that this exercise was meant to spin had to do with extracting from adjacencies that which had previously been unthought. Christopher Bollas' unthought known. In doing so, the listing was designed to tease out an unexpected trajectory, one object leading to another in threads of action and consequence. This form of making narrative would certainly serve me, since plot—the purpose it serves, its randomness—remains a mystery to me. I have never been able to fathom why one thing leads to another, why it matters, and why I should care. 'If I want a plot, I'll watch Dallas,' the incomparable Elizabeth Hardwick once said. Put otherwise: the items on the list would not so much provide plot points as be plucked out of their positions along a random vertical axis, and (re)positioned in a horizontal flow of diachronic text. Plot, no; story, definitely.

Discussing the vertical arrangement of the list in his essay 'The Book as Object' (1964), Michel Butor quotes from Rabelais' *Gargantua* (1534), noting that the good giant played 'at Flushes,/at Primero,/At Grand Slam,/at Little Slam,/at Trumps,/at Prick and Spare Not,/at Hundred Up,' and more. When I check in Rabelais' text, I see that the enumeration consists of no less than 218 games, including ones called *love, the fib, the lurch* and *needs must*, titles that, when listed, suggest a story. This is followed by a horizontal development: 'After he had thus enjoyed his games [...] and dispensed his time, the moment had come to take a little drink.' Enumeration, Butor concludes, can be introduced anywhere in a text, vertical and horizontal structures combined in endless possible arrays. I see the patterns Butor describes as a weave, and understand that, in speech too, we play this game of meshing horizontals and verticals every time we add a series of observational details to an otherwise forwardly propulsive sentence or paragraph.

If the horizontal movement of narrative is essential to transporting the reader somewhere else—for the reader must always move on elsewhere, even without plot—the vertical structure of enumeration brings with it an embarrassment of riches, a luxurious amenity. I remember, as a young child in Johannesburg, reading a book in which a group of children was stranded on a mountain in a snowstorm. I had never seen snow.

I recall loving the list of their equipment and food rations; remember experiencing it as alleviation from the frightening teleology of the story.

Perhaps the comforts of 'mere' enumeration are 'shallow and illusory,' but, as essayist William Gass drolly observes, 'so are most comforts.' In his astonishing essay 'I've Got a Little List' (2002), Gass writes: 'listing is a fundamental literary strategy. It occurs constantly, and only occasionally draws attention to itself,' though sometimes it does just that. Gass speaks of *The Mikado* (1885), of Calvino and Borges. He also cites François Villon, Walt Whitman, Robert Coover and Juan Goytisolo. I think of Joe Brainard's *I Remember* (1975) and Georges Perec's eponymous book (1978), as well as his *Things: A Story of the Sixties* (1965), which includes a whole chapter exhaustively itemising the hypothetical contents of an apartment that Jerôme and Sylvie, a couple in aspiration and trouble, imagine one day owning.

I choose, for the subject of my writing workshop, to list the contents of a plastic box bought at Muji. The objects in the box constitute the modest, now pared-down items that I have preserved from the top drawer of Ian's desk.

When is the right time to free ourselves of the belongings of the dead? The question of *when* can be overwhelming for those remaining, and possessions no longer possessed continue to exert the psychological pressure of a relic or fetish, as though to discard them might also mean to delete the memory of the deceased. My friend Sid took all her husband Quentin's clothes to a charity shop as soon as he died after seven years of cancer. They were the closest couple I knew and had been together for over forty years when Quentin died. Joan Didion, however, speaks of not being able to let go of John Gregory Dunne's shoes in her year of magical thinking, reckoning he would want them should he return, while of course simultaneously knowing that he would do no such thing.

In the first divestment of Ian's possessions, I keep precious mementos, give meaningful items of clothing and personal belongings to his children and sister, and then I take the less meaningful items (that is, items devoid of any particular power of evocation) to charity shops. But many things, neither important nor unimportant, remain. I live in a big house: there is no need to cull. The stuff is there, but manages to disappear from view, and from thought too. However, not having

cleared out Ian's desk drawers in the first commotion of his erasure from the living, I feel on safer ground just leaving them untouched and not thinking about what needs doing.

And untouched is how they remain for six years.

In 2016, I find myself—for the second time since Ian died—in a relationship with a man. The passivity—finding myself in desire—is not merely grammatical; I have a talent for falling into relationships without considering the tangents or parentheses, along the shortest route from frisson to consummation. If I thought through everything tangential or parenthetical, I would never do anything: that has been the logic, though in truth, it is more kneejerk than that. And G has a lovely, winsome gentleness, though he turns out to be a little deer, so easily startled by everything. He has a wiry frame and a sleek torso that he probably shaves; he has a bristly head of silver hair and thin, strong arms that I find sexy. I love the sound of his breath in bed and the smell of him and I love how clean and pared down his flat is. And he can dance; I mean *actually* dance, with a leading arm that knows how to veer me and press signals into the small of my back—which anyhow is an erogenous zone—and a left hand that knows how to cup my lifted right hand ready for a twist. It is a heady pleasure to feel our bodies synchronised in dance, even though I never fully relax into being led.

But here is what I discover: the smallest change in routine or personal habit signifies an unbearably seismic event to G, something to be avoided. He loves cafe and pub chains for their predictability, their known menus. He researches a film thoroughly before committing himself to a dangerous night at the local multiplex, preferring those based on what he quaintly calls *real life*. 'Risk averse' does not begin to describe him. He is so tender and so timorous, so manifestly ill chosen, though never actually chosen. My spacious, light-filled house seems, to him, hostile: it is too large. He thinks the pictures and fabrics and books and objects furnishing my space make my home look curated. He cannot feel contained in it, or by me, and there is no question of my feeling contained by him. It is amazing that we last over a year. When we separate, it is with mutual kindness; we have an almost painfully nostalgic parting lunch at Pizza Express in Cambridge. We now still exchange Christmas cards. The memory of him remains un-embittered.

An engineer by profession, as Ian had been, G is a perfectionist of the DIY job. But while Ian had been inspired and inventive, crazy-cool in his capacity for improvisation, a bricoleur, a trickster, a lateral thinker and solution finder, G does things by the book. He circumspectly criticises the complexity of Ian's problem solving, of which he finds traces everywhere in my house: too much wiring, too much space, too many sockets, some pipes left unlabelled.

One afternoon, while he is helping me with something practical in the house, I tell him he might find a small Phillips screwdriver in Ian's desk. I cannot remember if I call it 'Ian's desk,' but he knows where I mean. Returning with the screwdriver, he is blanched. *It looks*, he says, affronted, *like Ian's just popped out to the shops*.

I take this as an admonition. It is. *He's right*, I think.

A 'veritable organ of the secret life' is how Gaston Bachelard describes a drawer in *The Poetics of Space* (1958) and I was mistaken to direct G to Ian's. Without drawers, wardrobe shelves and the false bottoms of chests, Bachelard says, 'our intimate life would lack a model of intimacy.' In his glimpse into Ian's inner workings, G feels accused, not only of intruding into the private world of my dead husband, but accused, too, for the paucity of his own imagination.

Thus prompted, I finally clear the desk. Heaps of pencils and rulers and sharpeners—Ian was never a minimalist where stock was concerned—are joined by soldering silver and epoxy resin, rolls of string, elastic bands, callipers and protractors, ballpoint and fountain pens, small screw drivers, drawing pins, paper clips, luminous markers, index cards and old, hardened inks in little bottles. There's Blu-Tac and Pritt Sticks, now desiccated, and Post-Its losing their glue. Several pairs of reading glasses. And more, more. I tip all these things into a bin bag. But I keep the contents from the top drawer, intending to photograph them later.

Here is the list:

- a pair of cheap JVC headphones

- a white cotton handkerchief, slightly soiled, but now odourless

- an old watch with a leather strap; he'd long not used it, laterally preferring a digital one

- a pair of wire-framed spectacles, Boots own brand

- a red cash book filled with Ian's scribbles: annotations and calculations of how much various items and services cost during the building of our house, which was completed in 2008

- a folded gold paper crown from a Christmas cracker

- one pencil eraser, brand: Softy, in paper casing

- a small plastic box of Smints and a small metal box of Potters, tiny cough lozenges from Holland

- three passports, the oldest having expired in 1996, the newest still valid at the time of Ian's death

- a black leather wallet with various cards in it: Lincolnshire County Library; Cambridge University Alumni; Build Trade; NHS; Lloyds Bank Credit, Lloyds Bank Debit. Inside, there is also a note, in my handwriting, that contains an address in Rouen, and a phone number of a mechanic, from the time our car broke down in Rouen, where we had stopped to spend the night and see the cathedral in the company of J, my first husband, and his wife M.

- a black and white photograph of Ian and me together in my flat in Lisbon. The photograph shows Possum's agile, furred body curving between us. I'm holding her and she stretches over to smell Ian's breath. He's looking at her; I'm looking at the person who's taking the picture, my good friend Lucia, who died of pancreatic cancer a year before Ian died. There was a series of photos from that day and I had given Ian this one. It was probably taken in 2007.

- a sheet of paper torn out of a wire-bound notebook, with instructions for changing the codes on a keypad

- another sheet of paper, this time squared, with the number '8814' written in large black numerals, surrounded by an ellipse with spokes sticking out of it, like a child's drawing of a sun.

I know these contents both do and do not constitute a portrait of Ian. I remember most of these items in use. I remember the movement of

Ian's large, safe hands as he flipped open his wallet to pull out a credit card, his deftness turning a screwdriver. I remember him soldering tiny things. I remember the way the glasses embossed a path along the bridge of his august nose.

The paper crown brings with it a recollection of recurring Christmases, the best part of an otherwise suffocating day invariably spent at home with two of his three children, both in their twenties when I first met them. The third—the oldest—lives in Atlanta. Ian would don the crown from the first cracker he pulled and keep it on his head until we went to bed, still with it on, replete and relieved that the day had ended, usually without too much bloodshed.

*Goodnight Mr King*, I would say, each year.

He'd give me one of his downturned smiles, the legacy of his buttoned-upness, as though beginning to grimace but changing his mind halfway. And he'd say *goodnight Mrs King*.

What makes the swallowing catch in my throat—more than the passports or glasses, more than the paper crown, folded like a bat's wing—are the snippets of handwriting, un-self-conscious tracks of movement, his body's imprint, its pressure, thought arrested in its tracks. No listing can capture the low rumble that seeing this familiar script causes inside the cage where I keep my heart.

*8814.*

A debit card PIN? But I knew the PINs he used, and this was not one. The piece of paper bears the impress of something unknowable: something fleeting, a jotted mnemonic that fits within the vertical ordering of a list but finds no explanation in the horizontal expansion of a story.

Nothing, in this miscellany of everyday items, so arrests me with the palpable fact of Ian's deadness as this note-to-self, a reminder of something for which I have no reference point. An infinitesimal memory that was never mine, all gone.

# Stain

At the close of Virginia Woolf's novel *Jacob's Room* (1922) the reader is given to understand that Jacob Flanders has died in the trenches of World War I. Woolf's circumspection makes the young man's death all the more poignant. His very surname flags this up, but Woolf leaves everything vague, exquisitely scrambled in a kaleidoscope of impressionistic fragments. The book is filled with solipsistic silences and liminal spaces, empty rooms, misunderstandings. Jacob's friend, Richard Bonamy (no name in this book is random), whose love of Jacob is tinged with undeclared desire, attempts to interpret the contents of Jacob's room. 'He left everything just as it was,' Bonamy says. And why wouldn't Jacob have? It is then that Jacob's mother, Betty Flanders, holds out Jacob's shoes and asks: 'What am I to do with these?'

Rushed to hospital three weeks before he died, Ian too left everything just as it had been. But in fact, life as he once lived it had come to a standstill three months earlier with the onset of catastrophic headaches. Traces of his busyness had waned and his belongings had already settled into an uncanny second life as things abandoned. A year after he died, I found a single dose of his nightly medication—five small pills—hiding on a bookshelf in our house. Removing them showed up little dust-rimmed ghosts where they had been, pale like the skin under swimming costume straps.

We had been married for nine years when he died.

This was a second marriage for both of us: he had been only four months widowed when we met in Lisbon, where I lived and where his sister also lived, while eleven childless and fairly wild years had elapsed since my divorce. As is the case with many middle-class people, separately and together, we had accumulated many things that we loved and a good many things that we didn't even like but could not quite get rid of. Then, there was the fact that, since Ian was averse to shopping, he

 https://doi.org/10.11647/OBP.0285.09

had become a keen stockpiler. *It'll see me out* was one of his well-worn refrains, and, notwithstanding obsolescence and sell-by dates, mostly, whatever it was did see him out: litres of lavender and aloe vera liquid handwash; energy-saving light bulbs; Basildon Bond letter writing paper crammed into several drawers (untouched now, since no one writes letters); cables, adapters, routers, floppy discs, writable CDs and external hard drives; dozens of candles bought at the Dutch department store de Bijenkorf; and heart-stoppingly, three dozen colostomy bags.

Of course there were also papers, mostly neatly filed: personal and professional correspondence, pared down, but extending over decades; deeds, official records and reports of one kind or another; plans and permissions for the construction of our house, which he designed and in which we managed to live together for his last two year; detailed records of investments, finances, insurances; warrantees and user manuals; albums and boxes of photographs and negatives; a half-hearted stamp collection and a fat file containing every detail of the treatment for the bowel cancer that, in the end, was only indirectly the cause of his death.

Ian died of Aspergillus meningitis, undiagnosed at the time of his death but revealed in the autopsy. No sign of cancer in his brain, liver or other organs. He died, then, of a rare form of fungal meningitis, difficult to detect and treat (most survivors suffer cognitive damage: unthinkable) but contracted because chemotherapy had caused havoc in his immune system.

The body's various capabilities of tagging disease entail a labour of categorisation, distinguishing self from not-self, own body from foreign body. In this, the body is an archive. Dating to the 1950s and '60s, the notion that these functions are articulated into a complex and co-ordinated system of immunity is a recent theoretical development in immunology. In her riveting book *On Immunity* (2014), Eula Biss describes how cells honed for immunity are generated deep in the body, the bone-marrow and the thymus. She notes the dizzying array of cells specialising in different tasks, 'falling into an intricate arrangement of types and subtypes,' and interacting 'in a series of baroque dances.' Ian's furtive illness installed itself where chemotherapy had left a gap in his body's defences: a gap in which that courtly choreography broke down.

I never opened the envelope containing the coroner's report on the cause of Ian's death. Someone called me with the outcome of the inquest

as I was driving from an appointment with a gynaecologist, and I pulled up to take the call. I couldn't bear to read the details, the description of incisions and the thought of Ian's organs like offal on a slab. All these years later, the official document remains unopened, passive and malign in a grey archive file labelled *Ian*.

Back home, stricken, I read up on Aspergillus. I discover that its spores are in the air that we breathe, and mostly, they do not make us ill. They also lurk more thickly around garden compost. Any rotting material poses a risk of Aspergillus infection to immunosuppressed patients. A flash image appears to me, of Ian tipping vegetable peelings or fragrant grass clippings into the large compost vat at the bottom of our garden. Gloved to prevent anything passing through his skin, he would nevertheless have been breathing in that decomposing matter, while happily pottering on days when he was less fatigued during his last phase of chemotherapy. It is an image I try to tamp down, an unproven causality I cannot bear to think about. And it shows up a chink in what, by sheer effort of will, I had hoped would be an impenetrable wall of sanitised protection that I erected around Ian while he was in treatment.

Like me, Ian was averse to the *battle* metaphor or, worse still, the *journey* metaphor for his illness. It was just a matter of *shit happens*. I found it hard to believe that his oncologist had fallen in with this most tedious and untruthful of clichés, the journey with its inevitable, grim end. And when, not long after Ian's death, someone attempted to console me by saying it was *so unfair*, I turned on my heel. I did not need fake solace: it was normal to grieve. And it was *not unfair*. An elderly (some might say old) person dying of natural causes, however awful, is not a statistic in God's ledger of unfairness, and anyhow, there is no external agency considering the moral weight of a death by Aspergillus. The dying is just a fact of life, and if his death was not a fact in Ian's life, it was certainly a fact in mine.

Though he was a self-contained, reserved man who despised extravagant public displays of sentiment, which he too hastily read as sentimentality, Ian's warmth punctured his best attempts to hide it. I was not surprised, then, to find, tucked away in books, notes to and from his first wife Ulla; a paper envelope stuffed with cards that I made for him; charming play-doh figures fashioned years earlier by his daughter, Sanna; paper templates of his sons' feet; notes and drawings from all

his children, the three living ones, that is. Then, inside a flimsy frame, a child's scratchy drawing pasted onto a card, together with a tiny, wan photograph of Antonia, Ian's second child, drowned in a swimming pool in Germany before she was three.

I remember tears squeezing out of Ian's eyes when he first told me about Antonia, not long after we met. I remember especially his description of the rank smell of a carpet on which he was lying, face down, waiting for the helicopter to air-lift her inert body. By the time he described all this, she had been a quarter of a century dead. Later, he took me to her grave: *Kleine, süsse Antonia* is inscribed on the headstone. Ulla, whose cremated remains are buried next to Antonia's, was German. Ian's ashes are now interred there too: I knelt in the bitter January snow to place the urn in the hole. *There's room there for you too*, Sanna said. *Dad would love to be in a sandwich with you and Mum.*

Ian's possessions, his things... Any widow, any lover or close relative recently bereaved, any child of a parent who has moved from the family home into a care facility, must decide if, when, and how to dispose of the possessions that are remainders a past life.

I would not be the first to note that this is no easy task, and that, as Joan Didion made explicit in the famous account of her bereavement, magical thinking of one sort or another might render these decisions visceral and impulsive. If one does not bag up everything immediately, there is no definitively good time to do so, though anniversaries can prove useful, as can subsequent house moves or refurbishments. After Ian died, I found myself drawing his shoes, his shirts, his shaving brush.

*Be-longing* (begun 2009), part of a larger project titled *The Power of Possessions,* is a body of work by British photographer Carol Hudson, testifying to the old-fashioned belief in photographs as imprints of the real, and consequently, it announces the capability of photography to act as a placeholder for the thing itself. After her husband Tony's sudden death, Hudson didn't know what to do with his belongings, 'the leftover scraps of ordinary life,' as she puts it. She, like me—like so many others—was especially moved by evidence of her husband's touch, of everyday wear and tear. Hudson made black and white 'portraits' of her husband's possessions to enable her to release his actual belongings, granting herself the permission to get rid of them, while still preserving

her husband as an internal object. The photographs serve, in other words, as transit tickets in a trajectory of grief. Hudson concentrates in each image on a group of similar objects: a taxonomy of socks, books, ties, handkerchiefs, shredded papers. Each pile is ordered with a keen eye to pictorial design and composition (in other words ordered with a view to being photographed) and with a feeling for tone that takes into account the transformation of the objects into monochromatic images. Each of these pictures has the whittled down quality of a modernist still life. Each is also a melancholy distillation, an archive of things that have lost their primary use.

In a similar vein, attempting to stave off forgetfulness in the face of her father's worsening Alzheimer's disease, American artist Rosalie Rosenthal photographed objects from her parents' home; objects that had been packed up and given to her when they moved to accommodate her father's worsening condition. Titled *Midlife Tableaux* (2020–2021) these poised, exquisite pictures show objects shimmering forth out of smoky darkness, mining the old vanitas/memento mori tradition in their suggestions of mortality and in their dramatic chiaroscuro. The inclusion of the artist's own body and that of her daughter establishes a

genealogical thread and suggests the honouring of memory over time. Rosenthal writes:

> *Midlife is traditionally a nexus for recalibration; parents reach an age of needing care, children become adults, and those of us in the middle assess and adapt. Midlife Tableaux is a manifestation of that reconsideration of self through examination of significant objects in my familial histories.*

Rosenthal sees her guardianship of the objects as sustained in the act of photographic elaboration, and those photographs themselves serve as distillations of acts of care, each pushing against inevitable oblivion.

With Ian, I found that although the sorting began not long after he died, it extended over years; is not over yet.

For the first week, people were in and out of the house. Sanna and I went to Norfolk with my ex-husband J and his wife M, who had arrived a day after the memorial service that replaced a funeral (since Ian's corpse was in the service of science). They stayed with us in the house; their support had the lightest of touches. M would improvise delicious meals without making a fuss or asking where anything was, just finding her way around the kitchen and extemporising. That day in Norfolk, we trudged along Holkham Beach, which Ian had loved but which, that day, felt hostile, aggressive. Going there was a desperate bid for action of some kind, an enfeebled attempt at proving I was alive, dragging my heavy feet in fierce sunshine. A tempestuous wind whipped our clothes about us. My lips were crusted with sand. Sanna had brought Kato, an epileptic cocker spaniel she was fostering, who feasted on putrid seaweed and molluscs and was violently ill as we got back into the car. He was soon to come live with me: a dog blighted by misfortune but sweet and stoical in the manner of dogs. He died of a grand mal seizure two years later.

After everyone else left, Sanna remained to help with the sorting. The house seemed to lose coherence and become an agglomeration of disparate, jangly parts, many of them dispensable. I had to learn to distinguish between those things that would simply inform me that everything that had once mattered had vanished, and those that served as signposts in my own trundled trajectory towards life as a widow. I embraced the term without embarrassment.

Sanna was my first guide. She was kind and solicitous in a way I might not yet, then, have expected, and she was also the very soul of

efficiency in dealing with anything that I found difficult or boring to think about. Though we had had a few prickly moments in the past, we both now wanted to spend time together, affection blooming in the spaces left by Ian and in the recognition of what we had lost and what we now shared. She was both firm and tender in her ministrations.

After that, of course, I was on my own.

Since the dead cannot control the paths taken by their secrets or indiscretions, I feared discovering something that might warrant interrogation, an obstacle resistant to my prying. But I unearthed nothing more than a few random scrawls jotted in notebooks, and several receipts revealing how much Ian had spent without fessing up, though of course he was obliged to do no such thing: a state-of-the-art scanner to digitise negatives (only used a handful of times); a hugely powerful lawnmower that I could not manoeuvre; Quad speakers that made the eventual buyer drool despite one of them being broken; a circular saw (obviously essential for someone, but not me); a soldering kit. Out went those unwanted gifts, camping gear I would never use, down duvets that I didn't want. And of course, that was also the time to divest myself of things I had not had the heart to ask Ian to remove earlier: things from his life with Ulla. This resulted in some mistakes. I was stricken when, a year or two later, Sanna asked where her mother's vintage flour tin was. Who knew.

Then, there were the things I kept. That bag of *personal effects,* as they are called, handed to me at Addenbrooke's Hospital on that close August evening when Ian was merely one hour dead, including pyjamas and a pair of slippers imprinted with the memory of his feet and a cashmere jumper frayed at the sleeves and still impregnated with his smell. Almost all the contents of his filing cabinet, who knows when I might need to track something. Photographs. Certain fetishised items of clothing, each a synecdoche of the man. Anything that contained his handwriting. And a blue and white checked table napkin, the one he'd used on the day that I rushed him to hospital for the last time. Now I needed such bio-metonymies: things that had randomly experienced his touch and that expanded, like balloons, filling out as proxies, as fully substitutive objects. For all the years since his death, this napkin has lain, compliantly rolled up in the narrow, tarnished silver ring that bears Ian's initials. How old-fashioned that we each brought our own silver napkin ring to the marriage, mine a birth present.

I pull this napkin out of its ring from time to time, flatten it out and smell it, not quite sure what I expect or want to find. Nothing. It yields no smell, despite never again having been laundered. And not a stain on it either.

I realise I'm looking for a stain, just as I had hoped to find a small remaining filament of hair in my father's hairbrush.

I am not taken aback, then, reading in Eimear McBride's shattering, short novel *Strange Hotel* (2020), that the unnamed protagonist—a woman mired in an old grief and having casual sex in anodyne hotels, making sure to request ground-floor rooms to resist the temptation to jump—is attached to the idea of the molecules that her partner may have shed and left behind. He is many years dead, and though he was much older than she, in the years of survival, her age is about to overtake his in its place of absolute arrest: 'tomorrow I will be older than you, for the first time. I am about to pass you by. After all these years, and how it always was, the time where the shape kept its shape has almost run out.'

As I write this, approaching the age that Ian was when he died, thinking of the shape that grief takes—an outline that becomes familiar and, in keeping to its silhouette of absence, turns into a form of comfort—I return to the thought of the stain that isn't. The desire for a stain.

A stain in fabric (clothing, bedding, handkerchief, napkin) marks the site of a spill or an emission; a breach in the boundary that holds self and non-self apart. The intrusion of the stain, its persistence, indicates a failure: the failure to keep things apart. The labour of cleaning—of holding chaos, impurity, disease at bay—is a task of maintaining boundaries intact. I realise that with each thought of the word *stain*, I am reiterating a desire, a longing not for order and immunity, but for evidence of its opposite: for the visceral connection both to vitality and putrefaction contained in its uneven shape.

Holding Ian's bland and stainless napkin, I think not of spillage, but of manners. Of how annoyed he would be at people's table etiquette, irritated with slurpy chewing, with sounds of too much sucking or smacking of lips. Evidence of gustatory pleasure would elicit his signature, downward-turned smile. He'd roll his eyes too at the fashion for table conversation about fine dining or restaurants or TV cooking programmes. Food bored him, and especially talk of it.

The stain in question is non-existent, but I'm sleuthing for it: I want there to be a stain on the napkin, a trace of Ian's meals, his living days.

The stain is not (only) that which the body expels (through orifice or rupture—sweat, blood, dribble); it is an indexical sign of a having-beenness. A sensory snapshot.

But stainless as it is, I kept this napkin because of the idea of a stain; an idea of the last stain. Not in a Shroud-of-Turin kind of way, or not *only* in a Shroud-of-Turin kind of way, but also—powerfully—because of something I read decades earlier, something I took in and knew I would never forget. In Heinrich Böll's *Ansichten eines Clowns* (1963) published in English as *The Clown,* the protagonist, Hans Schnier, is a 'collector of moments,' a self-described monogamist with no church affiliation. His wealthy parents are devout Protestants who sent him to a Catholic school, where he met and fell in love with a girl called Marie. As a Catholic, she eventually feels the need to 'breathe Catholic air' and she leaves Hans for a man called Zupfner who shares her faith.

Reeling at the end of their seven-year relationship, which he can neither take in nor get over, Hans remembers—not for the first time in the novel—an earlier loss, the death of his sister, Henrietta. A 'lovely girl with fair hair,' she'd been killed at the age of sixteen while doing anti-aircraft duty, for which she volunteered seven months before the end of World War II. Hans' description of catching sight of Henrietta's napkin after receiving news of her death was perhaps my first full literary realisation of the power of the poignant, ghostly presence in people's lives of evocative objects.

I was sixteen—the age of Henrietta when she died—when I first read this novel. While the subtleties of the book's critique of the Catholic Church and of the hypocrisy and wilful amnesia of post-war German society would certainly have been lost on me then, I carry with me from that first enraptured, heartbroken reading the memory that Hans' mother was a Nazi sympathiser. It was she who had urged her daughter to do her bit 'to drive the Jewish Yankees from our sacred German soil.' In my memory—and in notes I made long after I first read the book— Henrietta's napkin has on it an egg stain. But I now reach for the old paperback with its overblown cover design, its broken spine and tiny print, and find that this is how Böll describes the napkin:

> When we got the news of Henrietta's death, the table was just being set at home, Anna had left Henrietta's napkin, which she didn't think was quite ready for the laundry, in the yellow napkin ring on the sideboard, and we all looked at the napkin, there was a bit of marmalade on it and a

small brown spot of soup or gravy. For the first time I sensed how terrible are the objects left behind when someone goes away or dies.

The stain, the napkin: the *thing*, the real object of memory, is not the physical object. It is the experience to which that object points, and it is that experience that seeing and touching an evocative object can serve to open out. In thinking about this 'thing,' misremembering becomes a form of interpretation, or perhaps re-interpretation, re-inscription: of exegesis. For all of us, certain objects serve as relics or tokens, memorials to past selves and lost loves, inviting the projection of certain associations. And while, incontestably, what we call a *self* is constituted by memory, it is also, importantly, the cracks in memory—mnemonic failure—that certain objects address. Repeatedly, I have found that objects remind me of certain events, but that those events are, in effect, misremembered. Some external check—a spoken or email exchange, a search in Google or in an archival document—audits my (mis)memory.

With *The Clown*, the misremembered image has taken root in me as a significant token. But Böll's stains of marmalade and gravy are more cleverly angled, less predictable than the egg stain of my recollection, multiplying into layered reminders of more than one meal. What I retained, however, from my first reading of the book, with its incorporated mis-memory, was the sense of the significance of objects-as-remains. A forensic, intimate archaeology. This is negatively reinforced in the novel when Marie walks out on Hans, leaving nothing in her wake. That *nothing* becomes palpable. Hans mourns her, above all, in the empty bedroom, in the 'tidy, clean wardrobe,' the absence of stains, the anti-trace. This is 'the worst thing she could have left.' We need, Hans seems to be telling us, the things that we associate with those we've lost. We find ourselves testing the abiding reality of the disappearance of our love objects in the enduring presence of their possessions.

At the moment of looking at Henrietta's napkin, Hans' mother decides to pretend that everything is normal, and continues eating, as if to say: 'life goes on.' But for Hans, it becomes clear that 'it isn't life that goes on, but death.' Not only the prematurity of death, but also its pervasiveness, its ongoingness, gives meaning to the objects that once enjoyed casual proximity with his sister.

In the study where I read and write, one of my large work surfaces has a glass top, held in place some inches above the wood. That glazed

space creates a kind of vitrine, an informal display cabinet into which things come and go, a serendipitous museum: tiny birds' bones, two bars of soap wrapped in vintage paper, various postcards and photographs, three small drawings made by friends, a heart-shaped pincushion, a blue painted foot on a broken Portuguese tile, a folding Kama Sutra. Ian's napkin has its place in that tiny gallery.

You are not expected to display in a vitrine, or anywhere else in your home for that matter, such items as your dead dad's dentures, your dead mum's sticky lipsticks, your dead dog's chewed up toys, your dead husband's table napkin. Too ordinary, too abject. And yet. There is death and grief in all these objects, but of course, signs of life too, of someone having once lived, of someone's intimate, dribbling, leaking, odorous corporeality.

That intimate bodiliness is most poignantly and variously expressed by clothes.

Many years ago, in the mid-1990s, in my studio practice, I worked with old dresses. It was around this time that I read Edith Wharton's *House of Mirth* (1905) and my now yellowing Penguin edition, bought in 1994, has the following section underlined:

> She [Lily Bart] had a few handsome dresses left—survivals of her last phase of splendour, on the Sabrina and in London—but when she had been obliged to part with her maid she had given the woman a generous share of her cast-off apparel. The remaining dresses, though they had lost their freshness, still kept the long unerring lines, the sweep and amplitude of the great artist's stroke, and as she spread them out on the bed the scenes in which they had been worn rose vividly before her. An association lurked in every fold: each fall of lace and gleam of embroidery was like a letter in the record of her past. She was startled to find how the atmosphere of her old life enveloped her.

In Lily's 'descent' (the falling metaphors for women stepping out of the social roles carved out for them are legion), as she spirals away from marriage and 'prospects,' veering off course from her peers and cohorts, class and status are, at every turn, intertwined with personal, embodied memories. The clothes, which no longer have a use, bring an almost unmediated re-experience of a life once lived and of opportunities missed.

In the 1990s, I collected amazing, glamorous frocks that came my way by various devious or serendipitous means. They are made of

taffeta, georgette, lace, crêpe-de-chine, organza. Onto them I pinned
stamps and photographs and keys and watch faces. I had them hanging
all over my home, their droopy shoulders corrected, as in deportment
classes, on the wooden skeletons of vintage clothes hangers. I would
never have been able to squeeze into these silky garments with their
tiny bodices and pinched waists, yet they spoke to me directly of how
femininity is construed for me; spoke to me about glamour and fantasy,
about grace, and about money too. And despite not having been worn
by anyone I knew, once I had worked with them, they felt to me like
personal reliquaries. That project, longstanding as it was, never came
to public fruition, but I have preserved what I consider to be the best of
those dresses, and I have remained fascinated by artists who use clothes
in their work.

In *Story of Dresses* (1990), a body of work that pressed itself upon
me during my own work with dresses, Annette Messager placed
frocks in glass cases, each resembling a votive offering and seeming to
memorialise a life once lived. On a far larger and more public scale, in
*No Man's Land* (2010), the thirty tons of used clothes amassed at the
Park Avenue Armory in New York by Messager's partner Christian
Boltanski, were reminiscent of the mountains of personal possessions
collected at Auschwitz from the stripped and the doomed. These piles
of clothes were destined for German citizens, owing to the shortages
in essential goods Germany was experiencing. The cultural memory of
the Holocaust seeps through much of Boltanski's work (he was born
in France in 1944) and all of it deals with life's passing: mortality and
memorialisation. In *No Man's Land,* each garment served as a placeholder
for an entire life lost.

Then there is Maira Kalman, who, with her son Alex Kalman, rebuilt
the closet of her mother, Sara Berman, installing it and its expensive,
stylish, obsessively ordered contents, which Maira had kept, at the
Metropolitan Museum of Art in New York (2015). The clothes are very
neat, starched, immaculately preserved, all in shades of écru and white.
The closet was presented as a small chamber in dialogue with the Met's
then recently installed Worsham-Rockefeller Dressing Room from 1882.

The closet represents Sara Berman's life from 1982 to 2004, when she
lived alone in a small apartment in Greenwich Village, but the book *Sara
Berman's Closet* (2018), featuring Maira Kalman's singular combination

of drawings, photographs and beautifully scripted, hand-written text, at once witty and slyly melancholy, is about the memories triggered by clothes and a few useful utensils, of which the potato grater (essential for *latkes*, a traditional Jewish pancake eaten during Hannukah) remains, for me, the most affecting. We see through Kalman's drawings Sara Berman in her pressed whites, and we hear her daughter's musings about Sara finding her style and shaping for herself a life that suited her and making time—*a* time—for herself. 'She edited out useless distractions. She cherished the small moments, which are the sweetest. Every action was done with care. Every day was filled with precise and brilliant actions. She bought a lemon. She mailed a letter. She wrapped a package.'

*Sara Berman's Closet* is about great style, but it is also about developing the wherewithal to cultivate that style. It is, in other words, about the social and economic ascent ('graduating' from shopping at Klein's in Times Square 'to Alexanders and then to Loehmann's') of an immigrant whose life had begun in a village in Belarus, escaping the pogroms in 1933 when Sara was twelve and travelling on the S.S. Polonia to Palestine (Maira, like me, was born in Tel Aviv) before relocating to New York in 1954. I once wrote a fan letter to Maira Kalman because I felt such affinity with her work and her person, but she never replied.

And finally: Louise Bourgeois, who felt, as Rosalind Jana puts it, 'both the solace and burden of garments.' In *What Artists Wear* (2021), Charlie Porter describes Bourgeois' small kitchen containing a rail of clothes opposite the gas stove. Like Sara Berman's closet, Louise Bourgeois' clothes rail contains mostly whites: shirts and tops, 'her everyday layers.' In the catalogue to *The Woven Child*—the exhibition of her fabric works at the Hayward Gallery in London (2022)—Louise Bourgeois' diaries and notebooks are copiously cited. Bourgeois writes about her need to preserve all her clothes—even stockings—for decades, 'some are old others dusty/ others out of season others are dirty with/stains in the front' but nothing will make her throw them away, since they are, as she baldly puts it, 'my past.' Bourgeois continued to hoard her clothes until 1995 when, aged eighty-three, she cleared them from her home and took them to her studio in Brooklyn. The lived reality ends and what she calls 'the history of the wardrobe' begins. During the last twenty years of her long life, Bourgeois made works out of these clothes as well as out of exquisite home fabrics that she had also kept for decades.

I was enthralled by the exhibition of these late works, visiting it twice as I was completing the editing of this book. The works I loved best were the ones in which the material and the thinking went hand in hand; often, these were not the largest or the punchiest works. But how I devoured

- the delicacy of the moulding and wadding of faces (those heads, as if bandaged into place, made of towelling fabric or jersey)
- the use of thread and spools
- the recurrence of knits and tapestry
- the woolly figures kissing
- the skeins of thread
- the puffy felty breast shapes
- the appearance of Bourgeois' own silky undergarments and draped linens
- the crocheted, cushiony objects piled into Brancusi-like pillars: soft Brancusi
- the spiders' webs made of mattress ticking
- the amazing drawings and prints on bits of trousseau (pillowcases, napkins)
- the gridded weaves made of fabric leftovers in the studio which was also a sewing room.

And I loved the fact that in her eighties and nineties, Bourgeois was still thrashing through obsessions of the infant with the mother, whose exaggerated breasts materialise a child's fantasy of femininity and maternality; still exploring desire and female sexuality, sometimes through the point of view of the once-upon-a-time child that she was, a fearful vision embodied by those scary headless, handless black stuffed and sewn copulating thugs.

That she imbued these refashioned items with a magical element— call it voodoo, call it fetish—is evident in her writings too, which, like the work itself, thrum both with visceral presence and with foundational loss:

> A newly widowed woman collects the
> Top underwear of her late husband
> Unwashed, and makes a doll with
> Elastic and places it on her bed at his place—
> Smell of sweat—it is a symbol of life
> Smell of feet and caress of feet
> Related to the bring me my
> Slippers.

I love how Bourgeois emphasises the fact that the underwear is unwashed and how she links the smell of her dead husband's sweat and the smell of his feet lingering in his slippers to a bossy speech act that, one senses, might not have been entirely welcome. *Bring me my slippers.*

Bourgeois wrote this short poem in pencil on the back of a pamphlet she kept. The pamphlet, by Werner Muensterberger, is titled *The Creative Process: Its Relation to Object Loss and Fetishism.* Muensterberger builds a theoretical bridge between the fetish in its anthropological sense, and the fetish as a psychoanalytic concept, steering us into his reading of the transitional object in D. W. Winnicott. He argues that 'primitive' fetishism magically reconstitutes the lost love object, in a process not dissimilar from that of the clinical fetishist or, more pertinently still, from the process undergone by a child with her early, treasured possessions. In Muensterberger's view, the inner search for the lost object is a restorative, magical act that also characterises creative work. Looking at Louise Bourgeois' late work, it is easy to understand how such a notion would have spoken to her and why she might have jotted the widow's note on turning her late husband's clothes into a pacifier on such a pamphlet.

I am mesmerised by works that contain this bodily quality of which Bourgeois speaks: of stains or odours, of having been worn or touched, of having had contact with orifices and skin. I am transfixed by the indexical traces of individual lives, how they have unfolded and left skid marks, burn marks, tears. I would rush any day to a place in which such objects were on display: not so much the house where such-and-such lived (too reconstructed, too fake, too dead) but something already avowedly mediated, curated. A museum of crying. An archive of scars. A collection of stains.

In 'A Modest Manifesto for Museums' (2013), Orhan Pamuk turns such a museological desire into a promise. He wants to see museums

filled with humble, everyday things, objects that reveal the stories not of civilisations, but of individuals. Or, in Maira Kalman's words, objects that reveal 'a small and monumental story.'

Pamuk sees such a museum as 'much better suited to displaying the depths of our humanity' than the museums that 'construct the historical narratives of a society, community, team, nation, state, tribe, company, or species.' The manifesto ends with a statement/pledge: 'The future of museums is inside our own homes.'

I know that for me, not all evocative objects—not all the things I need to keep, or have kept, or have kept a record of—are literal remainders in the way of Ian's napkin, of Henrietta's napkin. I know that some are meaningful and mnemonic in other ways, and not for the evidence of corporeality they bear. But I have a persistent attachment to the idea of the body's trace; an attachment to those banal objects that have become, over time, stained with human meaning. Here is a smudge, a blot at once material and ephemeral, marking the place where someone no longer is.

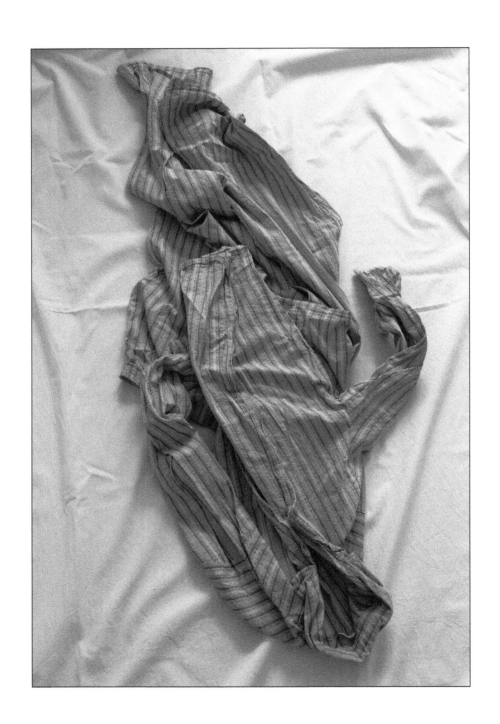

# Unforgotten

A nurse gave me Ian's pyjamas, together with his slippers, his sage-coloured jumper, mobile telephone and a few toiletries in a plastic bag. *Personal effects.* The pyjamas were what he was wearing when he died.

Earlier, she had warned me against staying in the ward while he was being extubated. *Extubated:* a cold, technical term for the process of switching off life support. I had signed the consent form.

Though Ian looked like himself, there was nothing of him left but the shell, the husk. *He'll turn yellow,* she said. *You'll never forget it.* I still thank her for that kindness. I imagine his skin the colour of beeswax, and I walk away. But before that, I put my hand on his familiar hand; a hand large and capable, where specific explanatory gestures lived, where touch of me once coiled. I kissed his brow, which was warm and living, though in effect no longer occupied. I looked at him with quiet, urgent attention, as if to impress on my mind the last signs of his being-in-life. I turned back at the doorway to see again that magnificent nose, the profile on a Roman coin.

There's a private waiting room (is it called a bereavement suite?) where I sat with two of his three children. The third, Ian's second-born son, who arrived late and then ate a curry in the hospital canteen, decided to stay on in the ward, as a show of grit or a kind of penance.

The pyjamas have remained with me. Striped blue seersucker, they are faded and crinkly, faintly yellowed around the neck. They now exist in place of the corpse I never saw. To touch them means to feel again their ridged, nubbly texture and be transported to an earlier time when fabric skimmed flesh. They smell ferny because they have been washed: the stench of hospital and death on them was unbearable. Laundering has removed them from the once-living flesh of my long dead husband.

Why have I kept them? Because they were so close to Ian's dying body, for sure, and to his living one too. Because discarding them would

   https://doi.org/10.11647/OBP.0285.10

have been—or seemed to be—heartless, as though it were Ian's very skin, now flayed, that I would be throwing away. But also, because looking at these pyjamas reminds me of their loose drape on his sinewy, athletic body. Seeing the pyjamas, I also see him. I cannot touch them without having both presence and absence at my fingertips. It is as though some lurking remnant of voodoo grabbed me. To throw these pyjamas away would be to discard the man and the recollection of his horrible death. As though holding the memory in my head—like a reference book, closed but ready for consultation—were not enough.

There is something rigid in this kind of thinking. Rigid with fear; moved by the dread of a loss that has, in effect, already taken place, the mourner's pre-emptive rigor mortis. To lose the memory would be to lose Ian again. To have to grieve all over again. To lose the material object, I am trying to say, might mean to see the memory transformed, perhaps beyond recognition. The fear of this—for there is fear attached to the possibility of freedom—is that such a transformation might signify a failure of loyalty, of love.

Fearing transformation is perhaps what Freud means when he writes in *Mourning and Melancholia* (1917, 2001) of melancholia not as a state that skirts close to the edges of mourning, but as its opposite: a condition of being stuck in a kind of self-absorption that hinders the work of grief, of mourning, *Trauerarbeit*. Mourning is, for Freud, a labour that a bereaved person must undertake, a process that begins with the removal of the love object (which, in death, it occurs to me, must always be sudden, however slow the process of *dying*). It is always a caesura, its distance from life and the living immeasurable. And we each suffer the anticipation of our own death as something at once unique and generic, personal and impersonal.

In *The Undying* (2019), having undergone aggressive cancer treatment, Anne Boyer writes beautifully of this dialectic. Death, she says,

> is both universal and not. It is distributed in disproportion, arrives by drone strikes and guns and husbands' hands, is carried on the tiny backs of hospital-bred microbes, circulated in the storms raised by the new capitalist weather, arrives through a whisper of radiation instructing the mutation of a cell. It both cares who we are, and it doesn't.

But although life and death are binary, our affect is not; our attachment to the living person whom we love is not amputated when they die. On the contrary, cathexis—the Freudian term for the concentration of mental or emotional energy on a particular person, idea or object—is not easily abandoned; not even, Freud tells us, when a substitute love object is already beckoning. As part of a process of disinvestment from a love object that has disappeared (by death, abandonment, or betrayal), the task of mourning is one in which you keep rehearsing that loss through repeated acts of reality-testing. It is carried out 'bit by bit and at great expense of time and cathectic energy.' Finally, the truth sinks in: the object of your love is well and truly gone.

Is this what is meant by closure? In the Freudian account of mourning, ideally—if the person lost is a chosen love object rather than someone structurally irreplaceable, such as a parent, child, or sibling— you gradually become free to re-attach to a new object. I am not sure what you are supposed to do when a sibling or a child dies; I think in important ways, many people never recover from such a loss. But with lovers, being able to attach to a new object is what is clumsily called *moving on*. Things are not always that clear-cut, but in theory at least, the beloved is dead or as good as, and then we learn through our suffering— through our mourning—that we ourselves are fully alive. In leaving me, P's parting shot in an email of dispatch entailed an expression of regret for not having given himself more time to mourn his wife.

And yet, pace Freud, bits of your lost love remain attached to you, like flesh to bone; fragments that are so meshed and integrated with your being that you would not want to shed them. P would occasionally call me by his late wife's name, or I would sometimes call him Ian, each of us, though apparently in love with the other, still somewhere clinging to the lost partner. 'When I'm drunk,' writes poet Don Paterson, 'the ghosts of all my old lovers file through me one by one; I realize I had never stopped loving them, only buried them alive in me.' I do not need to be drunk to access that vivisepulture. I have never had much patience with the notion of closure: I believe the dead—and also the lost undead—continue to reside in me, perhaps more at rest, or simply tucked away somewhere deeper, snoozing.

The pyjamas I have kept, I now think, are less a reminder of Ian than a token of memory itself. They reveal to me how tenuous my belief in my

capacity to hold onto inner objects without such outer props is. 'Even now, when I try to remember,' writes the listless, unnamed narrator of W. G. Sebald's *Austerlitz*,

> the darkness does not lift but becomes yet heavier as I think how little we can hold in mind, how everything is constantly lapsing into oblivion with every extinguished life, how the world is, as it were, draining itself, in that the history of countless places and objects which themselves have no power of memory is never heard, never described or passed on.

To rail against such bleakness, to be heard or passed on, it seems, the extinguished life has to be described, recorded, written, rewritten. It must enter into, and operate within, a signifying network, which is also a web of innumerable transformations. Thoughts and associations must be allowed to ebb and flow, to shift and change form if they are not to risk settling and finding their home on a site of amnesia.

In being associated first with Ian's living body, then with his corpse, later finding themselves in a drawer, then being unpacked and spread out for a photograph, Ian's pyjamas have turned from possession to still life. I find myself considering that move from material ownership to an art form, a genre that is verbally characterised by its immobility. And I wonder now if my attachment to the art of still life—to the stilling of life in objects selected for that purpose—might not always be a way of thinking about stasis, but also about its opposite: change.

# Still(ed) Life

Still life painting—especially that by the Dutch artists of the seventeenth century—seems to be about the quiddity of objects. There appears to be something staunch and immovable in those exquisite panoplies of natural and wrought things. In his beautiful poem 'Realism' (1995), Czeslaw Milosz says that 'we are not so badly off, if we can/Admire Dutch painting. For that means/We shrug off what we have been told/For a hundred, two hundred years.' The things captured in the paintings enable us to brush away hearsay and see the things for what they are: 'this here:/A jar, a tin plate, a half-peeled lemon,/Walnuts, a loaf of bread, last—and so strongly/It is hard not to believe in their lastingness.'

*This here*: the thingness of the thing, as it exists in the present moment. Pieter Claesz' lemon, or Manet's, or Maira Kalman's, or the one you

have in a bowl with three others, standing cool on a kitchen windowsill. You will believe in the lastingness of things, but look closer and you will see the worm in the fruit, the tear in the silk, the blossom about to turn, the drop of water soon to evaporate. Transformation—which is also putrefaction, death—is everywhere in these paeans to the riches of the table. The sufficiency of things, and their transience, both. In this sense, the objects of still life are like the objects of memory: apparently stable, they are in fact nothing if not mutable.

Being separated from the world—traditionally, set apart on a table—the objects of still life speak to us of the mundane, of the reassurance of ordinariness, of the continuity of lived experience. Historically, representations of the routines of daily living and the discourse of the unexceptional were known under the banner of *rhopography*, from the Greek *rhopos,* meaning trivial objects or trifles. Such a discourse was pitted against that dealing with exceptional acts of unique, fearless individuals (*megalography*) as represented in sculptures of classical antiquity and the Renaissance, or the genre of history painting. Epics. Battles.

However, there are artists who labour specifically to erase the historical distinction between the unique gesture of heroic actions and the commonality of everyday things. They show us that to focus on the specific can be a way of addressing that which is shared, common to many. To examine closely the ways in which individuals express their self-experience through the objects with which they engage—through the still life that stands for them—becomes a form of engagement with metonymic portraiture. You capture the person and her life through the objects she touches or uses, the things that, in that transfer back and forth between the visual and the tactile, come to describe her.

Numerous photographers working in different idioms have conjured unique experiences by training their attention to the small, constituent parts of a subject's personal idiom. What he wears. The implements or tools she uses. The things they put down on a table. In such works, the clothes and belongings of an individual present themselves to the viewer as proxies, standing in for that particular human presence. And if they communicate something of the dilated time of non-events—of nothing-in-particular happening—they are also often crisscrossed by traces of something-having-already-happened. An event that already was. Sometimes, a violent event; sometimes, death itself.

My photograph of Ian's pyjamas, crumpled on a white sheet laid flat on the floor—its ironed folds visible in the soft light, its allusion to a winding sheet manifest—becomes a still life that participates in a particular, if discreet, tradition of contemporary still lifes: things of the dead. Each of these still lifes stands on the site of a loss, representing its own contiguity with a once-living body.

## These Are Works that Move Me

a) In 2006, Swiss photographer Peter Püntener made photographs of clothes, shoes and other personal belongings at the Krajina Identification Project. Established in 1996, the remit of this project was to assemble and process the remains of those killed in the Balkans War. In a former industrial building on the edge of the Bosnian town of Sanski Most, human remains were gathered and arranged on trestle tables: skeletons, many of them missing bones, positioned as though in silent anticipation of an anatomy lesson. A single bullet has blasted through each skull. At the foot of each trestle table, dusty, torn and broken possessions and clothing found with the exhumed remains are gathered. Post-mortem examinations, ante-mortem data and DNA reports are collated and the results coordinated by local identification authorities in an attempt to return newly identified remains to families. This is the raw material of Püntener's work.

The items of clothing lie spread on white fabric body bags set against a speckled ground. The nature of Püntener's scant intervention in setting up the scene of the event of photography is tactile: Püntener picks up the dead person's belongings and rearranges them in a particular way, turning forensic document into work, mere things into a rudimentary still life, megalography in rhopography. The identical formatting of the individual images grants the pieces together the sense of a unified series, a listing linked by simple compositional and structural criteria. No information about the fact-findings or the deceased person is legibly included in the photographs; any relevant text is blurred. Püntener explains that this is because these cases might come to be used at the International War Crimes Tribunal in the Hague: 'the hand-written words you can still find on the white body bags represent a common religious farewell greeting to honor the deceased person.'

Clearly, though adhering to some of the protocols of conceptual art—the serial form, a coherent set of criteria, an apparently affectless approach—Püntener's work can only be considered art insofar as it is also already activism, intrinsically political. Its title amounts to an accusation: *Totenklage* translates as 'the lawsuits of the dead,' claims or actions filed against unnamed perpetrators in the name of dead victims. It is as though each photograph were also an accusation, a speech act. Like Kiki Streitberger's images of the belongings of Syrian refugees, Püntener's view is aerial. And like Streitberger's, the photographic prints invite viewing vertically in the conventional manner of pictures on walls, images in an art gallery or museum, enlisting complex sensory, personal and cultural associations.

In the grim pastiche of a still life—inert items spread out on a tablecloth—Püntener has arranged and composed the torn and stained remainders of clothes and belongings in such a way as to establish a meaningful corporeal syntax. Shirts are positioned above trousers, skirts above shoes, at once idealising and parodying the contents of the body bags. These compositions attest to the tactile relationship between the possessions of the dead and the photographer, his delicately corporeal intervention as he lays the clothes meticulously. We see in their arrangement Püntener's care, and we are quietly invited to imagine what it might be like to engage so intimately, so physically, with the belongings of ones who, whilst wearing or carrying these items, died so violently.

b) Seventy years after the dropping of the atomic bomb on Hiroshima, Japanese photographer Ishiuchi Miyako travelled repeatedly to that city to photograph objects that survived the bombing and are now housed in the Hiroshima Peace Memorial Museum. There are 219 photographs in the series ひろしま *hiroshima* (2007–2014) and they are either framed in white and unmatted, or unframed, thus to be hung on walls.

These images belong to a recognisable genre of Hiroshima photography, where, over the years, attention has moved from people to objects and then back again. But in several ways, Ishiuchi's photographs diverge from that genre. She uses no situating text—no captions or narratives associated with the display of such artefacts—allowing only the name of the owner of the thing, when known, to be included in her titles. The souvenirs of atrocity include a fragment of denture; a comb;

a broken watch; an embroidered cloth handbag; torn shirts; flimsy dresses; seared socks; a suitcase handle; shoes; buttoned gloves. In some of the close-ups, she isolates fragments such as tears, hems, borders, buttons, selvedge. Silk, organza and linen are stained, scorched, frayed, shredded.

Mostly, the garments and objects selected were once owned and used by women. It is not only materially, but also semantically that Ishiuchi focuses on the experience of the women of Hiroshima. ひろしま *hiroshima*, her title for the corpus, contains both Japanese rōmaji characters and hiragana characters. Hiragana, a syllabary that is one component of the Japanese writing system, is derived from the cursive script of Chinese calligraphy, and was historically used by women, who were not granted access to the same levels of education as men. Famously, in the eleventh-century *Tale of Genji* and other early courtly novels by women writers, hiragana was employed extensively or exclusively.

As in *Mother's*, the earlier series that Ishiuchi Miyako made using her dead mother's belongings, the items in ひろしま *hiroshima* reveal traces of intimate ownership. The photographer comes up close to these objects (I find riveting the shots showing her at work: no tripod, just her body bending over the things in a way that seems informal, personal, intimate). And she brings us up close with her: each image addresses the viewer directly, privately. Frequently, the items are cropped by the frame, almost filling our field of vision. The monstrosity of the bombing is implicit not only as a scarring of surface, but also as an omission: that which is left unsaid, outside the frame.

Each item issues an invitation to empathy through sensory engagement. In touching the frame or being cropped by it, each piece exists as pure foreground, implicating the photographer's body, and that of the viewer as well. Ishiuchi's sensuous absorption in the relationship between transparency and opacity draws the viewer's close attention to the material item in the present tense, leaving its relationship to a moment of horror in the past implicit. And it comes as no surprise, seeing the epidermal effect of these friable clothes, that for over a decade, Ishiuchi also worked on a series of close-ups of scars (1991–2003).

The scrutiny that the viewer is invited to lavish on the work is honed by the lighting of each photograph. We can see the seams, the weave, the translucent surfaces, fine as skin. More dramatically than Püntener's

images, because more explicitly 'beautiful,' Ishiuchi's photographs engage with the question of the aestheticisation of horror that has vexed so many twentieth-century critics of images of extreme suffering. Rather than turning her back on such aestheticisation, Ishiuchi presents it as an abrasive ethical challenge to the viewer.

Although the photographs of Ishiuchi, like those of Püntener, are linked to a specific historical circumstance, in their simplicity and the direct ways in which they attest to a collectively experienced catastrophe, they also suggest the universality of suffering. In her film *Things Left Behind* (2013), Linda Hoaglund observes that these photographs prompt us to imagine ourselves in the fashionable, beautiful clothes and shoes that Ishiuchi photographed. We then become subjects implicated in these works, and by extension, unwittingly imperilled by catastrophe. We become, to borrow a phrase from French philosopher Michel Serres, subjects born of objects.

Ishiuchi—who has stated that for her, photographs function in both form and content as traces of time—photographed her selected objects backlit on a lightbox. As the series progressed, she began to arrange them on tracing paper placed on the floor of the museum, relying mostly on ambient lighting. This change suggests a desire to remove the objects from associations of art and artfulness, offering them as objects of a more intimate and direct address. Amanda Maddox, Associate Curator of the Department of Photographs at the J Paul Getty Museum in California, where Ishiuchi's exhibition *Postwar Shadows* ran in 2015–2016, describes how the photographer squatted and knelt beside the items of clothing 'to inspect the tears and holes caused by irradiation, as well as the intricate, handmade qualities visible in the stitching, patchwork, and mending.' There is, in Ishiuchi's low-tech method, a bodily identification with these fragile, ruined items; a tender and personal approximation as she touches them, arranges them, frames them.

In these delicate yet lapidary objects, the atomic explosion has dramatised *in extremis* the separation of a time before from an ever-after. It seems to me that, in materially embodying that moment of catastrophic and consequential arrest, these objects take on the historical condition of photography itself, the way in which, in a single click or flash, photography brings about an abrupt cessation of the ongoingness of time. In that historical condition of photography,

the past is momentarily illuminated, flashes up, and then is at once extinguished and memorialised. The present tense of the photograph is a static arrangement of fragments, of parts. 'Here and formerly,' is art theorist Thierry de Duve's fabulously succinct formulation for such a temporality.

c) While Püntener and Ishiuchi's bodies of work attest to collective catastrophes, British artist Peter Watkins explores an experience of personal catastrophe: the suicide of his mother when Watkins was nine years old. Ute Watkins walked into the North Sea from a beach at Zandvoort in the Netherlands. Watkins has suggested that the form that her suicide took represents how existentially torn she felt between Germany, where she was born, and Wales, where the family lived; the drowning might have resulted from a confused idea of 'trying to make her way home, to swim across the North Sea back to Wales.' She had been diagnosed with schizophrenia in her late teens and had experienced a relapse shortly after Peter's birth. Her suicide occurred, in the words of her son, as the 'culmination of several months' struggle' with a new recurrence of her illness.

> she moved between her native Germany and Wales, between different houses and hotel rooms and two psychiatric wards, as the family tried desperately to take control of her deterioration. She no longer went by her Christian name, 'Ute,' but by 'Suzanne,'—her middle name. She was restless and manic, and seemingly heartbroken.

*The Unforgetting* (2011–2014) is not only a pained gathering of physical fragments from Ute Watkins' life, it is also, as the title suggests, a meditation on the precariousness and paradoxical workings of memory. It is an elaboration on the unforgetting that is the guilty premise of Peter Watkins' very existence, the burden of his having been born.

The title of this body of work is drawn from French writer and film maker Chris Marker's cult film *Sans Soleil* (1983) in which the narrator says: 'I will have spent my life trying to understand the function of remembering, which is not the opposite of forgetting, but rather its lining. We do not remember. We rewrite memory much as history is rewritten.' In appropriating and stretching Marker's idea, Watkins accommodates two propositions—remembering and forgetting—and their distinct negations.

*The Unforgetting* signals a purpose: to reverse the forward momentum of forgetfulness as it careens toward complete obliteration: oblivion. Is remembering the same as un-forgetting? The latter implies the removal of a block, an impediment, an obstacle. And an obstacle may well be, as psychoanalyst Adam Phillips has suggested, that which unpacks a desire, reveals it. With this title, Watkins suggests not something completed, but an ongoing process, undoing and dismantling the things that stand in the way of the child's development; things that impede the expression of *this* child's desire for his mother, whose self-willed death has both accused and excluded him, frozen him in his tracks, in the time of his childhood.

Peter Watkins' memories are filtered through evocative objects that situate his mother existentially, bureaucratically and experientially. He uses both found photographs and ones that he has artfully composed and made. We see Ute as a young girl, then as a beautiful young woman, presumably not too long before she died at the age of thirty-four. The objects depicted include an audio cassette tape and a Panasonic cassette player: his mother was a linguist and used to teach herself languages by recording her own voice. But the tape in the photograph was, Watkins tells Pauline Rowe,

> actually a mix tape that she had made, and left in my grandmother's car, and as the radio never worked, this became my soundtrack to the project. Another tape I have is of me, at two years old, singing nursery rhymes with my mother, the only recording I have of her voice.

A list itemising his mother's possessions found at the time of her death, reads as a poignant portrait. It includes

- an orange pocket torch
- three identity cards
- a set of house keys
- bank withdraw slips
- Hospital Personal Patient's Card
- a pack of Wrigley's Doublemint chewing gum (four sticks remaining)
- two grey-and-orange Lufthansa pens

Ordinary and resistant to poeticising, these listed objects, considered in the light of the son's desire to hold onto the memory of his mother, suggest that there is no guaranteed continuity between a material prompt and a reliable memory. Remembering and forgetting are each lined with the other: they wrap around each other, get folded and creased, furl together like a Möbius strip. Together, the four terms remembering/ unremembering/forgetting/unforgetting build a fragile and changeable mnemonic structure.

With formal severity, Watkins trains his attention onto a few objects, removed from their everyday contexts in the manner of the most abstract of still lifes. Captured in black and white, the images of Ute/Suzanne's possessions have a pared down and emotionally restrained quality. Wood features in many of these images as a warm, tactile material that also, for Watkins, stands for his mother's German identity. A small selection of impossibly floating books describes Ute as a reader. Then: a satchel; furniture covered in sheets; an obituary notice; small formal glimpses of suburban houses; indoor plants; an accordion and a baptismal dress, an item linked to a Christian ritual that eerily prefigures Ute's death by drowning. The black and white photograph of the baptismal dress is embedded in yellow Perspex, like an insect caught in amber. To some, this touch of colour might suggest sunshine or life itself, but to me, this yellow is the colour of jaundice and extubation, the colour of panic.

In these formal, subdued works, the freeze action of photographic capture both memorialises and stands for the sudden ending of Ute Watkins' life. Her son has created a spellbinding photographic installation that yokes intense emotion to its wilful inhibition. Stylised groupings of objects are interrupted by elusive, equally still portraits. Among the portraits, there is but a single one of the artist as a young man. Dated 2011, it shows him stripped to the waist, seated on a hard wooden chair, his fists clenched. Turned away from us, he allows us to see his back, which bears the large circular scars of cupping, a Chinese treatment for depression. The reticence of this image is, in part, a matter of point of view. Watkins positions himself at a distance, leaving the viewer at arm's length, refusing to submit to the temptation of close contact. This self-portrait with scars communicates a sense of profound isolation and vulnerability, a traumatic silencing. The tension between a desire to withhold (the face wilfully withdrawn from view) and the

wish to communicate (almost turning around) resonates outwards from this individual image to touch the entire body of work.

*  *  *

In all of the works that I have addressed here (Püntener, Ishiuchi, Watkins), the material objects in the image occupy a locus of radical loss. Each body of work—that corporeal metaphor for an aggregate of works is so apt here—addresses, in other words, the material expression of a violent loss of life. Each invites the viewer's attention to oscillate between the evocation of a particular deceased subject or subjects (Watkins' mother; named victims of the bombing of Hiroshima; Bosnia's missing, unnamed dead) and the impossibility of those subjects being fully or even adequately represented. In different ways, then, these works suggest the tension between an essential remembering and an inevitable forgetting. And that relation is configured, I think, as a relation between the visual and the tactile.

Writing about Peter Watkins, Benedetta Casagrande pays particular attention to the tactile. 'In dealing with things that have been left behind by our dead,' she writes,

> it is not so much the visual but the *tactile* which provides a posterior connection to whom we have lost—our hands discovering the surfaces which have been touched before; the gesture repeated in a ritualistic manner stretching through generations; an imaginary contact between our body and the body which we can no longer touch.

It is *the body which we can no longer touch* that remains, insistent as a ghost in the works of Püntener, Ishiuchi and Watkins. And indeed, thinking back to an earlier chapter, this is also applicable to the work of Carol Hudson, Rosalie Rosenberg and Tina Ruisinger.

I become especially interested in this aspect—the question of touch—at the time of writing, when, under the rules of social distancing, all bodies are bodies that I cannot touch.

With our lives shaped and altered by the Covid-19 pandemic, I find that such works—works about the evacuation of the body—have a particular resonance, a special poignancy.

For months on end, I am the only human in a large house.

I remember reading somewhere how lanugo, that fine body hair that human foetuses develop in utero, enhances comforting sensations of

being wrapped by amniotic fluid, serving as earliest precursors to the pleasure and security of being held, or later, embraced. I touch Monty, of course, and animal touch in some ways is everything: I note the place where the softness of his ear brushes against my thigh, or where his chin is cupped by my yielding flesh. My consciousness is attuned to the sinews beneath his fur. I find endearing and frankly laudable his need to be in the same room as me, and *quite* near, but not as close as I would sometimes wish. Monty cannot hug me, his touch has purpose for him, but is not purposeful in relation to me.

In being unseen and untouched by other humans, I feel a little disjointed, alienated, expelled from myself. 'When, in a room by ourselves,' writes Gabriel Josipovici, 'we reach outwards our hand in a mirror and meet only the coldness of the glass, we do not call that touching.' I can make myself come, but I cannot embrace myself: the limitations of touch test the limits of my self-containment, my autonomy. During lockdown, we are all caught in webs of meaning woven around the concept of contagion, whose etymology links *touching* with *together*, and whose cure is a kind of banishment.

I am drawn, then, to these works not only for the ways they track a relationship between a body and its absence, but also for the ways in which they talk to me of the present time.

Our moments of remembering and forgetting, of erasure and excavation.

Our oblivion and our unforgetting.

We handle the possessions of those who have died, and in that tactility and materiality, we nakedly feel our losses.

In folding away again Ian's pyjamas, I am aware of how I have grown accustomed to a world in which he is no longer present.

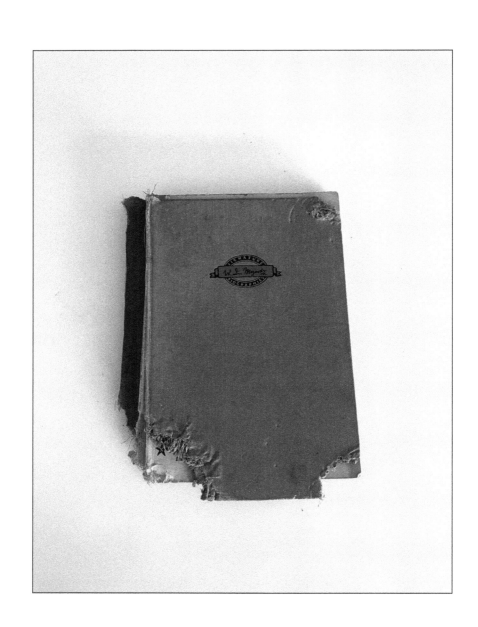

# Time

A body one can no longer touch. A spot where someone once was. A mark of someone's once-having-beenness: how could such absences not fill one—fill me—with bewilderment, with a sense of the incommensurability of loss?

With the death of my dog Kali (though I balk at the possessive pronoun, for certainly I was hers as much as she was mine), the gnawed toys lying around the house turned into bruising reminders of the scope of her life and the range of my love; reminders of attachment and dependence. And it has been the same with all subsequent dogs who have cohabited with me. Fairly neat by inclination, I'm lax about the bedraggled items the dogs have, over the years, left lying around. I do not try to impress upon them—these dogs—the orderliness of my domestic habits. When Monty, the current incumbent, chooses a battered thing from his big basket of recreational artefacts and brings it onto the sofa where together we sit of an evening, I swell with pride at his intelligence, his understanding that now is the time for end-of-day pursuits. He's hidebound that way. He'd bring out a pipe and newspaper were he so inclined.

Of all the doggy playthings to which I am attached, those that are most broken have pride of place in my private museum of memorabilia: a wool-feathered fragment of pheasant, half the ear of an elephant, the eviscerated pelt of a giraffe, a bunny tail, the paw of a hedgehog. A carnage of fluffy bits. Given to dogs as comforters, these toys have been yanked and nibbled, nuzzled and shredded. There are soft scraps of felted and furred fabric around the house that, at first mashed and soaked in saliva, dry into tough parchment. In the field of child development, such objects of attachment would be described as transitional.

To be transitional, an object must be linked to maternal care; it must have a tactile nature and must have been selected by the child within a

 https://doi.org/10.11647/OBP.0285.11

continuum of behaviour that begins with the sensation of being held; with feeling contained and safe. I find that this is easily translatable to canine behaviour. For dogs, negotiation with that object occurs in a context of general wellbeing: you won't see a fearful dog playing. It seems to me that for a dog, while standing for prey, a soft toy is either an object of self-comfort or an instrument of darting negotiation with humans.

My dogs, as chance would have it, have always been spaniels or spaniel crosses. Each one has taken possession of plush toys (invariably representing animals) by practicing the devotion of blinding and disembowelling the creature and removing its squeaky voice. I retrieve beady eyes and wadding spread on the floor. Later, the dog will shake and thrash and pull the thready viscera triumphantly, only to tease humans with them, inviting play. Daring me to want those things, to want them *badly*. Sometimes—and Monty is expert at this—the dog will use these gutted parts to preen before visitors or present them as gifts: trophies imprinted with ancestral memories. Then, they will settle to a long session of nibbling and sucking and chewing.

In ways usually less dramatic than dogs' toys, our things bear—visibly or invisibly, in filigreed, layered webs—the traces of actions. Objects get bashed or broken, worn or threadbare, scratched or stained; colour rubs away, matter encrusts, deteriorates and dissolves. Such marks of friction expose the immersion of all our objects in the corrosive bath of time. We either take this on board or, if we become obsessed with the stainless and immaculate, in a fever of consumption, we discard our things and buy new ones.

But it is not the case in all cultural contexts that flawlessness is privileged. I learn of the traditional Japanese concept of *mottainai*—regret over waste—appropriated and used motivationally by environmentalists. It is also the Japanese who have developed a way of welcoming brokenness and absorbing it into the famous aesthetic of *kintsugi*—the art of visibly repairing ceramics—where a resin mixed with gold dust is used as an adhesive for the damaged pieces. The random, lucent network tracks the places of brokenness and instead of attempting to disguise them, acknowledges them in gold. *Kintsugi* openly avows the transformation of objects over time and the part played by brokenness in their very thingness, their new wholeness.

The beauty of objects repaired in this way—the exquisite delicacy of the gilded veins transforming accident into purpose—attests to value as something impermanent, shifting.

You see this in museums too, when painstaking repair of objects remains discernible. Museums showcase not only their ostensible objects (and here I am using *ostensible* to display its own etymology in the Latin *ostendere*, to show), but also the fact of their temporality; not only the historical time of their fabrication, but their duration as each object inches towards its inevitable disintegration.

In Hannah Khalil's play *A Museum in Baghdad* (2019), we follow the lives of two women, British archaeologist Gertrude Bell, one of the founders of the Museum of Baghdad in the 1920s, and contemporary Iraqi-British archaeologist Ghalia Hussein, attempting to reopen the museum after wartime looting in 2006. In the cross-cutting and interweaving of the two timelines, the play addresses the narration of nation, the legacies of colonialism and the consequences of war. In the staging of the play by Erica Whyman at the Swan Theatre in Stratford-upon-Avon in 2019, sand served not only as a predictable enough metaphor of time, but—in a fast and steady downward stream at the end of the play—also suggested the relentlessly entropic way in which, over time, everything moves toward burial, disintegration, annihilation.

What is the time of an object? Temporal layers attach to objects like sediment, like dust. And some objects are overtly, visibly marked by different temporalities, displaying evidence of their own ruin. Curated by Edward Bleiberg, *Striking Power: Iconoclasm in Ancient Egypt* was an exhibition of damaged artefacts held in 2019 at the Pulitzer Arts Foundation in St Louis. With objects selected from the Egyptian, Classical and Ancient Near Eastern collection at the Brooklyn Museum, the exhibition tracked the widespread pattern of deliberately targeted defacement and destruction of Egyptian statuary, especially of figures of royalty or deities. The consistency of defacement of the noses of sphinxes and pharaohs, even in flat reliefs, suggested, for Bleiberg, that such statuary was vandalised to reduce the symbolic power of these figures. The display clearly spoke to other, more recent acts of violent iconoclasm.

Crucially, in this aggregation of broken things, works were taken out of the habitual museological context in which their historical origin

is explicated in wall texts and relocated within a narrative context underlining the politics and temporalities of destruction. But all objects in museums, by the very fact of being in a museum, are enmeshed in histories of displacement and migration, subject to the vicissitudes of ideology and the bullying mechanisms of market capabilities. All are, in short, subject to time.

On an intimate register too, every damaged object speaks of time. Look at the photograph heading this chapter: to the time(s) of reading and the time of destruction might be added that long duration through which the book's cover has gained its marks and stains, its pages yellowing over time. Every evocative object lives in several temporalities: varied times of doing, other times of undoing. Times of being ignored and times of provoking thought.

As things with which to think, evocative objects might also be described as thinking things. 'We think with the objects we love,' writes Sherry Turkle; 'we love the objects we think with.' In this sense, our evocative objects are like poems: amazing condensations, each—would it be an exaggeration to say?—a small locus of personal transcendence.

This notion comes into focus as I follow a thread in poet Brian Blanchfield's incomparable book, *Proxies: Twenty-Four Attempts Towards a Memoir* (2016), Blanchfield mulls over the formulation of a teaching colleague: 'a poem is a thinking thing.' In this phrase, Blanchfield hears 'both the poem's instrumentality for thought (it's something with which to think), and the processing of its materials (it's something that conducts thought, as if independently.)' Blanchfield titles the book's epilogue *Correction*, and in it he re-examines the material of all the preceding chapters, composed without recourse to the Internet or any other supplementary reference material (the words 'Permitting Shame, Error and Guilt, Myself the Single Source' standing as the epigraph to each chapter). In these corrections, Blanchfield checks his recollected material against the bibliographic sources that have informed his rich, broad-ranging associations. *Proxies* also speaks, then, of Brian Blanchfield as a reader. In the *Corrections,* he properly quotes Muriel Rukeyser, who says that poetry taps into something that is both unknown and known: 'that is the multiple time-sense in poetry, that is the ever new, which is recognized as something already in ourselves, but not discovered.' This is very similar to what, in a different context,

psychoanalyst Christopher Bollas calls the unthought known. Things that we apprehend unconsciously, but that continue to remain in the shadows of cognition; things for which we lack the tools of verbally articulate knowledge.

As a temporally complex thinking thing, an evocative object, like a poem, is a construct that uncovers as it abbreviates, channels as it transfigures. A thing through which we recognise that which might otherwise have remained mute. As with poems, we recognise but cannot prefigure the object's intertwined temporalities and woven meanings. Our most unassuming material possessions, addressing sight and touch, taste and sound, might reside quietly, unobtrusively, at the centre of our lives, and then over time, come to gain the patina of the evocative object. If our exposure to them occurs after an interval of time, this nudges us, eliciting stories that are not always self-same, even as *we* are not always self-same. In returning to them, we re-tell them. In this sense, evocative objects gain their comprehensive meanings in their association not only with thought and feeling, but also with words.

If you take the old-fashioned word *corsage*, and think of it as a souvenir, say of a particular ball on a particular evening, that corsage evokes a range of increasingly abstract qualities; it is, as poet and literary critic Susan Stewart puts it, metonymic to an increasingly lost set of referents: 'the gown, the dance, the particular occasion, the particular spring, all springs, romance,' and so on. But add a verb to *corsage* and something else happens, bringing it into the present. In her essay 'On Sentimentality' (2012), poet Mary Ruefle explores the sentimentality which, she suggests—undoing the negative connotations of this term—is of the very essence of poetry. It is terribly insufficient, she says, 'how an image of a crushed corsage [...] cannot recreate or give more than momentary value to the event it evokes in the mind of the retainer.' And yet the crushing of the corsage does embed it in time, in event, in association, and finally in memory.

The association of nouns and verbs (*corsage* with *crush*) in evocative objects—things upon, with, and through which actions have taken place—needs to be pinned down if it is to be communicated beyond the immediacy of its first appeal to the notion of time passing. In this sense, just as photographs require captions if they are to serve a testimonial or documentary function, the duration and temporalities of an object

require the verbal mesh of story if they are to evoke more than merely the passing of time.

Who crushed the corsage? Why? How does it come to be lying on this stretch of road?

# The Book of Our History

Published in 1955, *The Story of Mozart* has been in my possession for over half a century. It's a children's book written by Helen L. Kaufmann, who, I see, has also penned the life stories of Beethoven and Haydn, *The Little Book of Music Anecdotes* (1948), and other abbreviated histories of, and companions to, classical music. *The Story of Mozart* contains nondescript black and white line drawings by Eric M. Simon. There are clumsily rendered, stiff-backed people: the men in wigs and breeches and shapely, waisted coats, the women in petticoated gowns and mob caps. My favourite illustration shows a young Wolfgang, dressed like a little man and jumping into a puddle. '"Watch me, Papa," he yelled, waving his arms' reads the caption.

The font used in the book is large and serifed, the story simply and episodically told, with only tiny fragments of historical context. Papa is authoritative and Mama packs little Wolfgang's best suits for his tours. Wolfgang's sister is systematically called Nan rather than Nannerl, as though the Teutonic nature of her real name would prove too great a challenge for young English and American readers. Little Wolfi is instructed to take off his hat and bow low to the Emperor Francis and Empress Maria Theresa in Vienna.

The book captures, in broad lines, the rise of a prodigy and his early death: 'Wolfgang fainted over his work. Still, he worked on the Requiem whenever he could. He became so weak that he had to stay in bed all the time. The unfinished Requiem lay on the table beside him where he could reach it by stretching out his hand.' I remember how this first made me feel, reading about a young man dying, a genius to boot, long before I had ever heard the Requiem or known about the role of Franz Xaver Süssmayr in the version commonly heard today. There is nothing in the book about the crude language and vulgar streaks immortalised by Peter Schaffer in *Amadeus* (1979) (did Mozart have Tourette Syndrome?). Nothing about the compositions at the keyboard

being overseen by a mimetic starling in a cage, a starling that he bought on 27 May 1784, and that introduced a *fermata* to a phrase where there had been none and turned a G natural to a G♯; a starling Mozart kept for three years and whose death he mourned more ceremoniously than that of his own father. Not enough about the insanely prolific output, the heavily worked manuscripts showing palimpsests of revisions, the appropriated sounds woven into new inventions; nothing about the operas I would come to love above all others. Actually, there is not very much about the music or how to listen to it, how it is filled with play and laughter and sudden cracks revealing a dark underside, how it can permeate you with wonder: its melodic lines, its rarer moments of counterpoint, its intricate patterns and repetitions, its digressions and moments of pure, sweet melancholy.

Inside this copy, a dedication is written in red ink: *Special Prize awarded to Ruth Rosengarten for excellent progress in Piano Playing. From Ray Smith, Johannesburg, December 1964.*

Like my mother before me, I attended piano lessons from the age of six. A black and white photograph shows me in our flat in Tel Aviv at that age: straight backed, fiercely focused, my hands pitched like tiny tents upon the keyboard. My first piano teacher was a woman of huge height and girth, whose yeasty breath I could smell when she leant over me to correct the shape my fingers made. I don't remember her name.

Mrs Smith was my piano teacher when we first moved from Tel Aviv to Johannesburg in the early 1960s. She was a woman who was surely old, since her hair was a white powder puff. But her dewy skin was pale and unwrinkled. She had the softest layer of powdered down on her cheeks: down that you could only detect when the late afternoon sun leaned in, those searing Johannesburg sunsets breaking into shaded interiors, breaking into your body too. I still attach a feeling of tremendous anxiety to the thought of those sudden Johannesburg sunsets of my childhood. I both longed for and dreaded the faint mustiness of Mrs Smith's cool, tenebrous house and her feathery touch. She wore twin sets in pastel tones that came out of a Fragonard painting, and little angora cardigans that didn't then elicit in me a scream of horror, since I did not yet know of the torture of rabbits that goes into angora production. This association—Mrs Smith and her angora cardie—once sprang to mind

when I heard Tom Waits' 1979 riff in a famous performance of his song
*I Wish I Was in New Orleans*:

> Suzy Montelongo used to wear these angora sweaters. I'm crazy about
> angora sweaters. I guess it's kind of a hang-up of mine. She had angora
> socks, and angora shoes. I believe she was originally from Angora. I don't
> know where she is anymore, but every time I see an angora sweater, I
> think maybe inside will be Suzy Montelongo.

And so, in a fantastic compression, each time I read the dedication in
the Mozart book, I remember Ray Smith, and each time I remember Ray
Smith, I think too of Suzy Montelongo. I think of the nostalgia that wafts
through so much of Tom Waits' inimitable, gritty music and of how P
and I watched Waits concerts on YouTube with our bodies intertwined
in the libidinous heat of our early days—actually I think of P's tongue,
which is certainly one of the best tongues I've known, not too bullying
but not too solemn and passive either—and I think of my tinkly, childish
piano playing and how I loved being praised and strove to do well at
everything just to earn that praise, not ever endeavouring to try my
hand at anything I knew I would not be fairly good at—how good was I
at kissing?—but I was never excellent at playing the piano. And in this
compression of times, I remember Mrs Smith's hands as she turned on
the metronome or gave me lists of scales to practice, written up in red
ink on thin paper glued onto stiff cards. I remember playing nervous
duets in concerts with my friend Barbara, who, I heard, died in 2017 of
breast cancer in Amsterdam. And I remember, too, with twinned stabs
of relief and regret, giving up my piano lessons long after Mrs Smith
had been replaced by Mrs Cloete, realising, as I launched into life as a
university student, that something had to give.

Thought and affect, association and digression are laced together in
my responses, over time, to this book as a particular material object. On
its cloth-bound grey cover, a neat red scroll bears Mozart's signature.
This cover is discoloured, the spine is cracked open, the front is all but
loose, hanging onto the rest by a few threads. The binding has come
unstuck. And on three of the four corners, oh, bliss! Traces of a puppy's
gusto as she gnawed her way through cloth and board, unable to believe
her luck.

Kali, beloved creature, golden cocker spaniel, gentle and submissive.
She was, in effect, a consolation gift from J in 1984, after we had been

trying for over a year to get me pregnant. Eventually, it was at five years that I gave up trying. My nerves were frayed with the frantic daily ritual of thermometers and charts, with squabbles just when my vaginal mucous had the desired consistency of egg white, and when, consequently, I was trying to set the scene for some lavishly unspontaneous sex. In early December of that first year, I had returned to Lisbon, where we were living in a tall building overlooking a suburban railway station: returned from my first ever trip to New York with a suitcase full of exhibition catalogues, treasures from Strand Books and a too-large vintage man's coat.

A photograph taken on that trip at the Egyptian Temple of Dendur, transplanted into the Sackler Wing at the Metropolitan Museum, shows me looking coy and sultry against that ancient, monumental sandstone structure, the raked winter sunlight igniting my long hair.

The temple was built in the first century BC, just after the Roman conquest of Egypt, and the pharaoh depicted on its walls is in fact Augustus Caesar. The whole structure was given to the USA in 1965 in gratitude for a vast UNESCO campaign to save monuments that would otherwise have been submerged by the waters of Lake Nasser with the construction of the Aswan High Dam. But in the photograph, I am concerned with none of this: what I am concerned with is modelling the oversized coat that I think of as rather bohemian-chic. Looking at this photograph now, however, what I see in this person, this me, is someone biding her time, distracting herself from the main event, which was waiting for a baby to happen.

Back home. There she was. 'Surely the runt of her litter,' said the vet who checked her. He tried to have us send Kali back, as if one could; swap her for a better specimen. She was small-boned, honey-coloured. Lovely, with her narrow face and extravagantly fringed head, a delicate alien, shitting all over newspapers strewn on the kitchen floor, squeezing herself into a corner where, quaking, she hoped to remain unnoticed.

*What'll I do with her?* I remember asking, scooping her slithery body into my arms, smelling baby fur, foresty breath. Though I had longed for a dog, the reality weighed on me for a protracted moment: all that unsolicited responsibility. But it was just a moment.

*You'll love her*, J said.

And I did. I did.

Kali it was who, some months later, found my copy of *The Story of Mozart* just where I had left it, and Kali it was who, with puppy joy, had her way with it.

'Because (in principle) things outlast us,' W.G. Sebald writes in *Unrecounted* (1991), 'they know more about us than we know about them: they carry the experiences they have had with us inside them and are—in fact—the book of our history opened before us.' They are testaments, testimonials. This particular, material version of *The Story of Mozart* is the book of the book of my history, a reminder of trajectories, but also of roads blocked, directions thwarted.

I have not seriously played the piano since my early twenties.

J and I got divorced in 1993.

Kali, whom I cossetted and adored, is long dead. Her nibbled toys have been passed on to subsequent dogs, joining forces with the cherished trophies of these others. She absorbed and consumed all sense of the maternal I might have once achingly nursed in myself, deflecting the desire for a small human creature henceforth, and once and for all, to the canine.

Every dog I have had since has had to bear the burden of that maternal love.

I left Johannesburg in 1977 and I no longer live in Lisbon either.

I did not in the end—that strange formulation determined by the duration of fertility—have children, thus always remaining a childless child.

This whole trajectory, with beginnings and outcomes, with digressions and re-readings, with finalities contained in verb tenses, is metonymically condensed for me in a single object, a dog-chewed children's book. It is not my whole story, of course, but several narrative strands that are important to me converge here.

I feel their confluence when I take this book out of the calico dust bag in which I now keep it; when I hold it, open it again.

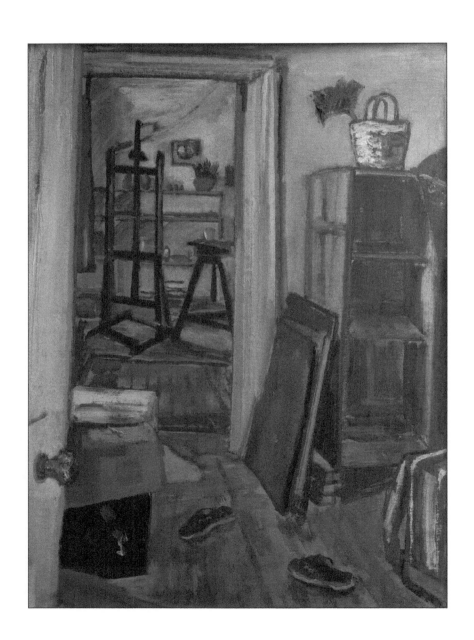

# Studio

I brought only one painting home with me after my mother's death in 2012.

The studio painting arrived at my parents' home when I was fifteen or sixteen, a time when I considered myself variously budding and building up a portfolio of my own: works in gouache, watercolour, crayon and pencil, all on paper. I was experimenting with painterly renditions of things seen or arranged: mostly still lifes, but also a few moody portraits, leaning towards the expressionistic. I remember feeling that this painting of a studio captured something that concerned me, something that incorporated me into its subject matter, since *arty* was already an adjective that others had attached to me. But that word seemed to describe something external—say the beaded anklet I refused to remove—more than the hunger I felt, the urgency to make things and to find meaning in things others had made: books, paintings, music, films.

The studio in the painting is double-roomed, or perhaps it is a repurposed room in a home; it's all rather modest. As viewers, we are positioned on the threshold, at a doorway through which we also see another doorway a little further in, with a room leading off it. I am now familiar with historical uses of this kind of invitation into a painted room, notably in Dutch seventeenth-century paintings—works by Pieter de Hooch or Johannes Vermeer—but also in the paintings of early twentieth-century French painters like Édouard Vuillard, Pierre Bonnard and Henri Matisse. In different ways, these works explore ideas of domesticity. Their address to an invisible, observing eye suggests intimacy, perhaps even secrecy: something discreetly shared between those who inhabit the space and an unnoticed observer whose position I furtively occupy. In this address, it is as though each viewer had accidentally and uniquely come upon the scene, and being arrested

 https://doi.org/10.11647/OBP.0285.12

before it, become a voyeur. I remember that first encounter with this device—the sense of a covertly glimpsed view—in a painting in my own home gave me a rush; a sense of being privy to something special, of sharing a secret with the initiated. This feeling of engagement, I now understand, interpellated me as a viewer, but also spoke to my idea of myself as a future painter.

The studio in the painting is uninhabited, but for all its emptiness, it is filled with humanity and potentiality. In the room that we glimpse through the second doorway stands an empty easel, painted in confident slashes of dark brown, and a tall stool set at an angle to it, as though the artist had just slipped out, taking with her the canvas on which she'd been working, perhaps to look at it in a different light, or from further away, or simply in another context, against a different background. A shelf holds a few modest items of painterly practice: bottles and jars and a fat blue vase containing a stash of paintbrushes, not dissimilar to the container that holds the paintbrushes in my current studio. I have kept this miscellany of brushes even though for over twenty years, my practice has not entailed painting. Sometimes, I use the tougher of these brushes for PVA glue or gel medium when I'm making collages, or (rarely) when experimenting with bookbinding, for which I really lack the patience and precision. In the painted studio, there's also a colour wheel on the wall. How quaintly old-fashioned. Who, today, refers to Goethe's colour wheel?

The front room—the room through which we, as viewers, need to pass if we're to imagine our way into the painting studio—is either a bedroom or a second studio space in which artists must do things subsidiary to, and supportive of, making art: eat, sleep, admin. Store things. Read. Of course, a contemporary studio might well be a rather different kind of space (studios are as historical as other built spaces), even if the artist is a painter. Here, however, the modest site is conceived in accordance with mid-twentieth century tropes of 'the artist.' We are shown a space unencumbered by either domestic or office accoutrements. The casual disposition of furnishing—the improvised nature of these furnishings and other objects—supports an idea of the artist as bohemian, unburdened by bourgeois fastidiousness.

A corner of bed juts into view on the right, with a striped cover (nothing floral or fussily patterned for this artist); two or three boards

or canvases lean against a set of empty shelves that seem to have been fashioned out of wooden crates, atop which stands a basket with a feather duster poking out. Sullenly, the paintings have their backs to us, offering no reward to our curiosity. Perhaps it is one of these that has just been removed from the easel: completed or abandoned in frustration or dismay. On the left, there's a trunk holding two boxes, which provide the two strongest colour accents in the painting: cobalt blue and chromium yellow. Finally, a pair of thong sandals has been left on the floor as though the artist had thrown them off casually. The light suggests that it is summer, and so, we surmise, she's feeling hot. Too hot even for flip-flops. She must be just out of sight, pulling on her work dungarees, bare feet slapping the floor.

The two rooms, then, adjacent and partially given to view, contain items that suggest a time of day, a temperature, a narrativised passage through time. This is a short segment of a day in the life of an artist, conceived or portrayed—clues are thrown around the room—as a certain type of person. What we have is a sequenced series of traces: physical remnants of actions that suggest a type of making, and also a type of life.

This was going to be my life. At fifteen or sixteen, I had a notion of what being an artist was going to be—what it looked like—that came from the few art books I owned, and others I earnestly consulted at the public library in Johannesburg. The fact that I was also an ardent reader and enthusiastic writer was an aside. *Artist* and *writer* were separate things, and I did not bother to think about how those activities might dovetail or speak to each another, or, indeed, get in each other's way.

After I had nourished myself on a diet of art reproductions in books, an exhibition of real Bonnard paintings materialised at the Johannesburg Art Gallery in December 1971.

The art gallery, now in serious disrepair, is in Joubert Park, close to the Bok Street Art School where I attended Saturday morning classes as a child. The park felt edgy then; certainly, it was a place where the inequities of apartheid were at once enacted and erased. But at that time, the symbolic nature of a Lutyens building presiding over a socially and demographically volatile inner-city area, already then bustling with improvised, informal and often transient trade, did not occur to me. It seems to me now that for the entire thirteen years that I lived in

South Africa, I remained in a self-referential, hazy nimbus into which the outside world made only rare incursions. I never considered the fact that, though I was a young woman in Africa, I was transfixed by a lineage forged by, through and for white men in Europe and then America.

I was blown away by Bonnard, and I still am. I was transfixed by the painterly luminosity of his canvases, the spangled showers of pastel daubs out of which intimate scenes bodied forth; I loved the everydayness of the subjects, their reserve. Bonnard's chief female models were the two women in his life, his partner and later wife, the maligned, bath-loving, hypochondriacal Marthe de Méligny (whose real name was Maria Boursin) and Renée Monchaty, who committed suicide, ostensibly for having been spurned; the occasional figure of a man is usually the artist himself. I loved the way this tiny cast of people and things, space and light were simultaneously substantial and the product of a shimmering evanescence of oil paint that erased their hard edges and facticity. I loved the sweet cohabitation of dogs and things in a comfortable middle-class domestic setting that remained strangely withholding. I later came to love this artist's reticence: the extent to which emotion was held back. But in 1972, I would not have put it this way.

At the time I began my fine arts degree, I had not yet heard of Käthe Kollwitz's fiercely anguished, political art or of Paula Modersohn-Becker who painted the first ever female nude self-portraits (including in pregnancy) and who died at thirty-one of complications from birthing; or of *Life? Or Theatre?* (1981), the obsessive, diaristic, confessional graphic novel *avant la lettre* of Charlotte Salomon, murdered in Auschwitz; or of Alice Neel who was soon to paint a nude self-portrait at the age of eighty, or even of Frida Kahlo, to whose work I was first introduced at an exhibition together with the work of Tina Modotti at the Whitechapel Art Gallery in London in 1982. There was no Internet, and my access to painters was via the Department of Fine Arts library, and the art library in town, where I often spent Saturday afternoons. I had not heard of contemporary women artists that I later came to love: Paula Rego, Louise Bourgeois, Eva Hesse, Ana Mendieta, Lygia Clark.

In 1975, Germaine Greer's *The Female Eunuch* (1970) was the first feminist book I read. I remember the excitement of reading that, but I was even more bowled over by art critic, essayist, novelist, poet and painter John Berger's book, *Ways of Seeing* (1972). 'To be born a woman

has been to be born, within an allotted and confined space, into the keeping of men,' Berger said, speaking directly to me. Although I was soon to read feminist art writers Linda Nochlin and Lucy Lippard, it was a man who initiated me into what a feminist art history might begin to look like. A woman, Berger observes, in being continually the object of men's gaze, must also continually watch herself.

> She has to survey everything she is and everything she does because how she appears to others, and ultimately how she appears to men, is of crucial importance for what is normally thought of as the success of her life [...] Men survey women before treating them. Consequently, how a woman appears to a man can determine how she will be treated.

I had no idea, until reading Berger, how I had internalised this model that he so succinctly summarises in *Ways of Seeing*, internalised it to the point of wanting to be surveyed, while being, at the same time, ashamed of a body that strained, above all, not to be scrutinised.

At home, I loved the painting of the studio for the loose, unfussy organisation of its spaces, the paint applied thinly; and certainly, I fantasised it as a woman's studio. Perhaps this was because it was so modest, so unpretentious and amateurish: it did not fit in with the models of bravado and virtuosity that had shaped narratives of male painters. I assumed the sandals to be feminine. Or was it, to my shame, the feather duster that clinched it?

The painting now hangs in my home at the end of a corridor, in filtered daylight. I see it many times a day, and when I pay attention to it, it raises an eyebrow at me, accusing me of having abandoned painting. It reminds me of a time when I would have felt the neat overlap of the words *artist* and *painter*, with painting and sculpture offering divergent paths for mediating experience that, for me, figured primarily as perceptual. That this should have been so testifies, perhaps, to my lack of imagination, but it also speaks of the structuring of the art curriculum in South African schools in the early 1970s, at once untouched by the artists and art movements that were shaking it all up in Europe and the United States (then the summation of everything, the world itself) and heedless of any possible relationship with local traditions, politics, and life in a beleaguered part of the world.

The role of the studio in the social and professional construction of the artist was to change radically over the following decades, though

my understanding of it lagged. But when, in the early 1970s, I was a fine art student pitching my easel in an undergraduate studio in the southern tip of Africa, I was also pitching my easel in Europe, fifty, or one hundred years earlier. This was the studio as the site of a particular kind of experimentation with things seen, or with certain styles of abstract virtuosity. The studio, in other words, was a place from which to consider the world through the lens of an established and narrow canon. South African artist William Kentridge, a contemporary and sometime friend, summarised his experience:

> For a white suburban house the journey through Africa began across the yard in the servant's room. I remember trips to the market in Mbabane with mixed smells of overripe fruit and fresh basketwork; only later I became aware of the sculpture made in Venda and understood that in Africa some people do live in mud huts and herd cattle, though not in the way shown in school films. But then in the heart, in the centre of Africa in the Houghton house, was Michelangelo's *Last Judgement* and Hobbema's *Avenue,* the latter on the cover of *The Great Landscape Paintings of the World,* a book my grandfather gave me.

That this canon should have been structured as a chain of fathers begetting sons was a notion that was consolidated for me in London, where, in 1977, I embarked on an MA in Art History at the Courtauld Institute. But it was several years—perhaps even a decade—after beginning to feel uncomfortable with the uneven gendering of the canon that I came to pinpoint its racial bias as well as its fixation on centres and peripheries, mainstreams and slipstreams. I was, in other words, always a bit behind the curve.

Disappointingly, however, feminism remained something that concerned me privately. I did not learn, at that time, how to politicise it or share it, and though many of my friends would have called themselves feminists, it was assumed rather than being the guiding principle of our bonds of engagement. Looking back, I feel as though I missed out on the 1970s and '80s. I did not have the bones of an activist: certainly, my life in South Africa had shown me that. I never found any form of civic sisterhood, nor did I gravitate towards groups or collectives in which I experienced self-recognition. It feels to me now that I lived in muted solipsism for many years. My friendships with women were then profound and essential, but not political; yet I longed for a life in

which political action and personal passion were intertwined. It existed, certainly, in South Africa in the 1970s, but I was not able to find it; I found it, rather, in books.

It was during my first two years in England in the late 1970s that I first read and fell in love with the writings of Kate Millett and Adrienne Rich. At that time, too, I came in contact with the work of women artists who delved deep into their experiences of womanhood/female sexuality, and who also forged working idioms that were particular to being a woman, at once corporeal and conceptual; works that were fluid, cumulative rather than monolithic, as profoundly personal as they were implicitly political, in a way that I could understand. Works with both guts and brains; works that measured time in the way that women's bodies measured time. Whether made in studios or improvised or staged in various other locations, the works of these artists breached the ideological constraints of the studio as a laboratory for male genius: Nancy Spero, Mary Kelly, Susan Hiller, Martha Rosler, all brilliant in different ways, whether breaking the bounds of a particular medium, or remaining within an existing one differently.

Now in the third decade of the twenty-first century, studios might continue to resemble our romantic, earlier ideas of artists' work spaces, but they may also look like offices, film laboratories, cutting tables, workshops with multiple assistants, foundries, communal clay ateliers or sewing rooms; they may be museum or library stacks, forests or fields, recording studios, architectural sites or digital work stations, while many artists have dispensed both with a dedicated workspace and with devotion to a single medium, or indeed to working singly rather than in teams and collaborations on public sites, in cities and in the countryside. The distinction between arts and crafts has finally been loosened, to the advantage of both. The range of possibilities is exhilarating, nothing like the tight fist of truth to medium that served as a credo when I was first an art student.

The fact that I considered painting in opposition to other forms of making, let alone in opposition to writing, came to obstruct me for at least two decades. By the 1990s, I was labouring to find connections and make pathways between what seemed to be divergent or even mutually exclusive ways of making. But back in the 1970s, I lacked the wherewithal to do this, and I was not aware that there were practitioners—women

practitioners—who were already doing just that: drawing and taking photographs, using found photography, mining archives, working with thread and fabric, writing, stitching, gluing, gathering materials already in circulation, ignoring the binary distinction between art and documentary and between different mediums, exploring process and duration: Hanne Darboven, Sophie Calle, Dayanita Singh, Ann Hamilton, Moyra Davey. Later still—now—countless fabulous younger artists who, in addition to busting genre and medium, also crack apart the binary gender split inherent in the feminism of the 1970s.

I still have an easel ready and waiting, but unused in twenty years; it is time to give it a new home. My workspace is divided into two separate areas, study and studio. In the studio there are four large trestle tables piled with inks, brushes, pencils, pens, watercolours, small gel printing plates, glues, cutting mats, scalpels and scissors. On the floor are many large boxes filled with papers and other found materials sorted into categories. There are shelves and drawers packed with fabrics, papers and filled notebooks, a large plan chest.

In the study, a long, glass-topped desk made of three tables riveted together in a long row and two moveable sets of drawers, all holding open books and piles of papers; a standing desk on which a 27-inch Retina display iMac commands a central position; a wall of floor-to-ceiling bookshelves, all packed; three tall filing cabinets and six short ones, also jammed full; a set of shelves bearing large box files and archive boxes, two printers, one desktop scanner; a day bed with a vintage kantha quilt covering it, cushions. My travels and my adventures in reading, all abbreviated, materialised. There are photographs and framed drawings on the wall.

In short, nothing in these spaces resembles that in the painting.

I stopped painting in 1997, during a three-month residency at Claremont School of Fine Arts in Perth, Western Australia.

Several things became clear to me there, at that distance from my everyday life. I knew I wanted to write, though initially that writing was linked directly to visual images and used them as a support. I made countless watercolours that incorporated text, and numerous others that contained text alone, rendered in watercolour: writing as drawing. I realised that what I had previously seen as discreet practices were in effect practices capable of mutual absorption, infiltration. That these

practices need not present themselves to me in terms of a binary choice. Finding an abundant spilling over of boundaries enabled me to recognise how little I now cared about making my own marks on canvas, much as I still often envy those who have continued to do so.

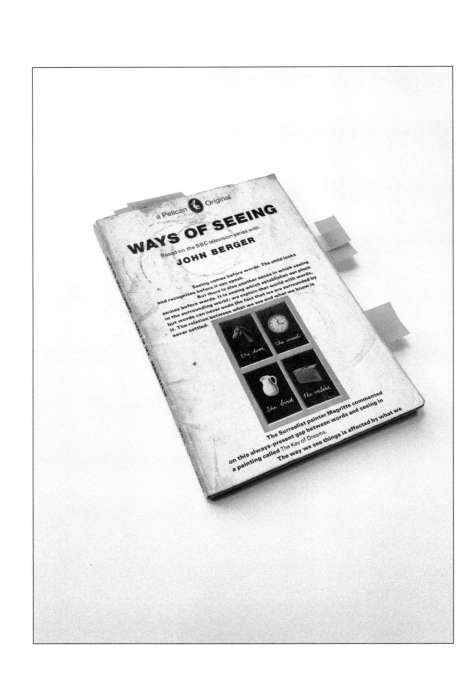

a Pelican Original

# WAYS OF SEEING

Based on the BBC television series with

## JOHN BERGER

Seeing comes before words. The child looks
and recognizes before it can speak.
But there is also another sense in which seeing
comes before words. It is seeing which establishes our place
in the surrounding world; we explain that world with words,
but words can never undo the fact that we are surrounded by
it. The relation between what we see and what we know is
never settled.

The Surrealist painter Magritte commented
on this always-present gap between words and seeing in
a painting called The Key of Dreams.
The way we see things is affected by what we

# Still

The thingliest of things inhabit our daily lives. How beautiful such objects are in certain still life paintings, or as details in genre painting: a jug in Vermeer, a coffee pot in Chardin, a glass vase in Manet. Weight, texture, surface, light, grain.

Contemporary Spanish artist Joseba Sánchez Zabaleta paints arrays of everyday objects on tables: a pile of small plates, an old silver spoon, an empty sardine can, its lid peeled open. Rendered in subdued tones and in the kind of precise, blocky brushstrokes that suggest sustained acts of looking, the objects are steeped in an atmosphere of muted abandonment. A sense of abandonment similarly pervades the work of Canadian photographer Laura Letinsky. In off-kilter compositions, she captures the remains of meals, each as the exquisite, melancholy aftermath of refined commensality. On crumpled and wine-stained white tablecloths, these decentred images evoke endings, recorded in the lambency of the morning after.

These tableaux are, in a sense, the muted hyperboles of still life as the genre of 'the culture of the table,' as art historian Norman Bryson calls it. It is a culture that, in Bryson's formulation, displays simultaneously a 'rapid, volatile receptivity to its surrounding culture,' and 'a high level of resistance to innovation in the forms themselves.' Bryson's words, unpacking the ethos of still life painting as a genre and exposing its relationship to table habits, articulate for me something about the quality of Letinsky's images, at once contemporary and archaic.

A still life is a framed tableau of objects which have been deliberately assembled, arranged and composed by the painter or photographer: in other words, objects that have been both looked at and touched. As an art form, still life is a sedentary art connected to the business of keeping a home. That idea was first planted in my mind by John Berger. It is also, Berger says in his celebrated *Ways of Seeing,* an art form that establishes

  https://doi.org/10.11647/OBP.0285.13

a link between seeing and possessing on the one hand, and possessions and oil painting on the other. The term *oil painting,* as Berger's work illuminates, describes more than simply a technique: it refers both to an art form and a tradition with social and ideological underpinnings.

Much of still life as a genre in both painting and photography is steeped in melancholy. It bears the evidence—or augury—of decay and ruin. The solid objects of still life are frequently made of materials that will crack, break, tarnish, fray, evaporate. They find their moment of poise alongside ephemeral things: lemons half peeled, oysters ready to be slurped, grapes whose bloom displays the artist's skill, a bunch of asparagus or one lonely sprig, overblown peonies, irises upright as sentinels: organic things on a cusp between ripeness and rot.

Traditionally the genre that shines a light on objects plucked from the material world, still life was considered to be destitute of significant action and narrative, and was historically the lowliest category of picture making. It is for that very reason that it has always called to me, since I generally prefer the fragmentary to the uniform or monolithic, the minor to the major key. Indeed, I have always felt that still life, in both its painterly and photographic iterations, has afforded me rich glimpses into worlds. The histories that still lifes contain are suggested rather than spelled out: of trade, of transportation, of extraction, of class, of labour, of gender, of domesticity and yes, even of cruelty to humans and animals: in short of all the relations that brought those items to this table. In *This Dark Country* (2021), a brilliant and methodologically innovative book on still lifes made by women artists (either queer or 'living awry to heteronormativity in some key sense') in the early twentieth century, Rebecca Birrell tenderly unpacks the narratives contained by the still lifes she scrutinises. Her words are applicable across the genre when she speaks of works that take 'the rough, raw material of a life' and reissue it 'as compacted, densely coded dramas on the trials of intimacy and of needs hungering at the seams of quotidian concerns.'

But in addition to this, still life artists frame the chosen objects conceptually and formally in such a way as to emphasise not only the concerns and the pleasures of the everyday, but also the vexations and delights of painting itself, of photography itself. Such works outline, as Birrell says of one still life painting by Vanessa Bell, 'how aesthetics might absorb the ephemeral idiom of the everyday.'

As a genre, still life slows you down, unhooks you from explicit causality and coincidence, immersing you in the experience of perception and a contingency that remains close to the domestic realm. Thick with story, still lifes are satisfyingly devoid of plot. What I mean by this distinction between narrative—or story—and plot, is articulated by art historian Michael Baxandall in a discussion of eighteenth-century painter Jean-Baptiste-Siméon Chardin, considered one of the great masters of still life painting. 'He narrates,' writes Baxandall, 'by representing not substance—not figures fighting or embracing or gesticulating—but a story of perceptual experience masquerading lightly as a moment or two of sensation.' How beautifully expressed. Crucially, Chardin is a painter who, for Baxandall 'can make a story out of the contents of a shopping bag.' More even than the story told by a bag of shopping, by the contents of a wardrobe, by the spill of condiments on a table, Baxandall sees Chardin's still lifes as essays on acts of attention.

While Chardin's still life paintings invite finely honed, drawn-out acts of observation, sixteenth- and seventeenth-century Dutch still life paintings, freighted with symbolism—the melancholy of memento mori seeping out of skulls, worm-infested fruit, and extinguished candles— are not merely arrangements of things seen, so much as explorations of forms of knowledge and craft. Objects as things to think with. As catalogues of natural materials—with their pearlescent, lustrous or pitted surfaces—and their transformation by humans, they probe the attributes of the material world (shells, fruit, pewter, glass, stone, linen). Often sensuous, sometimes sinister, they invite viewers to query how nature is at once revealed and betrayed, first in the making of things, and then in the painted representation of those natural and fabricated things. With minute and voluptuous attention to surface and detail, texture and light, still lifes by Dutch and Flemish painters such as Pieter Claesz, Jan Davidsz. de Heem, Willem Kalf and Clara Peeters stand for the very artifice that informs coeval notions of 'Art.' Art historian Svetlana Alpers quotes Francis Bacon (the sixteenth-century scientist, not the twentieth-century artist), for whom a working definition of art or craft (the two were twinned) was 'seeing that the nature of things betrays itself more readily under the vexations of art than in its natural freedom.'

Being vexed is what many contemporary painters do in and with museums as they examine the work of other painters for prompts, cues, assistance, resistance. More than nature, it is art that feeds art. And still life amply, if quietly, displays this to us. Leaping across three centuries from Dutch still life to Picasso, we notice how actual things—physical things (vases, sculptures, candlesticks, coffee pots, mirrors, drapes)— can be dense with allusion to the history of the *painting* of those things. Guitars, chairs, bottles, sheet music and newspapers now oscillate in their status: between being the things alluded to, and the material stuff out of which those things are fabricated—paper, string, charcoal, wood.

And then, there is Giorgio Morandi, a painter John Berger called 'the metaphysician of Bologna.' In his paintings, the irregular edges of a small range of objects jostle together, their contours abutting or almost touching, all within a shallow space. Our gaze is blocked from moving in or away. Now, it is invited to linger on the facticity of luscious, opaque, always-visible brushstrokes. The tonalities are muted and close in range: ash, dove and bone grey; agapanthus and duck-egg blue; calamine and blush pink. The contiguity and sheer repetition of vases, bottles and jars creates simplified cities of objects and arouses in the viewer—in me—a recognition that things are never entirely self-same.

Still life is a category of art, not of life. But as in still life paintings, the objects that lodge in our daily lives over time—a frequently used saucepan, a burnished wedding ring, a chipped mug, an old toy or a favourite pen—are rarely *simply things*. Art nuzzles into life and informs the ways in which we might arrange or think of objects. Alan Bennett speaks in *Untold Stories* (2005) of 'how personalized and peopled the material world is at a level almost beneath scrutiny.' He is thinking, he tells us, 'of the cutlery in the drawer or the crockery I every morning empty from the dishwasher. Some wooden spoons, for instance, I like, think of as friendly; others are impersonal or without character.' Bruised by use and marked by our personal narratives, objects are also enmeshed in webs of cultural signification. 'Even the humblest material artefact,' writes T.S. Eliot in his *Notes Towards the Definition of Culture* (1949), 'which is the product and symbol of a particular civilization, is an emissary of the culture out of which it comes.'

But such objects are also moveable pieces in human interactions— things shared or retracted, gifts, bequests, wilful or careless

destructions—ensnared in common histories and animated by the minds of users, by our minds. As such, objects inhabit us almost as though they were envoys from within: 'but what is the thing that lies beneath the semblance of the thing?' Rhoda asks in Virginia Woolf's *The Waves*.

It is not only vessels and utensils, clothes, and trinkets, that touch us. Books are objects of overwhelming attachment and association; heavy tomes or paperbacks, notebooks or albums in which the riches of content are allied with specific materialities. This, then. An unsent postcard—a Bonnard interior, light-brindled—slips out of the pages of a book of Neruda poems which is inscribed with my name and the year 1975, bringing with it a whiff of the ardent, aching person I was at that time. Along with the inscription of my own name and dedications on frontispieces, other postcards greet me when I return to old books: I've long enjoyed the habit of using postcards as bookmarks, and finding them later adds substance, a dusty coating of connotation to the time or times invoked by the book. Here is Roberto Calasso's *The Marriage of Cadmus and Harmony* (1988) which I never read, and which bears a postcard and a dedication, both from R, now dead, a much-loved lover married to someone else, whom—after a four-year affair, stunned in the aftermath of discovery and rupture—I described to my friends as *lost in action*. The quirky drawing of an 'Odder-Lisque' by the mercurial Nick Wadley slips out of the book of e.e. cummings poems that took my breath away when I first read them in the 1970s. I made sure to salvage this book from the wreck of my marriage to J, since so many of the poems reminded me of the best of us. Later, once we had become the kind of friends who examine each other's bookshelves, he snuck in a retroactive dedication *legitimising theft*. I cried when I found it.

Then there is John Berger's *Ways of Seeing*, a book I now think of as having owned since I was old enough to consider reading not only as a pleasure, but also as a mission of self-improvement. I pull it out of its position, ranked in my theory section between Walter Benjamin and Lauren Berlant. Placing it on my white desk and photographing it, I enable its transformation from thing, tool and prompt to still life. It is scuffed and battered in a familiar way.

Right now, I am trying to think through my attachment to my books— as treasure, as objects, as portals, as snapshots—and I am also trying to account for my need to sort and tidy. The pull to keep things, the push to

throw things away. I've read that people who can tolerate mess in their homes and work environments have a great sense of inner structure; we tidiers, contrariwise, are just attempting to build barricades against tsunamis of inner chaos.

# Declutter

It is those for whom tidiness *could* be an ideal—whether dimly or constantly pursued—that the contemporary decluttering industry targets. This formulation does not account for the complex dialectic of love and loathing that informs the hoarder's obsession, but I also assume that the fashion for decluttering is not aimed at chronic hoarders or committed collectors. Rather, the rash of manuals and the incrementally growing popularity of television programmes, YouTube channels and Instagram feeds devoted to getting rid of things speaks of an age of compulsive, yet replaceable, acquisition. Not addressing the toxicity of immoderate affluence—not, in other words, overtly political in their aim—these helpers are at once the symptom and the ultimate exploiters of cycles of perpetual consumption promoted by the machinery of late capitalism. 'The desire to consume is a kind of lust,' writes Lewis Hyde. 'But consumer goods merely bait this lust, they do not satisfy it. The consumer of commodities is invited to a meal without passion, a consumption that leads to neither satiation nor fire.' It is a consumption that leads simply to more consumption. This, in 1979.

In the midst of the decluttering fervour, Marie Kondo burst onto screens advocating the joy of minimalism and capsule wardrobes to generations of shoppers sooner or later looking for the next big thing in interior decorating: mid-century geometries, vintage chic or seaside boho. Kondo, a neat and winsome person, caused an explosion in the collective psyche of would-be minimalists. I think I was late in hearing about her in the context of folding T-shirts and socks, but I know she came into soft focus for me in 2017, when I was on a clearing binge. This was before she hit Netflix, but still, people were talking about her. On social media, where life is equated with lifestyle, tidying seemed to require consultants, gurus.

In the spring of 2017, my need for a deep clean was linked not to the season, but to an inner propulsion in the direction of discombobulation.

Contributing factors: work had never gone so badly and shifting away from art-historical and art-critical writing to a new practice of personal essay writing, I had not yet found friends or allies, except in books. Other than occasionally translating art-related texts from Portuguese to English, my sources of income had withered; I had done my back in and joined the battalions of osteopath-consulting, anti-inflammatory swallowing self-helpers; I had left G, the lover for whom I had finally cleared away the contents of Ian's desk. While I had a wide circle of wonderful friends, my work and romantic attachments felt flimsy and unmoored. And then Louise, a dear friend, who only six months earlier had been diagnosed with Creutzfeldt-Jacob disease, was dead. Louise's death was a catalyst that made my own seem not only possible, but also imminent. We had often celebrated our December birthdays together; we'd known each other since we were eighteen.

Though I felt as energetic as I had ever done, and though my arms were more toned than they had been twenty years earlier, I was not enjoying the effects of time and mortality on my thoughts, my joints, my prospects, my friends. I had not yet met P, the last man whose presence in my life changed my sense of the time to come. In the spring of 2017, with a view to an eventual downsized future on my own, I began thinking that I had better get a grip. I started sorting, clearing and cleansing, lugging bags of infrequently used items to charity shops. I had already heard of the Swedish method of tidying, *döstädning*, or 'death cleaning.' Decluttering Scandi noir style. This appealed to me. Clean up your shit before you evaporate, so that no one should have to do it for you, after you.

In an operation of uncharacteristic ruthlessness, and folding away my sentimentality, I found myself doing away with possessions I impulsively felt I would no longer use; things that I was suddenly mercilessly capable of demoting to mere stuff. I have noticed that at times of internal disarray, I get an obsessive, pernickety satisfaction from organising stuff.

But while arranging and tidying things leads me to the archivist's delight, it also provokes in me the archivist's anguish. How to categorise things? Categorising is an activity that can easily become compulsive. Perhaps this is because it has something to do with staving off death, keeping at bay the knowledge that eventually, everything returns to

the condition of matter. Though I've always been a sorter, harbouring the heart of a librarian in a body given to some measure of disorder (I overpack for every eventuality when I travel; I lose my mobile phone and keys and glasses and notes to self every day; I file papers safely and irretrievably), it became obvious that I was now also acting out a cultural trope. That like many other virtue seekers in the developed world, I was burdened by consumption guilt, weighed down by relentless accumulation. Bombarded by advice on how not to be possessed by our possessions, I had joined the fray. The Japanese and Scandinavian styles—which, as far as interior decor was concerned, I had always admired for their minimalist, clean lines, their uses of daylight and monochrome—were now mainstream, the *ne plus ultra* of lifestyle designers who arranged objects in pristine interiors for photo-shoots in grainy light—pared down still lifes curated for the well-heeled—and who saw me coming.

Since I first heard of Marie Kondo, she has forged a brand and built an empire around the fact that, in the developed world, we don't know what to do with all our things. Googling to learn more about the Kondo phenomenon, I read that the rise of professional declutterers in Japan coincided with the earthquake and tsunami in 2011. I wonder if there is a link between loss of lives and a re-evaluation of *stuff*, or if this is mere coincidence. Certainly, the notion that a desire for control in the small areas where one can exert it at moments of collective malaise makes sense. The Covid-19 pandemic brought a self-isolating crowd of DIY enthusiasts into focus. They get a mention on an NHS web page, along with trampoliners, with warnings of accidental injury during the Easter weekend of 2020.

Marie Kondo is a petite, exquisitely groomed woman, canny and telegenic. But one of the things that irks me about her is the fact that she is a woman. I understand that this is mostly beyond her control, but all I can think of is how gender-specific tidying a house has always been. The Instagram 'cleanfluencers' are also, it seems, exclusively women, adopting saccharine blog titles and hashtags such as 'Queen of Clean' and 'The Organised Mum,' reinforcing depleted gender stereotypes. I am curmudgeonly about Kondo's blithe and buoyant manner, and I feel churlish about her 'joy.' We should discard anything, she tells us, that does not spark joy. The tyranny of joy!

How to take into account the vicissitudes of joy itself, its temporal dimensions, its fluid contours, its evanescence? The occasional pleasures of melancholy? Reasons to keep possessions are knotted into our life stories and are profoundly linked to the ways in which we think of our losses, the ways in which we regard memory itself. There is something tautological about a decision to keep only those things that bring us joy. Surely even the hoarder's every item—in succession and in tandem—brings her or him a drop of curdled *tokimeku*?

When I think of rescaling my possessions in preparation for the inevitable downsizing, I am filled with dismay at the enormity of the task. And when I contemplate the possessions with which I identify most powerfully, those that define me, it is my books I think of. The accumulation and volume of these books is not conducive to Scandi-style, minimalist interior design. Books amble through my large house. In addition to the many bookcases—I would love the sleek Tylko or Vitsoe, but Ikea's ubiquitous Billy was all I could afford—there are also casual piles of books on tables and all over my study floor.

The bookshelves ostensibly hold distinct classes of books. These categories—despite my every effort at precision—remain porous, ill-defined, crammed with parentheses, overlaps, exceptions, exclusions. My favourite line in Walter Benjamin's essay 'Unpacking My Library' (1931) is the one where he says that the best way of acquiring a book is by writing it oneself. My second favourite sentence summarises how the classificatory systems we improvise for our books balance order against chaos: 'what else is such a collection but a disorder to which habit has accommodated itself to such an extent that it can appear as order?' he asks. And as I fret about whether Benjamin himself should be kept under *essays*, or should be his own category of cultural criticism, I know—I do know—that construing an order for books has vexed many a mind. I know, too, that the organising principles for such collections—inevitably imperfect—must accommodate their open-endedness. 'One of the chief problems encountered by the man who keeps the books he has read or promises himself that he will one day read is that of the increase in his library,' writes Georges Perec in his arch essay, 'Brief Notes on the Art and Manner of Arranging One's Books' (1978). The increase of the library, the promise of books still unread: how to organise it all?

Unread books enjoy a special status among my evocative objects. They are not secreted in drawers or tucked away as precious rarities in muslin or tissue paper. Rather, they are dispersed, lurking in plain sight among the read and partially read books on shelves and tables in my home. Unread they may be, but they are familiar, even as new acquisitions join their ranks: they are distinctly held by that possessive pronoun that links them to me.

Bibliophiles frequently find themselves called upon to justify the existence on their shelves of the unread. Umberto Eco famously derided the question 'how many of these books have you read?' preferring his library to exist as testimony to that which was still-to-be-known. I assume the question is, in part, a question of resource management: space, time, money. People are curious. But also, there is a certain puritan severity to the ways in which we are enlisted to explain how we use or squander those reserves. In the category of unread books, each stands as the marker of something—a thought, a question, an impulse, a desire—radiating out of a whorl of nested trajectories, (in)roads as yet not taken.

Thinking of my unread books leads me to that old tease, things unwritten. But I only glancingly make space for this thought. It is a thought that ushers in humiliation and frustration: ideas not brought to fruition, manuscripts (if they still go by that quaint term) summarily dispatched by publishers, projects ill-formed or hijacked by others. George Steiner, who had the courage and wiliness to write a book about his unwritten books, speaks of the consequences of negation and privation, the journeys not taken: 'consequences we cannot foresee or gauge accurately. It is the unwritten book which might have made the difference. Or not.'

But unlike the unwritten, the unread stands not for dissatisfaction, but for potential: the future reeling out into distinct vectors, unanticipated trajectories. Not a single one of my unread books is inert or inexpressive: together, they emerge (they continue to emerge) from a tangled web of interests and concerns that somehow, at times fortuitously, finds more direct expression in some other act of reading. Each, in other words, is the end point of an act of wandering—meandering—and occupies a position in an imaginary, freshly mapped constellation. If I gathered together all my many unread books, I would recall why each entered my

possession: not the circumstance or even the year of its acquisition, but where it fits in with my writing, how it links to my other reading.

In her essay 'I Murdered My Library,' novelist Linda Grant describes the process of moving to a smaller home and having to cull her vast collection of books, acknowledging her position within a certain demographic. 'Downsizing' is a concept as steeped in melancholy as in practicality, signalling the end of an active, socially participative period of our lives through the shrinkage of our personal space. We take on the contraction of our world for the convenience of it—less cleaning, less bother—but hers is an embrace that accedes to a subsiding of vitality too.

In divesting herself of many of her books, Grant feels she has committed an act analogous to destroying books. And once she has moved, to her dismay, she finds she has got rid of too many: 'the truth was, I now had empty shelves. Fewer books than space for them. The shame.' Grant misses her books when they've gone, and fears that her cultural capital—her status among literary peers and friends—has diminished. But more than this, she recognises that the downsizing as a presage, a memento mori: 'it is death that we're talking about. Death is the subject,' she says.

Writing to Moyra Davey, an artist who frequently photographs the books on her shelves, novelist and essayist Ben Lerner describes trying to scale down his library when moving to Brooklyn from a big house in Pittsburgh. Among his first considerations are books 'that I'd acquired but still hadn't read.' With the prospect of moving into a more restricted space, these books had become 'a little thinglier, heavier,' more insistent as objects.

To think about books as objects is to think about them in terms of value, editions, of new or second-hand purchases, but it is also to consider their status as gifts, tokens, prizes, special finds in charity shops or unusual, iconic book shops (Ler Devagar in Lisbon, Barter Books in Alnwick, Shakespeare and Company in Paris, Strand in New York, the Marylebone branch of Daunt Books in London.) Books exchanged; books as letters. Geeta Kapur—a beautiful, brilliant writer and curator living in New Delhi—once told me how, sometime in the 1960s, Vivan Sundaram, the artist who has been her partner and then her husband for over half a century, copied out a whole volume of Rilke poems and

sent them to her in a letter. How does one take the pulse of such a book, a transcribed object exchanged between lovers?

Books as objects in the history of thought and the history of design, but also objects with a history of readership and ownership, with a history of lurking too long on bedside tables, of supporting cups or buttressing other books.

Though the idea of tidying my bathroom cabinets and rolling up tea towels makes sense and gives me a certain pleasure, I feel that anyone who advocates that I abandon those books that I have not read does not understand the part that books can play in narratives of self-esteem, as Linda Grant's shame on having dispensed with too many of them reveals. More importantly, they serve as fortifications against the death-dealing finitude of the completed collection. As materialisations of a state of potentiality, my unread books suggest to me that there still is a future, that I still have a future. They nudge me to ignore my age.

I know that I cannot follow the example of Lerner's triage, much as I love his writing, and love his love of Moyra Davey's work, which I also love. I need my unread books. They stand in a state of perpetual invitation: a little daunting in their virgin status, they require a pencil and wad of luminous Post-It flags to feel a little more welcome in the world.

Each of these books, in its unread status, is a proxy, marking the location of an idea, halting upon a little clearing in an undergrowth of (other) ideas. By the same token, the books I have read, completely or partially—those I've alighted upon, like stepping stones—are arrived at circumstantially. They've captured me through a particular turn of phrase, or chapter heading, or index listing, throwing a slanting light on something else that is already holding me.

Now, I'm particularly taken by the idea of a *proxy*. Proxy: 'a stand-in, an agent, an avatar, a functionary,' writes Brian Blanchfield, also 'expresses a kind of concession to imprecision, a failure.' An approximation, an almost-but-not-quite. The almost-but-not-quite books lurk in waiting, richly suggestive.

I ignore them constantly, and then through some chain of associations, I pick out one of them, I dip in, I measure its relevance: something is ignited. I pay attention, I focus. I read on, or not. I need all these books,

not for 'sparking joy'—the very idea is kitsch—but for the states of potentiality they embody.

Who, I muse, wandering around my book-lined rooms, might ever want this particular conglomerate of novels, memoirs, art books, theory, anthologies of essays charting every phase of my reading life and enthusiasms, volumes of poetry dusty and new, exhibition catalogues, pamphlets, literary and art journals... Who would value this as anything other than a disassembled jumble of titles, a kind of material portrait? Taken together, my books—read and unread—are deeply personal. They not only map my intellectual history, they also track my loves in all their variegated morphologies, testifying to vagaries and obsessions, but also to the disruptions and discontinuities in my life: the stops and starts, the brief fads, the caesuras and redirections.

## Ways of Seeing

John Berger's discussion of how we look at paintings and photographs—of the social and cultural norms we bring to bear on acts of looking—has had an effect as profound as it is widespread. Based on the TV series whose name it bears, *Ways of Seeing* was published in 1972 and appeared on my intellectual horizon in 1973, when I was a first-year fine arts student at the University of the Witwatersrand in Johannesburg. The book, with its workaday appearance, its matt pages, its poor-quality black and white reproductions (degraded images, more like photocopies than the traditional greyscale photographic reproductions printed on glossy paper of 'art books'), and boasting the bold font of a manifesto, was bold in its claims too. With the simplicity of its enunciations, it was a game changer for my generation.

'The way we see things is affected by what we know or what we believe,' Berger announces at the outset, establishing his Marxist credentials, hinting at the ways in which viewing subjects are embedded in material circumstances, in bodies, in worlds: class, gender, status. This embeddedness in what is nothing short of ideology, Berger argues, has worked in favour of the ruling classes, a privileged minority that has invented a history of art to justify its own powerful role. Against such ideological mystification—and mystification, Berger concedes, may well also be 'pseudo-Marxist'—he proposes an examination of the

relationship 'which now exists, so far as pictorial images are concerned, between the present and the past.' He suggests that if we can see the present clearly enough, 'we shall ask the right questions of the past.'

Berger was a manageable, readable practitioner of a kind of social art history that was immensely engaged and engaging, countervailing the formalism that triumphed when I was an undergraduate. He was a first in many things. It was he, before Germaine Greer, who first threw light for me on the innate asymmetry of gendered representation in Western art, with his simple formulation: 'men act, women appear.' Marvellously—poor reproductions notwithstanding—two out of the seven pieces in the book are photo-essays, making their point simply by visual juxtaposition. And though I had by then already read André Malraux's *Museum without Walls* (1947), it was first through Berger that I began really thinking about the relationship between original works of art and their photographic reproduction in books. To me, Walter Benjamin's essay 'The Work of Art in the Age of Mechanical Reproduction' (1935) which I first read in the mid-1970s too, was a series of brilliant, fragmented thoughts positioned at a tangent to one another. I sensed a coherence that was too theoretically complex for me to grasp at that time. But with Berger, I began really thinking about what happens when works of art are photographically reproduced, and I began, for the first time, to explore analogies between photographic conventions and those of the Renaissance painters I was studying in Art History, *only connecting* in the most satisfying way.

I would come to use such comparative methods in my own teaching, whether regular (in the 1980s and '90s) or sporadic (after those decades). A few years after encountering Berger, I would be equally affected by Susan Sontag's then recently published *On Photography* (1977) and Roland Barthes' *Camera Lucida,* more or less simultaneously, but it was Berger who began the process of dismantling for me the hierarchical distinction between what I then thought of as the discreet fields of painting and photography, art and documentary.

Berger was not alone in recognising that photographs (especially documentary ones) need words to anchor and contextualise them: importantly, Walter Benjamin (to whom Berger acknowledges an obvious debt at the end of the first essay of this book) had already done that, and Barthes examined these links in a systematically semiotic

fashion. But Berger was personal in his didacticism, and if his writing on photography is no longer something I frequently reach for, to the young person I then was, this book opened an array of possibilities of looking and of reading.

Now, however, I am considering this book not only for its contents, but also as a material object. Its pages are stiff, amber-edged, and several seem to have once been wet and now buckle, sticking together as a result. Gingerly, I try to separate them without causing damage. The cover—with a purposefully tacky reproduction of Magritte's painting *The Key of Dreams* (1927) illustrating the disconnect between images and words—is imprinted with faint, overlapping circles where cups of coffee and glasses of water once rested.

In thinking about books as objects, I read Michel Butor, who speaks of the sequentiality that is one of the principal advantages of books over other forms of recording, and who anatomises in detail material aspects of the book that might become naturalised in the act of reading: the signatures that constitute the book as a physical object, its margins and characters, the figuration of the page as a whole and the partitioning of pages into diptychs. I also read a wonderful essay by Nicholson Baker about books as furniture, though strictly speaking, this is about the use of books as props in mail order catalogues selling furniture. The use of books as coasters, however, has not been explored. The idea of a book as a coaster—my *Ways of Seeing* supporting so many beverages—points my attention to the very idea of thingness, and the annoyances that things can occasion. 'Tripping over the dog's water dish,' writes Bill Brown, 'touching a glazed jug that doesn't feel the way it looks, using your paperback copy of *The Imperative* as a flyswatter to nail an angry wasp: these are momentary encounters—scenes of accident, confusion, emergency, contingency—wherein thingness irrupts.'

In my home, books used as coasters have usually been arrested at some station along their route from table or desk or armchair or bedside table, back to the bookshelf that is their formal abode. The book-as-coaster is a book I can't quite put away. The embossed rings on this volume evoke student life in various iterations. I remember—I do specifically remember—buying this book in 1974 in Johannesburg, but when I open it, to my surprise I see that the name that has been scrawled in large, loose, inky letters, is not my own, but that of a friend. *JMS Nov. 73*, it says.

JMS—Julie—and I met in 1977 on the first day of our MA course at the Courtauld, straining to understand each other's accent, but we connected. There was something cool about her: impish, stylish, organised, but in a relaxed kind of way, different from my frantic sense of being all over the place and trying to over-organise everything as a result. Her hands were bony and agile, and she hid behind a wispy blonde fringe. Back then, we often worked on our essays together at her bedsit in Willesden Green. She cooked and sewed well and made any place seem like a beautiful home, while my room in a grimy flat-share in Cricklewood was dismal, beyond the succour of Indian block-print bedspreads and daffodils in glass jars. She later married a Norwegian man and moved to Oslo. She and I now see each other infrequently (three times in Oslo, once in Stockholm, once in Lisbon, several times in England), but we keep in touch.

I seldom feel tempted to re-read *Ways of Seeing* now, though I have, over the years, dipped into it when writing; the blue index flags are from one of those readings and highlight some of the book's much-quoted phrases: 'men act, women appear,' 'the surveyor of woman in herself is male; the surveyed male.' If the book no longer seems urgent, this is partly because I now take its considerations for granted: they have been absorbed and internalised. But it is also because the binaries that structure its arguments are no longer precise, and not always apposite. But this does not mean the book stops being a landmark publication, for me and for many others too.

I do not remember borrowing this book from Julie, and I wonder now if perhaps, through some mistaken swap, she has mine; wonder if, after so many years, I should still consider this book to be her property.

I wonder whether books—if not the more luxurious, costly ones, then the trade books upon which we possibly do not lavish any special attention—might not be best suited to having nomadic, transient lives, passing from hand to hand. Yet I remain too attached to my books and bound to the idea that together, they bear the imprint of my trajectories, my productivities and my very personality, to give them away casually. I have, of course, offloaded books at charity shops. But overall, I'm a keeper where books are concerned. Even novels, often read only once, make a claim on my acquisitive attention, my desire to annotate and possess: they keep an eye on me; they keep track of me. I reckon that, after forty years on my shelves, this *Ways of Seeing* won't be missed in Norway.

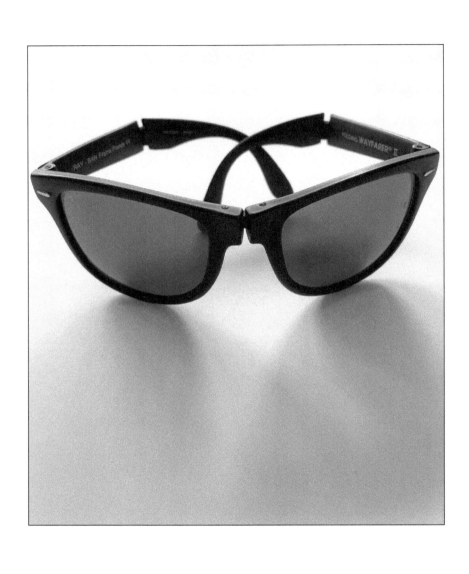

# Happiness

You would think I might nick a pair of sunglasses out of fashion hunger, style lust, but no. Not these. I wouldn't wear something as cheesy as a pair of folding glasses. I stole these in rage because I couldn't think of anything else I might remove from A's possession. I wanted a subtraction; something portable, something that he had about his person, that he would miss. The way I wanted him to miss me. This was in 1998 or 1999. It was a revenge theft, a quid pro quo.

I was living in Lisbon. In spring 1997, I had gone to Macau, Hong Kong and China on a research trip that I had managed to get funded. The working title of the project was *Sweet Dreams Are Made of This*. At that time, I was appropriating phrases from popular songs or films or books in my work.

My mission in Macau and Hong Kong was to gather *zhiza*. These are three-dimensional paper copies of techy consumer goods (laptops, radios, Walkmans, cameras, mobile telephones), clothes and accessories (Louis Vuitton handbags, Prada shoes, Chanel sunglasses), kitchen utensils, keepsakes, and money. The purpose of these paper goods is to be burned at funerals and at the traditional Hungry Ghost Festival on the fifteenth day of the seventh month of the Chinese calendar.

Hungry Ghost: is there any other kind? The idea of ghosts—the wraith-like revenants of the dead—still hungry for consumer items and luxury goods, high-status brands to accommodate them in their passage to the afterlife, tickled me. What next, I'm now thinking? Perhaps smoothies, face serums and pranayama for the hereafter?

The Chinese custom of ceremonially burning offerings as part of rituals of passage for the recently dead dates back thousands of years and is not unique to that culture in its desire to make provisions for an afterlife imagined as an extension of this one. The Egyptians did it. And dating to approximately 26,000 BP, the remains of a woman—the first

 https://doi.org/10.11647/OBP.0285.14

known shaman—in what is now the south Moravian region of the Czech Republic, lie in a grave under two crossed mammoth scapulae; around her, a collection of clay objects in the shape of dogs, bears, horses, lions and mammoths.

The idea of delivering objects to the spirits of the dead, presupposing them consubstantiate with the living and therefore party to the same desires, is not that bizarre a notion to me. It existed in my own home. Repeatedly, my mother would press upon us her desire to be buried with her cigarettes so she might continue to smoke after shedding her earthly body and transitioning to the next life. We left a pack of Kents leaning against the headstone at its unveiling, ten months after Fay's death.

In 2015, German political philosopher, installation artist and curator Wolfgang Scheppe exhibited his vast collection of *zhiza* at the Dresden Royal Palace. The title of the exhibition was *Supermarket of the Dead*: *Burnt Offerings in China & the Cult of Globalized Consumption*. Working in the Situationist tradition (a dynamic critique of capitalism yoking art and politics under the banners of Marxism and surrealism), Scheppe's research probes the politics of representation. He looks at urbanisation, migration and consumption in projects that culminate in books and international exhibitions.

My proposal, long predating Scheppe's exhibition of his collection of *zhiza*, I hasten to say, was devoid of any overtly political intent, despite the potential for such critique lurking in my appropriation of the language of display of luxury consumer goods. Rather, it entailed working around the question of desire itself, making my own versions of these objects, and fabricating assemblages using vintage dresses. For various reasons, the project was never fully realised, though I made numerous individual pieces using gorgeous vintage dresses. However, the legacy of that trip was to remain with me for years, the *zhiza* still now enjoying an afterlife in my home.

A and I had met through T, a friend in Lisbon. She had been enthusiastic about introducing us because of our shared readerly interests, at the intersection (reader, do not roll your eyes) of *po-mo* and *po-co*. So 1990s. A was working in Macau that first time I went there, living with his wife and two young children. It must have been a year after we were introduced that I travelled to Macau.

Our romance began when we first kissed on a cloyingly warm night on a street called happiness—*Rua da Felicidade*—with its overripe smell of durian and the percussion of mahjong tiles slapping Formica.

Folding Ray-Ban Wayfarers. There's a hinge on the bridge, and then again, their wing-like arms double up. The whole thing, when bent in on itself, is flat, a small parcel that you could slip neatly into your pocket. He'd do that. I see him in a shirt: white or light blue Oxford, with a breast pocket. In Macau, the sleeves might be rolled up, the hair on his tan arms glistening with the humidity of the place; in Lisbon, he might be wearing a navy-blue blazer in the golden, slanty light of an early autumn evening. I'm not sure he even owned such a blazer, but he might well have. It was in part something sartorial that won him a certain nautical nickname among my closest friends, those who thought I was a very particular kind of idiot. Anyhow, I wanted him to be the captain of my ship, my own fucking admiral, maybe.

He was—he is, but I'll try to stick with the past tense—no taller than me, which is not at all. He's stocky and at that time, had thinning dark hair (now a bristly buzzcut through which you can see his beautiful scalp), a powerful, bullish torso and thick, short fingers; he had a clean, piney smell and an infectious laugh that emanated first from his troubled eyes. He had dark furry whorls on his chest. His feet were small. It was difficult to know what made him so appealing, but certainly his irony and his intelligence were entirely engaging, and not only to me. His always-ready humour. His gravelly voice and his way with words. And his emphatic physicality: he was sexy. But nothing was quite as compelling as the *noli me tangere* mantle he wore under the demeanour of the guy with a big personality and a great sense of humour. You couldn't really get near him; I couldn't.

For three years, on and off, we dedicated ourselves to the business of each other's bodies, in actuality and in fantasy and in words. I submitted his mind—or rather, evidence of its workings—to my stringent powers of analysis, shaping sentences and making drawings in a constant flow of nervous and creative energy. I cloaked my longing for him in large and compulsively undertaken bodies of work. My work was the outcome of my inability to touch him even when we fucked, even when we sat across a table overlooking a starlit bay, magnetised each by the other.

How many times I gave up, left him, ditched the drip feed of his impossible love, quit submitting myself to torture by hope. It mattered

to me in continuously renewed bursts that he found me desirable (that he still does now is a bonus) and that he found me smart (ditto): a fatal combination, to see myself thus reflected in someone else's gaze. Well, at least in someone else's sunglasses.

These Ray-Bans stand in for something, but they are, in a sense, nothing in themselves. Opaque. I seized these sunglasses, I captured them, because A refused to return to me something that was mine. This is not a metaphor. I'll get to that later.

The folding sunglasses bear no trace of A's intellect or humour; of the dark cloud under which he likes to sit from time to time; of how running makes him feel; of how succinctly poetic he is in his writing; of his catholic musical tastes; of his tireless reading. They bear no imprint of his touch or smell. I would more readily have kept a paper table napkin, or even, disgusting as this might seem, a cigarette stub secreted from an ashtray. Something abject and dirty, used and finished, yet intimate, corporeal. Elvis Costello knew this when he sang, in his heartrending, changeable voice, that country tearjerker written by Jerry Chestnut, *Good Year for the Roses:* 'I can hardly bear the sight of lipstick on the cigarettes there in the ashtray/Lyin' cold the way you left 'em, but at least your lips caressed them while/You packed.'

## The Museum of Innocence

Some years later, I remember this desire, the wish for objects that I might narrativise, emotionalise and fetishise. A book reminds me of it. In 2009, my imagination is ignited on reading a review of Orhan Pamuk's novel, *The Museum of Innocence*, published in Turkish in 2008. I buy the English hardback as soon as the translation is available, and I immerse myself in a slow, long read; a fairly difficult read because the language, though beautifully fashioned in Maureen Freely's rendition, is a little stilted, almost courtly. I would imagine Pamuk's voice is similar in the original Turkish.

You could call this a historical novel about Istanbul, about the charms and hypocrisies of the inward-looking Turkish upper class. The images of this world are both splendid and faded; it is a world that Pamuk evokes as though through fog, through a haze of collective melancholy.

This book, I find, is just my thing, as I had anticipated it might be. Set in the 1970s and '80s, it is a tale of *amour fou* told through objects.

Much of the story unfolds in the vividly portrayed Nişantaşı quarter of Istanbul. The novel invites the reader (me) to eavesdrop on the collision of tradition and modernity in a stifling world in which social mores are governed by patriarchal codes. Its central protagonist is Kemal Basmaci, scion of one of Istanbul's grandest old families. A wealthy, spoiled playboy, in his thirties when we meet him, he becomes obsessed with an elusive and beautiful distant cousin, Füsun, who is a shop attendant and only eighteen when Kemal first meets and seduces her.

But as Kemal's mother warns him, 'in a country where men and women can't be together socially, where they can't see each other or have a conversation, there's no such thing as love [...] Don't deceive yourself.' We track Kemal's trajectory from infatuation to the pathological obsession that replaces love: 'by now there was hardly a moment when I wasn't thinking about her,' he tells us in Chapter 29.

Just as Nabokov's use of the first person invites us to see Humbert's erotic obsession with Lolita through the normalising lens of his own crazed eyes, Pamuk's use of the first person enlists us to identify with Kemal. We know from the outset that he creates a museum in memory of Füsun, and that, like a fetish or a memorial, that museum stands on the site of an absence, a loss. Indeed, we know that she has long left him. But we are only told of her death in a car crash towards the end of the book. Like Nina's death in another piece of fiction by Nabokov, the sublime short story 'Spring in Fialta' (1959), it is a dramatic loss that unleashes the melancholic reverie structuring the narrative in retrospection. Remaining untold for most of the book, Füsun's death informs the whole book's plangent, elegiac tone, figuring and fixing her absence into any picture Kemal might have of his own future.

Following him as he stalks Füsun, I am at once repelled by his passion and drawn to its steady, slow-burning flame. I recognise myself in his obsession. I am intrigued by the fact that both Kemal's age-appropriate fiancée, Sibel, and Füsun elect to give him their virginity: it is clearly, in both cases, a gift. In *The Museum of Innocence*, virginity itself is both a leitmotif and an evocative object. And Kemal is as obsessed with evocative objects as he is drenched in nostalgia: a desire for an obstacle-free immersion in a mythical place of wholeness and completion, a fusion with the mother of all memories.

Not surprisingly, then, after Kemal has lost both Sibel and Füsun, he takes refuge in the flat that his mother owns. This had been the private

setting of his affair with Füsun. He now turns it into a shrine. Bowing to the disconsolate, substitutive logic of the fetish, he surrounds himself with objects associated with Füsun, the things that knew random contiguity with her body and that now stand for her, and for the loss of her. As he collects and curates these objects into vitrines—and each of these eighty-three numbered vitrines earns a chapter in Pamuk's book—Kemal reflects on what it means to be an anthropologist, a museologist of his own experience. He visits strange collections and museums in different cities, becoming increasingly convinced that Füsun's possessions 'deserved display in comparable splendor.' The things that he collects include a spoon, earrings, stockings, underwear, sneakers, soda bottles, a half-eaten ice cream cone, 237 hair barrettes and—particularly mesmerising—4,213 stubs of extinguished cigarettes that were once—as if in a crazy hyperbole of a country and western classic—held between her lips.

It is a wall of cigarette stubs that greets the visitor to the Museum of Innocence in Istanbul, a narrow, corner building painted dark red, and yes, an actual place and a visitor's destination in the Çukurcuma quarter of the city. The gentrification of Çukurcuma is now manifest in the transformation of its many junk shops into boutiques and antique emporiums. Pamuk bought the property especially to house his museum, and in the late 1990s began buying and collecting objects with both the novel and the museum in mind. The two—book and museum—evolved in tandem, in reciprocity and interdependence, although neither is an illustration or an explication of the other. Separately and together, they attempt to dissolve the boundary between art and life, while never letting the reader/spectator fully lose their awareness of the artifice.

The Museum of Innocence—where collecting, curating and storytelling jostle and collide—opened to the public in 2010. A single admission ticket on page 520 of the English translation of the book, earns the reader/visitor free entry.

I go to Istanbul in the early summer of 2013. It is my second visit to this entrancing, complex city. Ian is almost three years dead. A's children have grown up and he has left his wife and taken up with a Brazilian woman. I hear she is wealthy and flies to Lisbon from Rio de Janeiro frequently but returns to Rio for weeks at a time. She has bought her own flat in Lisbon. I can see how this arrangement suits A. From time to time,

he and I exchange WhatsApps. Though sporadic, these exchanges bear abbreviated reminders of our past billets-doux; they hold the merest threads of long-gone entanglement, and yet they are still exquisitely intimate. We feel known and familiar, one to the other. We are all too aware of how those we have once loved might continue to lurk around unexpected corners, and mostly, though not always, we make sure to avoid those corners in our exchanges and in our occasional encounters in Lisbon. Every once in a while, he writes to tell me he wants to see me, plans to visit. It never happens; I'm not sure I want it to. Perhaps it's too late.

Still, I was infinitely grateful to A for the Christmas dinner we had together on FaceTime two months after P dumped me in lockdown, and for how much we were still able to laugh and enjoy each other. Occasionally over the years, we've succumbed to a deep, exhilarating, dangerous and nostalgic snog on some dark street or in his car: I love him for the fact that this is possible.

But I digress: back to the Museum of Innocence. I often enjoy works of art where the separation between lived experience and representation is fluid, uncertain. Sometimes, as in the work of Rirkrit Tiravanija and Tino Sehgal, the work is performative, collaborative and so indeterminate that you are not sure if you're a spectator or an actor, if walking through the artwork is the artwork. But I'm now thinking more specifically of work in which life is staged in a sequence of architectural/spatial gestures that entail a choreography of objects: artists like Ilya and Emilia Kabakov, Jannis Kounellis and Theaster Gates. These installations are always first and foremost works of art, only pretending to be life, but in the most immersive and beguiling manner. Pamuk offers us such an immersion, slyly putting 'life' itself into quotation marks, displaying it in a vitrine. He prepares us for this by naming the curator of Kemal's museum, Orhan Pamuk. 'As Kemal had asked of me' writes this narrator Orhan Pamuk, 'I wrote under each and every one of Füsun's cigarette butts the note our protagonist had made about that particular day. [...] I felt more like a craftsman than a writer,' he writes in *The Innocence of Objects* (2012), the beautiful book produced to accompany the museum collection.

In the Museum of Innocence, I am arrested by the artful elision of words and space; by the spatialisation of words. The reader becomes a walker and a visitor in a museum that is simulacral and *meta*, a museum

of a museum. For the visitor, as for Kemal, the museum stops time in its tracks, distilling it in the simultaneity and present tense of display. Together, the objects in the cabinets constitute a meditation on duration, on the dilated time of waiting: the lover's time, the lover's agony, which, with A, was my agony too. He was always late, and eventually, too late. 'I have here the clock, and these matchsticks and matchbooks,' says Kemal, 'because the display suggests how I spent the slow ten or fifteen minutes it took me to accept that Füsun was not coming that day.' But as Kemal the lover is transformed into Kemal the archivist and museologist, his use of language changes, no longer focussing purely on subjective experience, but rather on a viewer's appraisal of it. 'As they go from display case to display case, and box to box,' he says,

> visitors will understand how I gazed at Füsun [...] and when they see how closely I observed her hand, her arm, the curl in her hair, the way she stubbed out her cigarettes, the way she frowned, or smiled, her handkerchiefs, her barrettes, her shoes, and the spoon in her hand [...] they know that love is deep attention.

This makes the most profound sense to me during lockdown, with the withdrawal of P from my life. I think about Simone Weil's famous observation that 'attention is the rarest and purest form of generosity,' and it strikes me, now that I have lost love surely for the last time—well I don't intend to seek it out again, as I always have done in the past—that I might miss attention—that intimate address—more even than I miss touch. And I miss touch a lot.

In the Museum of Innocence, it is not long before the visitor realises, as the reader has already realised in the book, that the installations in the vitrines chart not only a creepy obsession, but also a melancholy *flânerie*, creating snapshots of the city, its social and material history. Deep attention to the woman morphs into detailed attention to the city: 'this is not simply a story of lovers, but of the entire realm, that is, of Istanbul.' And so it is that we remain with the palimpsestic image of Istanbul presented through these artefacts, with their fictionalised histories: sepia family photographs, cinema tickets, tombola stubs, postcards, clocks and watches, trinkets, earrings, a salt shaker, ceramic dogs, clothes pins, menus, a pack of cigarettes, a ruler, a taxi meter, a driver's license, glasses and bottles, a thermometer, doilies, and more. The individual objects oscillate between their existence as markers in a

particular narrative, and as constituent parts of the material culture of the city, of its inhabitants.

Pamuk invites me to think about how I experience lived history in a city, but also at home. In my home, amidst my own idiosyncratic possessions, I feel constantly enlisted to think about how objects might lead to collections (of books, of bowls, of scarves) and how collections walk me through recollections.

# Shame

I have not made these folding Ray-Bans my own: I don't wear them. They do not interest me as potentially useful or glamorous accessories. Rather, their status as relic informs my desire to hold onto them. But I also need to preserve them because they are markers of an exchange I could never quite fathom.

There was this ceramic figure that I bought in Macau.

That first time I visited Macau—then a Portuguese territory across the Pearl River Delta from Hong Kong—antiquarians filled their shop windows with the kind of furniture and porcelain that Portuguese visitors, still numerous, liked to purchase and to take back home.

This was half a year before Hong Kong reverted to Chinese sovereignty, and two years before the handover of Macau, which had been a Portuguese outpost for 400 years. I was particularly intrigued by a category of object somewhere between ethnographic curiosity and communist kitsch. They were polychrome ceramic statuettes, and though clearly mass-produced in line with iconographic prototypes dating from the Cultural Revolution of the 1960s, I remember thinking this object that I bought was well-finished, not shabby or cheap looking. Although not exorbitant, it had not been cheap either. I cannot remember what prompted me to buy it. I was never—not even in youth—especially drawn to the iconography of revolution. I suppose like many people of my generation, I sometimes flirted—in a manner that I fancied ironic— with the idea of kitsch, its facile nostalgia, emotion cheaply bought or stolen, to tease out Oscar Wilde's definition of sentimentality. For years afterwards, I could not remember what this piece represented, so thoroughly had the purchase been subsumed by the fact that I no longer had the object in my possession.

A had offered to pack it in his container and bring it to Lisbon when he moved back from Macau early the following year. The piece was too heavy for me to transport in my luggage, and rather than post it and risk breakage, I accepted the offer, which seemed to extend a thread of possibility into the future (next year! There would *be* a next year!). My *thing* in his *container* excited me as a parodic reversal of our erotic connection.

But then, in an equally parodic way, A exercised control through noncompliance, keeping the connection alive by refusing to return the ceramic figure to me.

I did not see the piece again, not for all the time I wished to retrieve it.

Through the several years of our bruising affair, every time I asked A for it and met with his casual laughter, I stumbled into a feeling of utter exclusion, of banishment from his home and from his person, from the ongoingness of his life. By the time I did clap eyes on it, years had elapsed. A was living on his own in a flat in Lisbon; I had left Portugal and was living in England, married to Ian.

I was taken aback, at A's flat, to see how many of my drawings were hanging on his walls, how much I still inhabited his life materially and was distilled and museumised within it. As soon as I laid eyes on my possession, this ceramic *bibelot*, I was overcome by a sense of freedom. *You keep it*, I said, *it's now legitimately yours*. Seeing it, I could not imagine what I would have done with a thing like that. It represents a scene of shaming such as I would not have wished to live with, not even as an ironically ideological ornament.

However, it only occurs to me now, so many years after this all stopped mattering, that what was being negotiated between us in A's refusal to give me the piece I had bought, was a scene of gendered humiliation. This might have pleased me had I thought of it at the time, pleased me more than a trivial larceny involving a pair of folding Wayfarers.

The piece depicts a member of the Red Guard wearing the green hat and uniform and red armband of her office, and in her left hand, she is holding Mao's Red Book.

I do not think I realised this figure was female until now: now that I look at this photograph; now that so many years have passed. Youthful ideological dominatrix, in her right hand she carries a megaphone, ready to denounce publicly the man kneeling at her feet. He is submissive,

cowed. On his head, the pointy hat of a dunce bears an inscription which, translated, says 'down with the foul intellectual.' I am told by M, my ex-husband's Chinese wife, that the placard around his neck reads 'Reactionary Academic and Expert.'

# Lost

The evocative objects I've been writing about are tangible things that also inhabit the unreasoned (and unreasonable) space and time of the unconscious. They attract the operations of free association; meanings adhere to them, and so they become connective nodes within networks of recollection, projection and erasure. They might have once participated in the humdrum: a cigarette lighter, a hairbrush, a table napkin. Now they have become instrumental in thought, certainly, but also in feeling. In my relationship with these objects, thought and affect are intertwined and inseparable.

This beautiful artefact, incorporating several painted images illustrating the Kama Sutra, is a keepsake of a different order. In a sense, it does not enlist the multiple associations, the reverie, the thoughtful or affective (re)engagements of an evocative object. It is more an object with a single mnemonic origin. In other words, though I engage with it aesthetically, as an object of connotation it is static. It was a gift from A and it remains associatively caught in the net of circumstances of that initial exchange. It is, nevertheless, extremely precious to me.

In 1997, a few months after returning to Lisbon from my first trip to Macau, agitated and intoxicated with the beginnings of our affair—an affair I sensed from the start would unravel me—I embarked on a three-month residency in Perth, Western Australia. The two people who ran the painting programme at Claremont School of Art had seen my work the Basel Art Fair and got in touch with me via my Lisbon gallerist. I embraced this invitation, caressed it, loved it as one loves a buoy.

A would continue living in Macau for at least another nine months. Although I would be geographically closer to him, I felt that travelling to Australia would distance me from him, and in doing so, would remove me from everything that was holding me back; everything that prevented me from living my best life. By an act that externalised my

    https://doi.org/10.11647/OBP.0285.15

magical thinking, I would untangle myself from the bonds A and I had quickly established earlier that year and that, already then, were tethering me and tying me up in knots.

It is hard for me now to inhabit the mind of the person I was: a woman who had embarked on a long-distance relationship with a man both circumstantially and constitutionally unavailable. Here was that inescapable vocation for just one being that Marguerite Duras insists is a feminine trait; I always wanted to disagree with such a generalisation, but I secretly think she might have a point.

However, it was also this: I was in love with the idea of an obstacle, a challenge.

Writing about the obstacles we make for ourselves or even just the ones we put up with—and I think of this a great deal as I find excuses for not writing, even when all I want to do is write—Adam Phillips notes that an obstacle can only be construed when it can be tolerated. An obstacle, in other words is 'a way of not letting something else happen, a necessary blind spot.' It took me three years to disentangle myself from A, from my obsessive attachment to him, to the idea of him. To take myself, in other words, out of that blind spot into a place of light and visibility. To see, and to become visible again. In that new place of visibility, in the year 2001, Ian found me.

Now, for the first time, I am reading through diary entries from those years when I was all ravelled in A's skeins. I dip into our exchanges too: there are thousands of emails. An archive of my mistakes, my gullibility when it comes to *mots doux,* my inability to tolerate uncertainty. There's a long email in which A explains his relationship with his wife and children, as though this needed exegesis, saying, too, that their eventual return to Lisbon was inevitable but as yet unplanned, telling me how *extraordinarily captivating* he finds my *sensibility and direct manner.* Aha, my bluntness. Everyone sooner or later has something to say about that. His words read as an excuse, yet I recognise, in their prosody, the pitch of their rhetoric, the allure they had for me then. I translate from the Portuguese:

> No, Ruth, I do not want to lose you. I don't, however, know how we are going to have each other. This process of getting to know each other has been difficult, but unstoppable. You're going to be in Australia for months. Then you'll return to Lisbon. I don't know where I'll be by then.

Are we ever going to meet again? I feel certain that we shall. For sure in Lisbon, in '98. As I told you when you were in Macau, I feel homeless. Exiled. Please, please don't feel excluded when in reality, you're right here, inside of me. Let's speak tomorrow. I'll call. Sending you a huge kiss.

On a printout of this email that I have stuck into my diary, I have written, in blue ink: *This is like trying to catch a fish with your bare hands.* Though I do not remember receiving that specific email, I know it would have thrown me into a turmoil of uncertainty, a panic of disarray, describing, as it does, both a want and a rebuff. In the face of all of A's existential posturing, I would have pushed for some kind of plan. All I remember is that we did, then, make a plan. The plan was to meet in Singapore on my stopover on the way to Perth.

Predictably enough, this did not happen. He cancelled a few days before my departure from Lisbon. I no longer recollect what this cancellation cost me in rescheduled flights. I do know that in exchange for an illicitly sensual and possibly nerve-wracking rendezvous, he sent me a parcel. In it, a small notebook with pages made of washi paper that caused my pen to snag and bleed. With it, this beautiful object, a painted Kama Sutra, folding into a small *leporello*. That word for an accordion-pleated book borrows its name from Don Giovanni's servant and brings with it the echo of *mille e tre,* a catalogue of conquests and lovers. How perfect a gift from a man onto whom I projected the capability of ceaseless erotic captivation, a thousand and three other loves in Spain alone, and that's before we count the ones in my head! But more aptly, more startlingly, the opening and closing of these concertina pages serve as a deft metaphor for my own psychic exposure and eclipse. At either end of the long foldout, two pieces of wood with chamfered edges, each depicting, in exquisite miniaturist detail, a couple fucking: she with her knees bent and feet lifted, he kneeling and penetrating her.

With her, I can feel thrust and depth, the thrill of being appetitive; I can feel the dissolution of boundaries that happens in sex, but also its opposite: each body in its distinct integument.

I google Kama Sutra positions to find the name for this one. I'm directed to endless porn sites and blog posts with schematically rendered images of heterosexual couplings, two of which I bookmark because I'm amused by the drawing. *Indrani*, this position is called. I like that. Indrani. Hindu goddess of jealousy and beauty.

The Kama Sutra was published in English in 1883 in a (mis) translation by explorer, translator and orientalist Richard Burton, in effect a rendition fudged and flawed in accordance with Victorian tastes, which veered in equal measure towards prudery and titillation. The mistranslation, which has been the primary—and much pirated— source of the Kama Sutra in the West, also skews and erodes women's agency, as Wendy Doniger argues in her book *Redeeming the Kamasutra* (2016).

I cannot read the Sanskrit letters, shaped in gold on the black verso side of the painted images, but those images are gorgeous. Two young people, a man and a woman, meet on a mat. The artist grants their sexy capers a form of attention that is at once explicit and courteous. The colours are kept within a close range of black and terracotta, with touches of green and blue, and the two bodies are neatly contained in their fleshy contours. I love the way the woman knowingly, seductively, keeps her earrings and necklace on, and I love the sensuous regard in which the man and the woman hold each other. It seems to me that these two people, who are contained and quiet in their appreciation of each other, are equal in desire and its expression. That this is love without obstacles. I remember finding myself jealous of these painted figures, their availability one to the other. I know that, opening the parcel and finding this exquisite object, I will have felt a pang of longing partnering the voluptuous pleasure of being wanted or admired sufficiently to be the recipient of such a gift. It also made palpable my sense of the impossibility of the bind in which I found myself, and I understood, I think, that though desire was on offer, only its tokens could be exchanged.

In early 2020, I WhatsApp A to tell him I'm writing about objects. That's all I say at first, *writing about objects*, and I ask him where he bought this Kama Sutra. He replies: *in Kathmandu in 1995. I was there with my children. I remember watching the sun rise over the massive Annapurna.* Then he tells me he is now immersed in a project, attempting to retrieve some of his earliest writings and to rewrite them. *Palimpsests pursue me,* he says, referring, I think, to my invocation of this Kama Sutra too. He can be portentous, occasionally even lacking in self irony.

Some weeks later, he writes again, this time mischief in his tone: *Have you written about the Ray-Ban sunglasses?* he asks. I say *yes, I have.* Then, despite the vividness of his memory of Kathmandu, Annapurna, his

children, the sun rising, all that, he says: *if you write about the Kama Sutra, I told you that I'd bought it in Kathmandu. That's not true. It's from India, and I got it in 1980. Sorry about that.*

I'm not sure what to make of this. I think he means 1990, not 1980—I don't think he visited India when he was in his early twenties. But I don't ask. And does *not true* refer to a wilful lie, or to a misplaced memory? I, too, have those: there's no way of knowing without pursuing the issue messily. I decide to drop it.

I look through a diary from two years after we met, two years after Macau and Australia—this was a time when I was compulsively documenting my life—and now, we're both in Lisbon, and the disappointment of the meeting that did not happen (for which I use the word 'Singapore' as shorthand) continues, in a local key. There are several outings to the Alentejo that he aborts, and alongside the meals out and afternoons at my flat (some languorous, some discombobulated), there are many more that he postpones or cancels. When he does turn up, it's often a lot later than planned. Sometimes he phones at two or three in the morning. Or he rocks up, maudlin, at ridiculous hours. Well past midnight that very last time, when I didn't let him in and ran downstairs, a black coat thrown over my pyjamas, to sit crying furiously and burning with humiliation in his car under the spread of one of the tisane-smelling linden trees that line so many streets in Lisbon. I sit there crying and railing and thinking that if transience is the condition for pleasure, then A takes the art of pleasure to its rarefied extreme. But his administration of the smallest doses of gratification is also a form of sadism into which I have kept myself locked by a reciprocal compliance.

And all the while, in the wake of changes that happened while I was in Australia, this longing and frustration nourishes my work. While the topics of my work now break into my affective life, I experiment formally and materially with the rapid and apparently improvised. I stop painting in oils. I begin making photographs and shyly probing the potential of photographic and drawn self-portraits; the word *selfie* has not yet come into existence. I begin using inks and watercolours, making small, washy drawings annotated with a punch line, garnished with a smattering of caustic or melancholy phrases or lines from songs. I no longer want my love of images and my love of words to do battle with each other.

Then, in 1999, I start elaborating a body of work in which scant, stylised drawings—awkward illustrations of massage positions—are surrounded by pages and pages of text. I do not know how the idea of the massage came to me, or where I found the source material, it looks like a catalogue of sorts, but it hit me as just what I was looking for, something about the convincing, or indeed coercive, power of touch.

Re-stock your fridge

There are, by the time the series ends a year later, about 150 sheets of matt A4 watercolour paper, their surfaces filled with writing. Writing as drawing, drawing as listing: a series of exhortations, both fresh and clichéd (letting meaning in, keeping meaning out), written in regular schoolgirl script in leaky watercolour, each incarnadine stroke as controlled and determined as I wished I could be. The letters seem threaded together, red on white. A year later, I have a string of phrases— this time in Portuguese—in this same script stitched red on a milky linen tablecloth.

It is only now, so many years later, that it occurs to me that the form of this script has a specific link to the Kama Sutra that A gave me. In the Kama Sutra, the lure merely begins with *kama*, the sensual, the carnal, the realm of erotic desire. The *sutra* is the telling of this in aphorisms.

The word *sutra*, which is etymologically linked to the English *suture*, means string or thread, and came to be used metaphorically to describe the stringing together of aphorisms into manuals. My collection of text drawings, then, was nothing more nor less than a manual on the contradictions of erotic desire and its mental and spiritual reverberations. A Kama Sutra.

The instructions are randomly arranged, ordered only in accordance with the available space and a jagged, spoken lyricism. The adjacency of contradictory instructions provokes in me a shiver of tautological recognition. For this, *this*, is my condition:

*Allow desire to agitate your imagination. Mend a fuse. Embody your ideas. Adjust quietly to altered circumstances. Shop at Shanghai Tang. Be the person your dog thinks you are. Muster up a new level of intensity. Re-invent your platitudes. Keep your charity anonymous. Count the minutes. Go slower. Watch the feathers flying. Pick up some moral fibre. Step up to a new terrace of consciousness. Slouch towards Bethlehem. Follow your needer. Notch up to a new level of intensity. Make the stopgap into a genre. Fully embrace your horror vacui. Leave a trail as you go. Put your hackles up. Supply the required quotient of pain. File your photographs thematically. Press, don't pressurise.*

*Adjust quietly to altered circumstances.   Address my body.   Abandon your quest for the eternal.   Chart your disaffection.   Forget your tragedy.   Interpret ritualised receptions.   Show your hand.   Don't feel obliged to choose between Elvis Costello and Tom Waits.   Familiarise yourself with my handwriting. If you can't change the work, change the title.   Be master of your own plans. Disrupt a narrative arc.   Forge my signature.   Go easy on the testosterone. Take refuge in familiar verbal enclaves.   Agonise over details.   Travel light. Force my hand.   Don't count the small change.   Find an opening.   Pave a road. Cultivate total somatic awareness.   Bite your own toenails.   Embrace the fate of the loser.   Perfect your alibi.   Boldly reveal your unfortunate defects.   Lose your mother's apron strings.   Take asylum in my home.   Get used to prosthetic devices.   Draw crazy patterns with your feet.   Carefully follow the protocols of lovemaking.   Jettison your inherited anguish.   Don't turn transgression into a style.   Make monogamy your source of true inspiration.   Imagine another scenario.   Tie me down.   Guide me through the undergrowth. Bypass the merely capricious.   Watch as I rewrite the history of feminine compliance. Enhance your own prestige.   Fill me with your longing.   Fill me with your semen.   Look out of a different window.   Explore hidden topographies.   Be someone else.   Stew in your own juices.   Take in the scenery.   Shield me with your name.   Beware booby traps.   Perform an autopsy on my past.   Ransom your last hope.   Submit to the seriousness of pleasure.   Establish a noble ancestry.   Rock the boat.   Waltz with Matilda.   Query the reassurance of familiar misery.   Unfold me in slow motion.   Breathe.   Familiarise yourself with the stages of feminism.   Try both switches.   Take available routes.   Mend broken vessels.   Read between the lines. Stretch torment to extremes.   Watch the stars falling.   Gauge the distance.   Be my human shield.   Expose raw ends.   Blend into the domestic decor.   Don't blame your children.   Uncover every inch of me.   Underline in pencil.   Work overtime.   Sacrifice your incomparable logic.   Allow me to feed you.   Do not utter the true meaning of the ruined deal.   Suspect my every move.   Be my homeward dove.   Undertake a programme of comprehensive damage control. Adhere to the sonnet form.   Trust me.   Read manuals.   Take courage in defeat. Eat emptiness with a teaspoon.   Move out of the married man slot.   Insist on new explanations.   Make alien matter pliant.   Allow the sigh to subside.   Fast. Rephrase the question.   Don't count crows' feet.   Shit or get off the pot.   Learn the language of the battlefield.   Cling to my threadbare optimism.   Reorganise your solitude.   Refine your sense of scale.   Cauterise existing wounds.   Call me when you're single.   Edit your dictionary of complaints.   Fuel yourself with important social concerns.   Assume impossible positions.   Test the limits of the bearable.   Hijack an untenable idea.   Travel further than planned.   Bandage your narcissistic wound.   Narrow your spectrum of options.   Learn Hebrew. Blindfold me.   Yield to others.   Render used meanings obsolete.   Look beyond probability.   Live up to half my expectations.   Avoid anticipating nostalgia. Foster continuity.   Mistrust my sincerity.   Abandon the comfort zone.   Invent*

a new iconographic repertoire.  Don't whinge.  Subscribe to a generous thought.
Don't mistake me for someone who cares.   Acquire fluency in the language of
dogs.   Watch me from a great distance.   Don't wait for luck.   Reinstate lost
causes.  Inject my veins with ludicrous hope.  Hesitate.   For me, undergo an
ordeal by love.   Unpack your metaphors.     Listen to the history of feminine
resistance.  Elicit fierce loyalty.  Applaud discordant prose.   Play second fiddle.
Be yourself, but on purpose.  Employ stinging accuracy.  Beg me to stay.   Find
the vanishing point.   Prepare a wide background of contrast.   Caress the meaty
part of the curve.   Live forever.   Make do.   Don't be a jerk.   Tell me your real
name.  Unpack your suitcase of regrets.  Enjoy the shabby delirium of absence.
Study the Kamasutra.   Offer me a little of what you've already lost.

Follow intuitive preferences. Underline in pencil.
Examine material evidence. Staunch the flow.
Invent your own aesthetics. Violate the decorum
of sight. Leave me your phone number. Revise
your itinerary. Stretch torment to extremes
Be my homeward dove. Refuse to believe. Mourn
irretrievable objects. Turn off the gas. Divulge
the unspeakable. Undertake a programme of
comprehensive damage control. Change the
record. Work overtime. Suspect my every move.

# Hair

One day, I retrieve from its long slumber the *Better Homes and Gardens Baby Book,* which serves as a record of some of the details of the first three years of my life. *Better Homes and Gardens* was launched in Des Moines in 1922. It presents, in its very title, an aspiration. Our homes, our gardens, our lives, can and should be improved. If today, we feel nudged or compelled to *optimise* our lives, in the 1950s when my parents acquired this book, *better* was good enough and presented a reasonable term for normative striving.

Not surprisingly, since my mother was never much of a record keeper, this baby book is filled with notes in my father's hand: his beautiful, backward leaning script. Here, in the way he has embraced the project of data collection, I recognise my own love of record keeping, the exacting attention of the archivist: the birth announcement in the newspaper, the congratulatory telegrams, a copy of my birth certificate, a short list of gifts received, several small monochrome photographs meticulously pasted in. Then there are the handwritten records of delivery (natural, no anaesthetic), details of the physical examination at birth (no exceptional birth marks, no heart murmur), the pink skin, the body height and weight, circumference of chest and head, an extraordinary chart of every single hour of the first week's 'natural rhythm' (sleeps, nurses, bottle feeding, wakens, cries, bath), vitamins administered, first weight loss, subsequent weight gains, first illness, breast milk pumping, the fact that, like most children of my generation, I was schedule fed every four hours. Of course I was schedule fed! Every symptom ever examined under the microscope of my own interest in psychoanalysis bears the mark of this: a lifetime of difficulty with frustration and delayed gratification, and the need to exercise it, like a tired but insistent muscle.

Following on details of the earliest days of my life—a time that is, for all of us, at once unremembered and, if we are lucky enough to have

 https://doi.org/10.11647/OBP.0285.16

a stable home, always already constructed through words and images that have been put in place by our caretakers—my father tracks my further development. He trails off at around my third year. News of teeth as they emerge, of the capability of holding toys and managing spoons, of giggling, of refusing breast milk, of the first signs of temper, of bladder and bowel training, of drinking from a cup and pointing, on instruction, to eyes, nose, hair. I am fascinated to read that the first full-blown tantrum, at seventeen months, is approximately coincident with the first use of sentences, confirming theories of the relationship between linguistic representation and loss, and therefore frustration and terror. My father writes: 'At 17 months, talks beautifully in whole sentences such as "Ruthie wants soup." Talks non-stop and is in motion all day long.'

Between two of the pages of this relic, I now come across a piece of paper pressed flat and thin. I do not remember if I have ever seen it before. Over time, this fragile thing has almost stuck to the book. I carefully prise it away, amazed at this delicate treasure. It is a child's drawing made on a piece of unbleached paper, possibly extracted from an exercise book, a notebook, or perhaps it is part of an envelope. The page has been roughly snipped with scissors—maybe a small pair of nail scissors or the kind of blunt cutting instrument that children are given—so that it is impossible now to fathom the original scale of the drawn image relative to the whole page, or how that image was initially positioned on the blank page. I know that, in analysing children's drawings, positioning and scale are relevant. But there's nothing to tell me whether the page surrounding what I now see was blank or filled.

On the verso side of the image, a child has written in Hebrew. She has pressed hard with a B or 2B pencil, emphatic letters that identify her. 'Ruth here, aged six and a half,' she has written. And then, as if doubly to ensure that authorship and ownership have been asserted, she has added: 'also by Ruth.' So: *Ruth here*, and the image is also *by* Ruth. I am intrigued by this doubling—or splitting—of self, but I know that any conclusion I draw from it would be overdetermined. At once too obvious, and too conjectural. Nevertheless, I feel compelled to return again and again to this drawing, finding in it a message in a bottle tossed into the ocean long ago.

This is my work, or rather, it is Ruth's, me and not me. The girl in the drawing is pictured from the back. And she does seem, if I am to judge

by the proportions of her body—the slim, straight torso, the skinny legs—to be a girl rather than a woman. There is a head of long, straight dark hair flicked up at the bottom. The child's difficulty in rendering that—the hair that has departed from the flat plane and projects into the viewer's space—has been solved by turning the flick into a kind of fat scroll, or a plaited loaf. In fact, above this plaited loaf is the shadow of an earlier one, a hirsute *chollah*, which has been scribbled over with the pencil, as though Ruth who is making the drawing has decided to lengthen the girl's hair, as well as thickening it. The length of hair is clearly an important signifier, as is its dressing: two red clips at the top of the head, I suppose securing stray wisps of fringe.

I say this with a grimace, the type that paraphrases 'time is cruel,' since at the time that I find this tiny drawing, all but the last traces of fringe on my head have disappeared. The doctor seems confident that my loss of hair will not be permanent; that it does not follow the known patterns of alopecia. She attributes the hair loss to a bout of cellulitis a few months earlier. I had never heard of cellulitis before, and the first I knew of it was the feeling of a clamp around my head. The pain was similar to that of shingles, difficult to describe, dull and piercing at the same time. The cellulitis extended from the top of my cheekbones, through my eyelids to the first quadrant of my scalp, swelling and reddening and then bursting into florid scabs. I looked grotesque. Prescribed antibiotics, debilitated with fatigue, I mostly stayed indoors for a fortnight, though a trip to the supermarket brought stares that gave me a taste of othering such as I had not ever previously experienced.

Loss of hair is so primal a threat, one hears of women facing chemotherapy who say they dread hair loss more than any other aspects of their illness or treatment. When I recollect my earlier head of big hair, the titian waves swirling off my forehead, tumbling down my back, I cannot help believing that punishment is at work for the hubris of youth: I had so taken for granted the refrain *you have such amazing hair.*

Now, not knowing if there will be regrowth, I toy with my choices, all of which have at least to bypass the Donald Trump comb-over. I perceive empirically, as we all do, that wind is the enemy of the gleaming pate under cover of a curl or two. And baldness seems preferable to the mullet option. Bandana, tick; hat, tick. But for indoors? I cannot see myself enduring a wig, so my first thought is a buzz cut, despite knowing it's not a good look for anyone over twenty-five, except Annie

Lennox. Google searches point to rocking that baldness on Instagram or opting for scalp micropigmentation, i.e. tattooing. All the while, I wish I still *needed* hair clips, that childish accoutrement that figures, for the six-and-a-half-year old I once was, as a sign of neat grown-upness. Indeed, going by this drawing, being adult was, for me, all about the hair, the clothes, the accessories.

In the drawing, despite the length of hair, I have taken care not to omit the fragile stalk of a neck emerging beneath it. This has the odd effect of making the head seem ridiculously long. It is also the most conceptual—in other words, the least observational—part of the drawing, since it has nothing to do with how a head of long hair would or could be seen from the back, but rather, with the prior knowledge of the existence, just there, of a neck. This tiny stem links the head to a washboard torso onto which arms are attached by articulated ball and socket joints, fitting neatly into capped, puffed short sleeves. The girl's back, unmodulated by any form of waist, slots neatly into the ballooned spread of a flounce. The dress is pale green: vertical crayon marks follow the direction of the torso, and horizontal marks fill the wide, bell-shaped expanse of skirt, which has thin piping along its hemline.

The visible area of the legs projecting beneath the dress is bisected by marks indicating the back of a knee, more like folds, or the edging of socks. Free of ankles, these legs are tagliatelle fed into kitten-heeled shoes. As with the hair, the child artist has been exercised by the representation of three-dimensional things on a two-dimensional surface, and here she has clearly relied on observation and rudimentary perspective rather than conceptualisation: all you can see of the foot, from behind, is the ball of the heel. The arms are like saucepan handles, semi circles devoid of joint or angle, and clearly, hands present—as they so often do in drawing—a difficulty. The left one is kept out of sight, the right is balled into a fist. Around the right wrist, a handbag is looped, its green hue matching precisely that of the dress.

I am fascinated by the plenitude of detail, which is mostly (except for the knee creases) about the dressing, the presentation. The omission of a face—rational from the point of view I have chosen—also means the exclusion of all signs of affect. I seem to be interested, rather, in an idea of femininity performed in tottering steps and girlish costume, matching greens offset by punchy touches of complementary red.

Unreconstructed, I love this girl stuff. I feel sure that at the front, there would be red lipstick to complete the look.

Near the head of this figure, one word is written in the child's emphatic script. This caption addresses me now across the decades, grabs me, pierces me. It is the punctum of the drawing. Even though *punctum* is a photographic term—a detail that pricks or wounds the viewer's expectations—it fits here. The punctum speaks directly from—and to—the unconscious. In this drawing, that single word that pierces me is 'Mummy.' It is written in Hebrew letters, but phonetically, it spells the English word, *mummy*, rather than the equivalent Hebrew word, *ima*.

This caption is where the drawing is hurt by an encounter with the real. It is the word and not the image that leads me straight to my bilingual childhood. It is the word that separates me from other girls my age, there where I am living in Tel Aviv, where these other girls call their mother *ima*, while already then, I call mine 'Mummy', with a Hebrew accent. That word, *mummy*, also signals my passage, just over two years later, from being a little Israeli girl to being a little South African girl, a bifurcated identity, never quite losing the one nor quite adopting the other. These identities would later be joined by two others, my Portuguese self and my English one, all jostling hopelessly for supremacy, all cohabiting and still today hailing me in different and not always predictable speech acts.

Here in this drawing, the word *mummy* in Hebrew letters also pinpoints the site of my longing. This girl, this curly, reddish-haired me, wants what she cannot have: long, straight dark hair. She wishes too, for high heels and beautiful clothes with matching accessories.

How to account for desire, and how to deal with its non-gratification? That question permeates the drawing, even as it percolates through life itself. In wanting certain things, the girl identifies with a mother whom she glamourises and idealises. My mother, after all, had short, curly hair. Yet still, this is both the girl and her mother, *my* mother, with all the things the picture could not show: her rasping voice, her accent, her peep-toe shoes, that Estée Lauder perfume. My mother, *walking away*. I want this drawing to tell me more than I already know, and in a sense, it does just that, simply by virtue of being virgin territory to mine, lost until now. But in some other sense, it explains nothing: it brings me old news of how I always felt about my mother, her lack of maternality,

her narcissism: like all narcissism, hers was more a clawing need for approbation than an expression of self-love.

## Gorgeous Nothings

I am compelled not only by the content of this small drawing, but also by its physical properties, its existence as a little something that might well have landed up being discarded, along with so many other drawings made at around the same time: where are they? Why were they not kept? Not a full drawing, but something extracted, like a doodle or a note on the margins of something else: calendars, diary pages, envelopes, receipts. There is an old-fashioned (and of course newly refashioned) thrift to such recycling of materials (bringing them from the brink of nothingness back into somethingness), but it is also the very idea of marginalia that interests me. Margin: a space that, in its very status (unimportant, secondary, on the edge), releases the maker from the pressure of composition, the compulsion of the virgin mark, the mantic statement. And yet, in their fragmentary nature, things jotted down on such bits of paper can seem particularly significant, if not oracular.

There are works that I love, made as marginalia. Made as if in passing, yet distinctly not unimportant; made with urgency and often in response to something fleeting, an observation or a thought. As 'active tracers of the inner speech-current'—George Steiner, spot on—jottings in informal formats are powered by an unconscious sense of freedom and enablement. Not necessarily disputatious, in the most literal sense of marginalia, but afterthoughts and forethoughts: such mark-making permits itself to bypass any prior formal strictures. They are governed by the making-do logic of bricolage, the poetics of improvisation. In this sense, they align well with working procedures (living art, anti-art) sponsored by the international Fluxus group in the 1960s and '70s.

Emphatic or lyrical, such works of improvised marginalia occupy a distinct if undeclared place in modernism. They are made by artists and writers who are soothsayers of the diminutive, who channel inner truth, eschewing the grand and the sweeping. Emily Dickinson, celebrated as a verbal miniaturist, made an art form of the punctuated pause, the interlines, the spaces between words. Fifty-two of her poem-thought-fragments, written on scraps of paper or flaps of envelopes, were

published in facsimile as *The Gorgeous Nothings* in 2012. The rapture
that this book produced in me, beginning with its perfect title, warrants
its own essay. The envelope poem fragments are enticing testimony to
a mind's fertile power of abbreviated association: 'Summer laid/her
simple Hat/On its boundless/shelf.' Or 'But are not/all facts dreams/
as soon as/we put/them behind/us.' Or 'Our little/secrets/slink/away.'
Or 'Clogged/only with/Music, like/the Wheels of /Birds.' The length
of the lines, governed by the happenstance of available space, forces a
syncopated rhythm on the phrasing.

But beyond the delicate and thrilling power of verbal evocation, these
testify, too, to the visual power of words: concrete poetry before its time.
Spatial arrangement and the small, marginal form are essential to their
meaning. And it is easy to see how the dash, so typical of Dickinson's
idiosyncratic punctuation, is born less of syntax and more of something
at once dictional and gestural.

Then, there is James Castle, a so-called outsider artist who spent all
his life (1899–1977) in Boise, Idaho, born deaf and living and working
for decades in extreme isolation. Castle's works come into being from a
variety of sources, including his reuse of images derived from printed
media—advertising and illustration. Drawing with pronounced energy
in soot and spit on envelopes and pieces of card, he also produced
idiosyncratic paper constructions and handmade books. He stitched and
tied and marked in an idiom that extends beyond—but also mirrors—
that of modernism, with his allusions to mass culture (logos, brands,
stamps, ephemera), to the larder, the storeroom and the workroom.

Swiss writer Robert Walser, also considered an outsider, was
another consummate crafter of the minute and fragmentary. He wrote
stories, always in pencil and on the tiniest surfaces—cards, receipts,
calendar pages, envelopes—in an encrypted script. The writing of these
microscripts is so minuscule that his pages give the impression of being
seen from a distance, telescoped: intimacy reversed. More than this,
language seems to have become abstract (the punctuated marks of the
passage of ants), or indeed, asemic: 'hieroglyphs for which the code
has been lost,' in Theodor Adorno's formulation of the 'writing' that
constitutes all art.

Walser is a droll, self-deprecating elaborator of short prose, even when
he writes novels. Sliding between first- and third-person narrations, his

texts are rhythmic, mysterious, visionary. And they are ambulatory: ('without walking I would be dead,' he says): walking is intrinsic to them, corporealising the act of writing, especially, though not exclusively, in his novella *The Walk* (1917), in which we accompany a writer walking to escape the accusatory silence of the blank page. The point of view of Walser's stories is profoundly internal, a ruined psychic landscape. Diagnosed with schizophrenia after suffering a mental breakdown in his mid-fifties, his writings reveal a compassionate fascination with the ordinary and the limited. Both as sound text and as visual marks on the page, his writing turns the marginal into the main event. 'I was never really a child, and therefore something in the nature of childhood will cling to me always,' says the narrator of his short novel *Josef van Gunten* (1909). 'To be small and to stay small. [...] I can only breathe in the lower regions,' he declares.

# Me

I love finding things previously unknown or forgotten among my familiar possessions.

Enraptured with this fragment of drawing that has slipped out of my baby book, I photograph and post it on Instagram with a short text and a few obvious hashtags. In response, I receive a DM from Isabel, an artist acquaintance in Lisbon, who attaches a jpeg of a drawing I gave her in the early 1990s. We had exchanged works: hers was a table sculpture: a long baguette made of resin, with knives deeply buried in its translucent body, at once homely and aggressive. I cannot recall what she chose in return. Receiving her message with its attachment, I am reminded of this series of washy pen and ink drawings reprising the motifs of my childhood, lifted directly from my family archive. I had begun to work with and from family photographs in the mid-1990s.

The subject of the drawing Isabel has chosen comes from one of the earliest colour photographs of me. I am daintily holding open the edges of my dress, as though unfolding a fan. My fingers are securing the frilled hem, and it is important for me, clearly, to display the full range and extent of the swishing flounce. My legs have blurred together in a wash of watercolour, but my feet are visibly splayed like those of a little ballerina.

I remember this dress. It was made of crisp cotton, with small turquoise and white checks. It had two bands across the bodice, incorporating diminutive figures in procession around my flat chest. Together with a green dress—not unlike that in Little-Me's drawing—my father bought it for me in London, which was a city steeped in both ritual and glamour. The capped sleeves match the ones I've given the figure of *Mummy* in the drawing that I made at around the same time as I posed for this photograph. Though the forty-something-year-old person who has drawn herself from a photograph is aware of the nested meanings of meta-representations, there seems to be a continuous thread linking the

first drawing with the second: a continuity of fantasised femininity. The earlier drawing, however, is a gift from the past shored up in the present. In that child's drawing, fully identified with my mother, I long for her as she turns her back to me, turns her back *on* me. I express the unmet desires that then defined, and—perhaps, to my dismay in looking at the two drawings together—that continued to define my position, my location, my place in adulthood and in femininity.

Well, at least I have finally escaped the tyranny of the ponytail. I have come to love short hair. Ollie, my hairdresser, gave me a great pixie cut to accommodate the hair loss and reassured me. *Believe me*, he said, *I've seen alopecia many times, your hair will grow again.*

As soon as I see myself in the mirror, I realise that—bald patch notwithstanding—this look accords better with how I now feel about myself, and especially, with a life in which exercise—running and yoga—plays a part, as it did not when I was young.

To my delight, in 2020, in the enforced isolation of the pandemic, the bald patch yields first a reassuring, downy nap; then more robustly, it grows thicker, longer. My lockdown hair is fuller, softer and more lustrous than my hair was in the prehistory of that time, only a few months earlier.

First lockdown, when I still think that my partner P and I have a future together, brings its own surprising intimacies. When P and I have dinner dates on FaceTime, he comments on how my hair has grown, though I know he likes it short. A look passes between us, and I know we are both thinking of the moment when, with no screen separating us, no thin slice of technology wedged between our bodies, we will at first shyly, searchingly, kiss. We will press our oldish bodies together and then he will grab a handful of hair on the crown of my head, and, with this, I will be wordlessly invited to extend my throat in a way that I know he likes, that he knows I like, and he will lick the underside of my chin and then he will kiss my neck. That kiss will be full, both a reward and a promise, and then, with eyes half closed, I will loosen my no-longer-titian hair from his grip and tilt my head up and touch his face with both my hands, and he will remove his glasses, which is always a signifier of that particular intimacy and he will smile and run his hands through my hair and along my neck, and then he'll say: *wow, it really has grown*! and our hearts will be going like mad and I will smile and say yes. Yes.

# Afterword

At the start of the second lockdown, in October 2020, I lost the relationship in which I had invested my sense of delight in the present and hope for the future. I say *lost* as though I carelessly mislaid it, as I constantly mislay my glasses or my keys, but in fact, this rupture came from left field, as the sporting metaphor goes.

I did not feel sporting about it: I felt winded, wiped out, erased.

That loss is not the subject of this book, and only one object that I associate with that relationship—a small St Christopher trinket—has found its way into these pages, and that only in passing.

But the presence of this man and this loss hovers over this book and attaches to several of its chapters, especially the last one, in which I have had to change the tenses in the final edit. It attaches, most explicitly, however, to that vast, immaterial and invisible evocative object that is music, or rather, its constituent parts: tracks compiled into a very long playlist.

P sent me a track a day, sometimes two or three, for the entire first year of our relationship, a time I experienced as blissful. In attempting to duplicate this playlist to ensure not losing it as I had lost him, and

 https://doi.org/10.11647/OBP.0285.17

while writing about listing, I accidentally erased it all. Irretrievably, as it turns out.

I know that, through the lens of psychoanalysis, there is no such thing as an accident. But it seems to me that in no pocket or particle of my being did I wish to lose this man again by dispersing the evocative objects that acutely, singly and cumulatively, evoked all that was sweetest in our time together, and all that was most bitter about our (to me) unforeseen end.

# Reading

Adorno, Theodor. *Aesthetic Theory.* Trans. Robert Hullot-Kentor. London: Bloomsbury Academic, 2012 (1997).

Agamben, Giorgio. *Homo Sacer: Sovereign Power and Bare Life.* Trans. Damiel Heller-Roazen. Stanford, CA: Stanford University Press, 1998 (1995).

Alcott, Louisa May. *Little Women.* New York: Barnes & Noble Classics, 2004 (1868, 1869).

Alpers, Svetlana. *The Art of Describing: Dutch Art in the Seventeenth Century.* London: Penguin Books, 1989 (1983).

Appignanesi, Lisa. *Everyday Madness: On Grief, Anger, Loss and Love.* London: Fourth Estate, 2018.

Arnatt, Keith. *I'm a Real Photographer.* Exhibition catalogue with texts by Brett Rogers, David Hurn and Clare Grafik. London: Photographer's Gallery, 2007.

Ashbery, John. *As We Know.* London: Penguin, 1992 (1979).

Bachelard, Gaston. *The Poetics of Space.* Trans. Maria Jolas. Boston: Beacon Press, 1994 (1964).

Baker, Nicholson. *The Size of Thoughts: Essays and Other Lumber.* London: Random House, 1997.

Barthes, Roland. *Camera Lucida.* Trans. Richard Howard. London: Vintage, 2000 (1980).

Barthes, Roland. *Mourning Diary.* Trans. Richard Howard. Text established and annotated by Nathalie Léger. New York: Hill and Wang, 2010 (1977).

Batchen, Geoffrey. *Forget Me Not: Photography & Remembrance.* New York: Princeton Architectural Press, 2004.

Baxandall, Michael. *Patterns of Intention: On the Historical Explanation of Pictures.* New Haven, CT: Yale University Press, 1987.

Beauvoir, Simone de. *A Very Easy Death.* Trans. Patrick O'Brian. London: André Deutsch, George Weidenfeld and Nicolson Ltd. and G. P. Putnam's Sons, 1965.

Bellamy, Dodie. *Bee Reaved.* Passadena: Semiotext(e)/Native Agents, 2021.

Benjamin, Walter. 'Unpacking My Library', in *Illuminations*. Trans. Harry Zohn. London: Pimlico, 1999, pp. 61–69.

Benjamin, Walter. 'The Work of Art in the Age of Mechanical Reproduction', in *Illuminations*. Trans. Harry Zohn. London: Pimlico, 1999, pp. 211–44.

Benjamin, Walter. *A Berlin Childhood around 1900*. Trans. Howard Eiland. Cambridge, MA: The Belknap Press of Harvard University Press, 2006.

Bennett, Alan. *Untold Stories*. London: Faber & Faber, 2008.

Bennett, Jane. *Vibrant Matter: A Political Ecology of Things*. Durham, NC and London: Duke University Press, 2010.

Bennett, Claire-Louise. *Checkout 19*. London: Jonathan Cape, 2021.

Berger, John. 'The Metaphysician of Bologna.' *ARTnews*, 6 November 2015. https://www.artnews.com/art-news/retrospective/the-metaphysician-of-bologna-john-berger-on-giorgio-morandi-in-1955-5253/.

Berger, John. *Ways of Seeing*. Harmondsworth: Penguin, 1972.

Berger, John. *About Looking*. London: Bloomsbury Publishing, 2015 (1980).

Berlant, Lauren, and Kathleen Stewart. *The Hundreds*. Durham, NC: Duke University Press, 2018.

Birrell, Rebecca. *This Dark Country: Women Artists, Still Life and Intimacy in the Early Twentieth Century*. London: Bloomsbury, 2021.

Biss, Eula. *Notes from No Man's Land: American Essays*. London: Fitzcarraldo, 2017 (2009).

Biss, Eula. *On Immunity: An Inoculation*. London: Fitzcarraldo, 2014.

Blanchfield, Brian. *Proxies: Essays Near Knowing (A Reckoning)*. New York: Nightboat Books, 2016.

Bobb, Brooke. 'Maira Kalman Has Put the Contents of Her Mother's Closet on Display inside the Met.' *Vogue*, 23 March 2017. https://www.vogue.com/article/fashion-runway-maira-kalman.

Bollas, Christopher. *The Evocative Object World*. London: Routledge. 2009.

Bollas, Christopher. *Being a Character: Psychoanalysis and Self Experience*. London: Routledge, 2010 (1992).

Böll, Heinrich. *The Clown*. Trans. Leila Vennewitz. New York: Bard Books, 1963.

Borges, Jorge Luis. *Other Inquisitions (1937–1952)*. Trans. Ruth L. C. Simms. Austin: University of Texas Press, 1975 (1964.)

Boscagli, Maurizia. *Stuff Theory: Everyday Objects, Radical Materialism*. London, New York: Bloomsbury, 2014.

Boyer, Anne. *Garments Against Women*. London: Penguin, 2015. .

Boyer, Anne. *A Handbook of Disappointed Fate*. New York: Ugly Duckling Presse, 2018.

Boyer, Anne. *The Undying: A Meditation on Modern Illness*. London: Penguin/Random House, 2019.

Brown, Bill. 'Thing Theory.' *Critical Inquiry* 8/21, Autumn 2001: 1–22. https://doi.org/10.1086/449030.

Brown, Bill. *Other Things*. Chicago and London: University of Chicago Press, 2015.

Bryson, Norman. *Looking at the Overlooked: Four Essays on Still Life Painting*. London: Reaktion Books, 1990.

Butor, Michel. 'The Book as Object', in *Inventory: Essays*. Ed. Richard Howard. Numerous translators. London: Jonathan Cape, 1970, pp. 39–56.

Calle, Sophie. *True Stories*. Arles: Actes Sud, 2018.

Casagrande, Benedetta. 'A Passionate Practice: Peter Watkins, *The Unforgetting*.' *Skinnerbox*, 17 February 2020. https://www.skinnerboox.com/blog/theunforgetting.

Clurman, Irene and Dana Ben-Canaan. 'A Brief History of the Jews of Harbin.' *JewishGen KehilaLinks*. https://kehilalinks.jewishgen.org/harbin/Brief_History.htm.

cummings, e.e. *Poems 1923–1954*. New York: Harcourt, Brace and Company, 1954.

Cumming, Laura. *On Chapel Sands: My Mother and Other Missing Persons*. London: Chatto & Windus, 2019.

Curtis, Verna Posever. *Photographic Memory: The Album in the Age of Photography*. New York: Aperture, 2011.

Davey, Moyra, Sholis, Brian, Lerner, Ben, Lebovici, Elisabeth, and Rosenberg, Eric. *Moyra Davey*. Göttingen: Steidl, 2019.

de Duve, Thierry. 'Time Exposure and Snapshot: The Photograph as Paradox.' *October* 5, Summer 1978: 113–25.

de Waal, Edmund. *Library of Exile*. London: British Museum Press, 2020.

Dennett, Terry. 'Popular Photography and Labour Albums,' in *Family Snaps: The Meanings of Domestic Photography*. Ed. Jo Spence and Patricia Holland. London: Virago, 1991, pp. 73–83.

Dickinson, Emily. *The Gorgeous Nothings: Emily Dickinson's Envelope Poems*. Ed. Marta Werner and Jen Bervin, with a Preface by Susan Howe. New York: Christine Burgin/New Directions, 2012.

Didion, Joan. *The Year of Magical Thinking*. New York: Alfred Knopf, 2005

Dillon, Brian. *In the Dark Room*. London: Fitzcarraldo Editions, 2005.

Diski, Jenny. *Strangers on a Train*. London: Virago, 2004 (2001).

Doniger, Wendy. *Redeeming the Kama Sutra*. Oxford: Oxford University Press, 2016.

Doshi, Tishani. *Girls Are Coming Out of the Woods*. Hexham: Bloodaxe Books, 2018.

Duras, Marguerite. *Practicalities: Marguerite Duras Speaks to Jérôme Beaujour*. Trans. Barbara Bray. New York: Grove Weidenfeld, 1992 (1990).

Eber, Irene. *Wartime Shanghai and the Jewish Refugees from Central Europe: Survival, Co-Existence and Identity in a Multi-Ethnic City*. Berlin: Walter de Gruyter, 2012.

Eco, Umberto. 'How to Justify a Private Library', in *How to Travel with a Salmon and Other Essays*. Trans. William Weaver. New York: Harcourt, 1994 (1992), pp. 95–97.

Ernaux, Annie. *Exteriors*. Trans. Tanya Leslie. London: Fitzcarraldo Editions, 2021.

Eliot, T.S. *Notes Towards the Definition of Culture*. London: Faber & Faber, 1973.

Fitzgerald, F. Scott. 'Bernice Bobs Her Hair', in *Bernice Bobs Her Hair and Other Stories*. London: Penguin, 1982, pp. 7–34.

Foster, Hal. 'An Archival Impulse.' *October* 110, Autumn 2004: 3–22. https://doi.org/10.1086/449030.

Foucault, Michel. *The Order of Things: An Archaeology of the Human Sciences*. Unnamed translator. London: Tavistock/Routledge, 1989 (1970).

Fournier, Lauren. *Autotheory as Feminist Practice in Art Writing and Criticism*. Cambridge, MA: The MIT Press, 2021.

Freud, Sigmund. 'Mourning and Melancholia', in *The Complete Psychological Works of Sigmund Freud*, 14. Trans. James Strachey. London: Vintage, 2001, pp. 239–60.

Gass, William. *Tests of Time: Essays*. New York: Alfred A. Knopf, 2002.

Grant, Linda. *I Murdered My Library*. Kindle Single: Amazon, 2014.

Hardwick, Elizabeth. *Sleepless Nights*. London: Faber & Faber, 2019 (1979).

Henri, Adrian, Patten, Brian, and McGough, Roger. *The Mersey Sound*. London: Penguin, 1967.

Hens, Gregor. *Nicotine*, with an Introduction by Will Self. London: Fitzcarraldo Books, 2015.

Hiroshima Peace Memorial Museum Database. https://hpmm-db.jp/en/.

Hyde, Lewis. *The Gift: Creativity and The Artist in the Modern World*. New York: Vintage Books, 2007 (1979).

Jana, Rosalind. 'Louise Bourgeois and How Old Clothes Can Haunt Us.' *BBC Style*, 7 April 2022. https://www.bbc.com/culture/article/20220406-louise-bourgois-and-how-old-clothes-can-haunt-us.

Jernigan, Candy. *Evidence: Objects Lost and Found*, with a Foreword by Chuck Close and Introduction by Stokes Howell. San Francisco: Chronicle Books, 1999.

Joyce, James. *Ulysses (The Corrected Text)*, with a Preface by Richard Ellman. London: Penguin Books, 1986 (1920).

Josipovici, Gabriel. *Touch*. London: Yale University Press, 1996.

Julavits, Heidi. *The Folded Clock*. London: Bloomsbury Circus, 2017.

Kaufmann, Helen L. *The Story of Mozart*. London: Sampson Low, 1960 (1955).

Kentridge, William. Excerpt from *Stret* 5/3, November 1988, in Carolyn Christov-Bakargiev, 'William Kentridge', in *William Kentridge*. Ed. Carolyn Christov-Bakargiev. Brussels: Société des Expositions du Palais des Beaux-Arts, 1998, pp. 9–39.

Kristeva, Julia. *Powers of Horror: An Essay on Abjection*. Trans. Leon S. Roudiez. New York: Columbia University Press, 1982.

Kuhn, Annette. *Family Secrets: Acts of Memory and Imagination*. London, New York: Verso, 1995.

Kumin, Maxine. *Selected Poems 1960–1990*. New York: W. N. Norton, 1997.

Lebowitz, Fran. *On Smoking*. https://www.youtube.com/watch?v=aGcG7e03Nts.

Lévi-Strauss, Claude. *The Savage Mind*. Trans. Doreen Weightman and John Weightman. Chicago: University of Chicago Press, 1966.

McBride, Eimear. *Strange Hotel*. London: Faber & Faber, 2020.

Maddox, Amanda. 'Inside the Photography of Ishiuchi Miyako', *Getty*, 6 August 2015. https://blogs.getty.edu/iris/inside-the-photography-of-ishiuchi-miyako/.

Maddox, Amanda. *Ishiuchi Miyako: Postwar Shadows*. Los Angeles: J. Paul Getty Museum, 2015.

Magnusson, Margareta. *The Gentle Art of Swedish Death Cleaning*. London: Canongate, 2017.

Martin, Rosy. 'Too Close to Home: Tracing a Familiar Place', *n.paradoxa: international feminist art journal* 3: *Body, Space and Memory*, January 1999. Also available at www.rosymartin.co.uk/tooclose_essays.html.

Maupassant, Guy. 'A Tress of Hair', in *The Short Stories of Guy de Maupassant*, VI. Unnamed translator. Miniature Masterpieces, 2017. http://www.online-literature.com/maupassant/288/.

Miller, Nancy K. *What They Saved: Pieces of a Jewish Past*. Lincoln and London: University of Nebraska Press, 2011.

Milosz, Czeslaw. *Facing the River*. Trans. Czeslaw Milosz and Robert Hass. Manchester: Carcanet Press, 1995.

Muensterberger, Werner. *Collecting: An Unruly Passion. Psychological Perspectives*. Princeton: Princeton University Press, 2014 (1994).

Myles, Eileen. *Afterglow: A Dog Memoir*. New York: Grove Press, 2017.

Neruda, Pablo. *All the Odes*. Ed. and trans. Ilan Stavans. New York: Farrar, Straus and Giroux, 2013.

Ngai, Sianne. *Our Aesthetic Categories: Zany, Cute, Interesting*. Cambridge, MA and London: Harvard University Press, 2012.

Nicholl, Charles. 'Sneezing, Yawning, Falling: Charles Nicholl on the Writings of Leonardo da Vinci.' *London Review of Books* 26/1, 2004. https://www.lrb.co.uk/the-paper/v26/n24/charles-nicholl/sneezing-yawning-falling.

Olalquiaga, Celeste. *The Artificial Kingdom: A Treasury of the Kitsch Experience*. New York: Pantheon Books, 1998.

Orr, Deborah. *Motherwell: A Girlhood*. London: Weidenfeld & Nicolson, 2020.

Ozeki, Ruth. *The Book of Form and Emptiness*. London: Canongate Books, 2021.

Pamuk, Orhan. *The Museum of Innocence,* Trans. Maureen Freely. London: Faber & Faber, 2011 (2009).

Pamuk, Orhan. *The Innocence of Objects*. Trans. Ekin Oklap. New York: Abrams, 2012.

Pamuk, Orhan. 'A Modest Manifesto for Museums.' *American Craft Council Magazine*, June/July 2013. Also available at https://www.masumiyetmuzesi.org/en/mani-festo.

Paterson, Don. *Best Thought, Worst Thought (On Art, Sex, Work and Death)*. Saint Paul, MN: Graywolf Press, 2008.

Pearce, S.M. *Museums, Objects and Collections: A Cultural Study*. Leicester and London: Leicester University Press, 1992.

Perec, Georges. *Things: A Story of the Sixties,* with *A Man Asleep*. Trans. Andrew Leak. London: Vintage Books, 2011 (1965).

Perec, Georges. 'Brief Notes on the Art and Manner of Arranging One's Books', (1978) in *Species of Spaces and Other Pieces*. Trans. John Sturrock. London: Penguin Books, 1997, pp. 148–55.

Perec, Georges. *I Remember*. Trans. Philip Terry. London: Gallic Books, 2014 (1979).

Phillips, Adam. *On Kissing, Tickling and Being Bored*. London: Faber & Faber, 1993.

Phillips, Adam. 'Philip Roth's *Patrimony*', in *On Flirtation*. London: Faber & Faber, 1999, pp. 167–76.

Phillips, Adam. *Attention Seeking*. London: Penguin Books, 2019.

Porter, Charlie. *What Artists Wear*. London: Penguin Books, 2021.

Proust, Marcel. *Remembrance of Things Past, Vol. 3, Within a Budding Grove*. Trans. C. K. Scott Moncrieff. London: Chatto & Windus, 1972 (1922).

Proust, Marcel. *Remembrance of Things Past, Vol. 5, The Guermantes Way*. Trans. C. K. Scott Moncrieff. London: Chatto & Windus, 1972 (1922).

Püntener, Peter. '*Totenklage:* Press Release'. SACI Gallery, Florence, 27 February 2011. http://1995-2015.undo.net/it/mostra/115381.

Raab, Lawrence. *The History of Forgetting*. London: Penguin Books, 2009.

Rabelais, François. *Five books of the lives, heroic deeds and sayings of Gargantua and his son Pantagruel*. Trans. Sir Thomas Urquhart of Cromarty and Peter Antony Motteux. University of Adelaide. https://ebooks.adelaide.edu.au/r/rabelais/francois/r11g/complete.html.

Roth, Dieter. *Diaries,* with Essays by Fiona Bradley and Jan Voss, Sarah Lowndes and Jan Voss and Edited Extracts of Dieter Roth's Diaries. Exhibition catalogue. Edinburgh: The Fruitmarket Gallery, 2012.

Roth, Philip. *Patrimony*. London: Vintage, 1991.

Rowe, Pauline. 'Peter Watkins: The Unforgetting.' *Paper Journal*, 29 October 2020. https://paper-journal.com/peter-watkins-the-unforgetting/.

Ruefle, Mary. *Madness, Rack and Honey: Collected Lectures*. Seattle and New York: Wave Books, 2012.

Rugoff, Ralph, and Stephanie Rosenthal, *Louise Bourgeois: The Woven Child,* with Essays by Lynne Cooke, Rachel Cusk and Julienne Lorsz. Exhibition catalogue. London: The Hayward Gallery, 2022.

Ruisinger, Tina. *Traces,* with an Essay 'What Remains' by Nadine Olonetzky. Heidelberg: Kehrer Verlag, 2017.

Scheppe, Wolfgang with Freiderike Assandri, C. Fred Blake et al., *Supermarket of the Dead: Fire Offerings in China and the Cult of Global Consumption*. Cologne: Verlag der Buchhandlung Walther König, 2015.

Sebald, W. G. *Unrecounted*. Trans. with a Note by Michael Hamburger. New York: New Directions Books, 2004 (1991).

Sebald, W. G. *Austerlitz*. Trans. Anthea Bell. London: Penguin Books, 2011 (2001).

Sedaris, David. 'Letting Go: Smoking and Non-Smoking.' *The New Yorker*, 28 April 2008. https://www.newyorker.com/magazine/2008/05/05/letting-go.

Self, Will. *The Butt*. London: Bloomsbury, 2012.

Serres, Michel. *Statues: The Second Book of Foundations.* Trans. Randolph Burks. London: Bloomsbury, 2014.

Singh, Julietta. *No Archive Will Restore You.* Santa Barbara: Punctum Books, 2018.

Smithson, Aline. 'Memory Is a Verb: Rosalie Ronsenthal: Midlife Tableaux.' *Lenscratch*, 12 March 2022. http://lenscratch.com/2022/03/memory-is-a-verb-rosalie-rosenthal-midlife-tableaux/.

Sontag, Susan. *On Photography.* London: Penguin Books, 1979.

Sontag, Susan. *Reborn (Journals and Notebooks, 1947–1963).* Ed. David Rieff. New York: Farrar, Straus and Giroux, 2009.

Spence, Jo. 'Soap, Family Album Work... and Hope', in *Family Snaps: The Meanings of Domestic Photography.* Ed. Jo Spence and Patricia Holland. London: Virago, 1991, pp. 200–07.

Spence, Jo. 'Shame-work: Thoughts on Family Snaps and Fractured Identities', in *Family Snaps: The Meanings of Domestic Photography.* Ed. Jo Spence and Patricia Holland. London: Virago, 1991, pp. 226–36.

Spieker, Sven. *The Big Archive: Art from Bureaucracy.* Cambridge, MA: The MIT Press, 2008.

Stein, Gertrude. *Operas and Plays.* Barrytown, NY: Station Hill Press, 1987 (1932).

Steiner, George, 'The Uncommon Reader', in *No Passion Spent: Essays 1978–1996.* London: Faber & Faber, 2010 (1996), pp. 1–19.

Stepanova, Maria. *In Memory of Memory.* Trans. Sasha Dugdale. London: Fitzcarraldo Editions, 2021.

Stern, Lesley. *The Smoking Book.* Chicago and London: The University of Chicago Press, 1999.

Stewart, Susan. *On Longing: Narratives of the Miniature, the Gigantic, the Souvenir, the Collection.* Durham, NC and London: Duke University Press, 1993.

Streitberger, Kiki. 'Artist's Statement', in *Sony World Photography Awards.* Exhibition catalogue. London: Somerset House, 2016.

Svevo, Italo. *The Confessions of Zeno.* Trans. Beryl de Zoete, with a Preface by Michael Hoffman. London: riverrun, 2018 (1930).

Szondi, Peter. 'Hope in the Past: On Walter Benjamin,' in Walter Benjamin, *A Berlin Childhood around 1900.* Trans. Howard Eiland. Cambridge, MA: The Belknap Press of Harvard University Press, 2006.

Szymborska, Maria Wisława. *Poems New and Collected, 1957–1997.* Trans. Stanisław Barańczak and Clare Cavanagh. London: Harcourt, Inc., 1998.

Tattoli, Chantel. 'The Surprising History (and Future) of Paperweights.' *The Paris Review*, 20 September 2017. https://www.theparisreview.org/blog/2017/09/20/the-surprising-history-of-paperweights/.

Tuana, Nancy. 'Viscous Porosity', in *Material Feminisms*. Ed. Stacy Alaimo and Susan Hekman. Bloomington: Indiana University Press, 2008, pp. 188–213.

Turkle, Sherry. *Evocative Objects: Things We Think With*. Cambridge, MA: MIT Press, 2007.

Ugresic, Dubravka. *The Museum of Unconditional Surrender*. Trans. Celia Hawkesworth. London: Phoenix, 1998 (1997).

Vulliamy, Ed. 'The appalling reality of Bosnia's missing dead.' *BBC Future*, 12 December 2016. http://www.bbc.com/future/story/20161212-the-appalling-reality-of-bosnias-missing-dead.

Vuong, Ocean. *On Earth We're Briefly Gorgeous*. New York: Penguin Press, 2019.

Walser, Robert. *Josef von Gunten*. Trans. Christopher Middleton. New York: The New York Review of Books, 1999.

Walser, Robert. *Microscripts*. Trans. Susan Bernofsky, with an Afterword by Walter Benjamin and *Some Thoughts on Robert Walser* by Maria Kalman. New York: New Directions/Christine Burgin, 2012.

Warner, Marina. *Inventory of a Life Mislaid: An Unreliable Memoir*. London: WilliamCollinsBooks.com, 2021.

Watkins, Peter. *The Unforgetting*. Jesi: Skinnerboox, 2019.

Weil, Simone. *Gravity and Grace*. Trans. Emma Crawford and Marion von der Ruhr. London: Routledge Classics, 2002 (1999).

Wharton, Edith. *House of Mirth*. London: Penguin, 1993 (1905).

Williams, William Carlos. *Paterson*. New York: New Directions, 1946.

Woolf, Virginia. *Jacob's Room*. Oxford: Oxford University Press, 2000 (1922).

Woolf, Virginia. *The Waves*. London: Random House, 2004 (1931).

Woolf, Virginia. *Between the Acts*. London: Penguin Books, 1991 (1941).

Woolf, Virginia. 'Solid Objects', in *A Haunted House and Other Short Stories*. London: Vintage Books, 2003 (1985), pp. 115–20.

Zhang, Dora. 'A Lens for an Eye: Proust and Photography,' in *Representations* 118/1, Spring 2012: 103–25. https://doi.org.10.1525/rep.2012.118.1.103.

# Index

ひろしま *hiroshima* 172–173
Israel 49, 54–56, 88–89, 94, 96–97, 103, 112, 114, 120, 128, 130, 248
Istanbul 225–227, 229

**J**

Jernigan, Candy 30–32
Jews 5, 14, 49, 54–55, 63, 72, 88, 96, 112, 128, 130, 156, 160
  Jewish diaspora 128
  Jewishness 62
  Russian Jews 96, 112, 128, 130
Johannesburg 24, 48–49, 54–58, 73–74, 89–90, 97, 103, 141, 188, 191, 196, 216, 218
Josipovici, Gabriel 82, 179
Joyce, James
  *Ulysses* 43
Julavits, Heidi 74
  *The Folded Clock* 74

**K**

Kabakov, Ilya and Emilia 228
Kafka, Franz 86
Kahlo, Frida 197
Kalf, Willem 206
Kalman, Maira 159–160, 163, 169, 276
  *Sara Berman's Closet* 159–160
Kama Sutra 20, 158, 234, 236–240
Kapur, Geeta 214
Kaufmann, Helen L. 187
  *The Little Book of Music Anecdotes* 187
  *The Story of Mozart* 187, 191
Kelley, Mike 71
Kelly, Mary 37–38, 200
  *Post-Partum Document* 37–38
Kentridge, William 199
Khalil, Hannah 184
  *A Museum in Baghdad* 184
*kintsugi* 183
kitsch 3, 80–82, 216, 230
Kollwitz, Käthe 197

Kondo, Marie 209, 211
Kounellis, Jannis 228
Kristeva, Julia 50, 69–70
  *The Powers of Horror: An Essay on Abjection* 69
Kuhn, Annette 8–9, 16, 116
  *Family Secrets: Acts of Memory and Imagination* 8
Kumin, Maxine 49
  'How It Is' 49

**L**

Latvia 95, 114
Lebowitz, Fran 83–84
legacy 58, 62, 73, 88, 96, 146, 184, 223
Leibovitz, Annie 113
Lerner, Ben 214–215
Letinsky, Laura 204
Lévi-Strauss, Claude 15
  bricolage 15. *See also* bricolage
  *pensée sauvage* 15
  science of the concrete 15
  *The Savage Mind* 15
Lippard, Lucy 198
Lisbon 56, 85, 145, 148, 190–191, 214, 219, 222–224, 227–228, 231, 234–236, 238, 251
Lispector, Clarice 83
lists 30, 102, 134–142, 144, 146, 171, 176, 189, 239, 244, 255
loss 2, 6, 11, 15, 19–21, 33, 38, 45, 49, 63, 68, 88, 103, 106, 113, 135–136, 156, 161, 167–168, 171, 178, 182, 211, 226–227, 244–246, 253–254
love 2, 4, 7, 10–11, 13, 17, 19, 21, 24, 27–28, 30, 33, 45, 51, 57, 65, 69–71, 74–75, 78–79, 82, 84–85, 88, 96–97, 109, 113, 130, 135–136, 141, 143, 148, 151, 153, 156–157, 161–162, 167–168, 182, 185, 188–191, 197–198, 200, 208–209, 212, 215–216, 224, 226, 228–229, 234–238, 242, 244, 248–249, 251, 253, 277
Lucite (Perspex/Plexiglass) 80–81, 177

# Acknowledgements

I began writing this book in 2019, but most of its development took place during the pandemic of 2020–2021.

I've read many books in the process of writing these essays; a large number had been lurking on the margins of my consciousness, waiting for an opportunity.

Writing a book is an opportunity; lockdown was also, weirdly, an opportunity.

I immersed myself in what Laurie Anderson lost in the flood and in Judith Schalansky's inventory of lost and obsolete things and in Lydia Davis and in writings about dust and garbage because those are intrinsic to things, and in Maira Kalman's deliciously painted celebrations of objects and in Moyra Davey because everything she does is interesting to me and in a great deal of poetry and in writers that have not even made their way into my bibliography because they are not directly cited: Dionne Brand, Mary Cappello, Lauren Elkin, Marianne Hirsch, Margaret Iversen, Judith Kitchen and Dinah Lenney, Bernadette Mayer, Daniel Miller, Julie Myerson, Anthony Rudolf, Leanne Shapton, Joanna Walsh, Claire Wilcox, Minna Zallman Proctor.

Books padded my lockdown cave. I also began, through an increased involvement with Instagram and its distinct formal constraints, to find a new voice and a place in a larger online world of writers and makers whom I would not otherwise have met and who were inspiring in ways I could not have anticipated. It has been a fruitful period of change, and I feel that the title of this book, chosen near the beginning of the project, has turned out to be more apposite than I imagined it could be.

I am grateful to Sarah Chambers, Anne Janowitz and Julie-ann Rowell for reading and commenting on a good number of these chapters in draft form. Our regular discussions of one another's work—in real life and on Zoom—accompanied the inception of this book and its

progression. My thanks for lateral thinking and nudging me in different ways to Nadina Al-Jarrah, Hetty Einzig, Kathy Joyce, Sue Kaplan, Brigid MacCarthy, Andrea Mindel and Lorna Scott Fox. A special, heartfelt thank you to Jenn Law for always being the most astute and sensitive of interlocutors and readers, and for lending me her fine eye for design detail. Thank you, too, to Anthony Rudolf who read the whole script at a crucial point and saved me from some embarrassing errors. Thank you to Zé António Sousa Tavares for generous permissions, always. Thank you to Melissa Purkiss for editorial expertise and to Alessandra Tosi, Luca Baffa, Laura Rodríguez and Anna Gatti at Open Book Publishers for being amazingly helpful and supportive during the production of this book.

Though he does not understand this acknowledgement, my life would have been inestimably poorer during the writing of this book without the steady companionship of my dog Monty, and without the love he elicits from me. My gratitude to Dan Rosengarten and Leora Yaffi—my brother and sister—who, at long distance, kept me buoyant when I might have sunk and whose memories have bolstered or bumped against mine. I dedicate this book to them, with love.

# About the Team

Alessandra Tosi was the managing editor for this book.

Melissa Purkiss performed the copy-editing, proofreading and indexing.

Anna Gatti designed the cover. The cover was produced in InDesign using the Fontin font.

Luca Baffa typeset the book in InDesign and produced the paperback and hardback editions. The text font is Tex Gyre Pagella; the heading font is Californian FB. Luca produced the EPUB, AZW3, PDF, HTML, and XML editions — the conversion is performed with open source software such as pandoc (https://pandoc.org/) created by John MacFarlane and other tools freely available on our GitHub page (https://github.com/OpenBookPublishers).

# This book need not end here...

## Share

All our books — including the one you have just read — are free to access online so that students, researchers and members of the public who can't afford a printed edition will have access to the same ideas. This title will be accessed online by hundreds of readers each month across the globe: why not share the link so that someone you know is one of them?

This book and additional content is available at:

https://doi.org/10.11647/OBP.0285

## Donate

Open Book Publishers is an award-winning, scholar-led, not-for-profit press making knowledge freely available one book at a time. We don't charge authors to publish with us: instead, our work is supported by our library members and by donations from people who believe that research shouldn't be locked behind paywalls.

Why not join them in freeing knowledge by supporting us: https://www.openbookpublishers.com/support-us

# You may also be interested in:

**Discourses We Live By**
**Narratives of Educational and Social Endeavour**
*Hazel R. Wright and Marianne Høyen (eds)*

https://doi.org/10.11647/OBP.0203

**Liminal Spaces**
**Migration and Women of the Guyanese Diaspora**
*Grace Aneiza Ali (ed)*

https://doi.org/10.11647/OBP.0218

**Essays on Paula Rego**
**Smile When You Think about Hell**
*Maria Manuel Lisboa*

https://doi.org/10.11647/OBP.0178

Lightning Source UK Ltd.
Milton Keynes UK
UKHW020631250822
407772UK00002B/30